| *Bernini* ‒

DATE DUE

AG 9'01			
AP 23 '05			
MY 31'11			

DEMCO 38-296

K

GIOVANNI CARERI

Bernini

Flights of Love,
the Art of Devotion

Translated by Linda Lappin

THE UNIVERSITY OF CHICAGO PRESS

CHICAGO & LONDON

GIOVANNI CARERI is former cultural attaché for the Italian Cultural Institute in Paris and has taught history and theory of art at the Ecole des Hautes Etudes en Sciences Sociales.

The University of Chicago Press, Chicago 60637
The University of Chicago Press, Ltd., London
© 1995 by The University of Chicago
All rights reserved. Published 1995
Printed in the United States of America
03 02 01 00 99 98 97 96 95 1 2 3 4 5
ISBN: 0-226-09272-0 (cloth)
 0-226-09273-9 (paper)

This book was originally published in French, in 1990, by SOGEDIN—Editions Usher as *Envols d'amour: Le Bernin: montage des arts et dévotion baroque*. The English translation, except for the foreword by Hubert Damisch, which is translated from the French edition, is based on the Italian version published in 1991 by Editori Laterza as *Voli d'amore: Architettura, pittura et scultura nel "bel composto" di Bernini*.

Library of Congress Cataloging-in-Publication Data

Careri, Giovanni, 1958–
 [Voli d'amore. English]
 Bernini : flights of love, the art of devotion / Giovanni Careri ; translated by Linda Lappin.
 p. cm.
 Revision of the author's thesis (doctoral)—Ecole des Hautes Etudes, Paris.
 Based on the Italian version published in 1991, with new foreword.
 Includes bibliographical references and index.
 1. Bernini, Gian Lorenzo, 1598–1680—Criticism and interpretation. 2. Christian art and symbolism—Modern period, 1500– —Italy—Rome. 3. Ecstasy in art. I. Title.
N6923.B5C2713 1995
709'.2—dc20
 94-19961
 CIP

♾The paper used in this publication meets the minimum requirements of the American National Standard for Information Sciences—Permanence of Paper for Printed Library Materials, ANSI Z39.48-1984.

CONTENTS

FOREWORD

When a visitor enters the church of Sant' Andrea al Quirinale, he is confronted with something of a paradox, if not a challenge. In the nearby church of San Carlo alle Quattro Fontane, built by Borromini twenty years earlier, the interior, in an oval plan, extends lengthwise from the portal to the altar, forming a kind of nave. But the Bernini church is completely different: it extends transversely. The line from the portal to the altar corresponds to the shortest axis of the ellipsis. The comparison does not end there. In San Carlo, the half-obscure nave leads to an altar of the most modest sort, illuminated by the single candle of the Holy Sacrament, just as the copula with its intricate geometric decor is diffusely illuminated by the lantern. In Sant' Andrea, by contrast, light floods in through the open windows at the base of the cupola, while the panes of the lantern are made of yellow-tinted half-opaque glass, whose stifled luminescence isolates this lantern from the gilded ribbed vault. The altar, surmounted by a painting of large dimensions, itself surrounded by a flight of angels in gilded stucco, occupies a place within the choir, which opens behind the screen formed by four monumental marble columns veined with red, as are the pilasters that decorate their base.

This would all amount to nothing if our visitor were not from the outset established in the position of a viewer through the effect of a calculated arrangement in which the resources of painting and sculpture combine with those of architecture to create what Giovanni Careri, reappropriating for his own purposes the notion introduced by Baldinucci in his *Life of Bernini*, chooses to analyze under the name of *bel composto*. The figure of the crucified saint presented in the altar painting escapes from the frame of the representation, turned as it is toward a spectacle that neither the visitor, who is forbidden to enter the choir, nor those who are attending to the martyr in the painting are allowed to contemplate. Yet, at the same time, the visitor who has just entered the church and is immediately facing the choir cannot

help but be struck by the great sculpted figure in white stucco installed in the cornice above the choir, who seems to have been arrested (as in a "freeze frame" in film) in his ascending movement. This is suggested not only by the saint's attitude, characteristic of the "rise to heaven," but also by the interruption in the architectonic lines of the pediment, which is both its corollary and its index.

In his study of *bel composto*, Giovanni Careri rightly seeks to break with the scenographical model and the reference to the theater, which in this case take the form of a commonplace. If there is *composto*, the procedures that define it and the effects it is aiming at owe nothing to the "theater" of painting, nor to that of sculpture or architecture. What we are dealing with in this particular case is closer to what a man of the cinema such as Eisenstein would have called the "montage of attractions": that is, a calculated sequence that mobilizes heterogeneous elements as much by their substance as by the conditions under which they appeal to the senses or understanding, making them work together in an expressive synthesis that is intended to act on the viewer, manipulating him, moving him, "agitating" him (in the manner of *agitprop*). The only difference is that cinema reduces the attractions to the unity of a single substance, photographic in the last analysis. On the other hand, the *bel composto* takes advantage of the way the materials assert their differences in levels to better confuse or displace the borders between painting, sculpture, and architecture, and to pervert or transpose the constraints and traditional rules to which these three arts obey. This works so well that the very differences that might exist between them are in this case at play as a factor of synthesis or integration. It is this play that Careri proposes to set forth, using the example of the three Bernini chapels, through a description that, in pushing beyond the limits of the genre, takes on the value of a method, even as it assumes a properly theoretical, if not metaphysical, dimension.

The reference to the notion of "montage," borrowed from cinema, nevertheless poses a problem inasmuch as that notion was totally foreign, and for good reason, to the aesthetic thinking of the time—unless, with Eisenstein, we maintain that cinema represents a kind of synthesis, in the Hegelian sense, of the arts of the past, "surpassing" them even as it integrates them. In this view, cinema would retrospectively provide the key to past arts, just as, if we are to believe Marx, man's anatomy provides the key to that of the ape. But this problem—the necessity and the proper use of anachronism in the matter of art history—encounters another, which, if

possible, is even more fundamental and to which Careri's text constantly alludes. Since, in his own words, it is a question of "giving a precise historical determination to the process of contemplation induced by the *bel composto*," it is obvious he cannot succeed except by proceeding to a kind of eidetic variation that, among other things, feeds on the knowledge of angelology and mystical literature (beginning with Loyola's *Spiritual Exercises*). But it necessarily begins with the experience to which anyone entering the Sant'Andrea church even today is immediately subjected in being transformed into a viewer. What is proper to the *bel composto*, its constitutive determination, is that, as the condition for its own functioning, it produces the viewer, who in the end is its true material. It then lies with the viewer to enter into the good graces of the sacristan and gain permission to enter the choir and contemplate in his turn the vision painted in the lantern, with which both the crucified saint on the canvas and the officiant of the mass is honored at the moment of the elevation. This intrusion invests all outward appearances with an indiscretion, since it corresponds to a kind of short circuit in the network of the initiation experience to which novices were subjected in accordance with the teachings of Loyola. In its way, it nevertheless corresponds to the very functioning of art. In its time, that functioning (as Careri's analysis of the *bel composto* superbly demonstrates) could have produced the effects whose mechanisms he uncovers in the formal description—set forth as it is with a flawless historical knowledge—only because even today that description appeals to the "transcendental viewer" in us. This book—and therein lies all its value—imposes the idea of such a viewer with an ever renewed force and insistence.

HUBERT DAMISCH
(Translated from the French by Jane Marie Todd)

INTRODUCTION

> The opinion is widespread that Bernini was the first to attempt to unite architecture with sculpture and painting in such a manner that together they make a beautiful whole [*bel composto*]. This he accomplished by removing all repugnant uniformity of poses, breaking up the poses sometimes without violating good rules although he did not bind himself to the rules. His usual words on the subject were that those who do not sometimes go outside the rules never go beyond them.[1]

In this passage, so brief yet rich in content, Filippo Baldinucci testifies to the belief, generally held in his day, that Gian Lorenzo Bernini had created a new way of linking the arts together. If it is true that his whole work may be interpreted from the point of view of the insertion of sculpture into architectural space, or of the insertion of architecture into urban space, then the most complete realization of the *bel composto* may be found in the interiors of his chapels and churches. This is not only because here painting always plays a decisive role, but also because the interior of a baroque chapel is an autonomous organism, complete in itself: a dark world sealed below by the balustrade and lit from above by the light of a lantern. Covered by a luminous celestial dome, this dark, earthly place is populated by bodies made of paint, marble, stucco, and flesh. Here we find represented the "flights of love" of the souls enamored of the Bridegroom, the ecstatic deaths of martyrs, and the intense devotion of the faithful. The metamorphoses of the spirit become visible in the transformation of physical bodies. This mysterious alchemy fuses the divine and the human, life and death, pleasure and pain, fatigue and repose, all events that cannot be represented without the tension that arises from the coexistence of opposites. The surfaces of bodies, the epidermis of marble, the creases of fabric abandon their form and are reunited in the formal scheme of an oxymoron: they are both tense and relaxed, wrinkled and smooth, luminous and dark. This configuration of materials and figures, like its pathetic content, is organized into a

sort of montage consisting of a series of progressions or leaps from one component of the *composto* to another. This bringing together of art forms, all of which are governed by different rules and regimes, creates a series of shifts from one level to another in an irregular and ongoing process. These conversions from one component to another mark the critical thresholds of the dynamics of the *composto*. Its progressions and reversals are given form in the transition from a sculpted figure to a painted one, in the leap from an emblem to a story, in the transcendence of stucco in marble, in the interplay of concept and sensory perception, and in the transformation from the general to the particular.

In order to show how the Berninian *composto* works, I have selected three ensembles Bernini created in Rome between 1664 and 1675: the Fonseca chapel in San Lorenzo in Lucina (1664–75), the Albertoni chapel in San Francesco a Ripa (1665–75), and the high altar in the church of Sant' Andrea al Quirinale (1658–70). The design of these three ensembles, of course, was determined in part by the different architectural contexts in which each one is situated: while the first is a chapel that utilizes the available space offered by the plan of the church, the second calls for a major modification of a preexisting chapel. The Quirinal altar may be interpreted only within the context of a church wholly designed by Bernini. Furthermore, whereas the Fonseca chapel and the Quirinal church must be analyzed with reference to the devotional practices of the Jesuits, the Albertoni chapel was conceived within the spiritual context of the Carmelites and Franciscans. Despite these differences, however, the three ensembles may be compared insofar as they are all examples of the *bel composto* in which painting, sculpture, and architecture are combined.

Although my analysis focuses on these three places, the problematic nature of the *bel composto*, as posed by Baldinucci, must be considered within the bounds of a far more general investigation, one that has informed all aesthetic inquiries since Kant's *Critique of Judgment*: how unity is created from the multiple and heterogeneous elements of a work of art. The heterogeneity of the arts in the *composto* is richer and more complex than the heterogeneity of any of those arts considered separately. The harnessing of three systems of representation requires the violation of the rules governing each one and the reordering of all three systems under a new rule. If a new rule is generally needed, however, the same rule does not work for every *composto*. The theme of the *composto* and the specific viewer for whom it was created, like the choice of materials or the arrangement of colors, are elements that each time must be fused anew into a single unit.

The construction of the *composto* must be viewed from two angles: that of its composition by the artist and that of its reception by the spectator-worshipper. The montage of each *composto* induces the spectator to re-assemble its disparate elements into a whole through a diverse "free play of the faculties." If we wish to attempt to recreate the reception of a hypothetical but historically determined viewer, we must take into account the historically defined forms of contemplation that dictate the rules of a game in which understanding and imagination mingle, a game that is less free than in the Kantian formulation.

The beholder's reception of each of these ensembles occurs within the context of a very specific devotional practice, involving not only a complex system of religious beliefs but also a certain discipline of the imagination. A special training of the spirit, together with a ritual protocol, may transform the believer through its sacramental effects. In reconstructing a hypothetical spectator-worshipper, we must begin by studying the indications inscribed in the forms of montage particular to each *composto* in relation to the schemes of reception deriving from the various forms of Christian contemplation in the seventeenth century.

Bernini's chapels have often been described in terms of theater because of the nature of their decoration and because of the emotional impact they have upon the viewer. Although these ensembles were conceived as "emotional machines," I believe that comparing them to the theater confuses rather than clarifies the issue. The theatrical paradigm is far too general a model both historically and theoretically. In the case of these ensembles, the observer participates by applying a specific form of contemplation to the act of reassembling the heterogeneous elements of the *composto* into a whole. The emotional and cognitive dynamics of contemplation are sustained and carried forward by the leaps from painting to sculpture to architecture. The generalized comparison to the theater reduces the constitutive heterogeneity of the *composto* to mere spectacle and does not allow us to dismantle it in order to see how each component performs its specific function.[2]

The word *composto*, a noun deriving from the past participle of *comporre* (to compose) is the opposite of *semplice* (simple), and indicates something composite, made up of various elements. It is a very common word. Leonardo uses it in his *Treatise on Painting* to describe the work of the poet: "If you wish to find the proper office of the poet, you will discover that he is none other than a gatherer of things stolen from the various sciences with which he creates his own deceitful *composto*, or one may perhaps say more honestly, his false *composto*."[3] Marcello Fagiolo dell' Arco notes that as the

opposite of "simple" (*semplice*) the word *composto* appears in Leonardo in reference to the work of man in general who, unlike nature, cannot create anything "simple" but only "infinite composites" (*infiniti composti*). It is interesting to note, moreover, that Tasso made use of this same semantic concept in describing the composite nature of man, who is "made of many parts and powers."[4]

In their understanding of the term *composto*, the Italian Jesuits of the latter half of the seventeenth century followed the example of Saint Ignatius of Loyola, who used the word *composto* to indicate the association of soul and body that determines human nature. In a sermon given "on the eve of Saint Ignatius," General Giovanni Paolo Oliva said:

> Insilit in te Spiritus Domini," He said to each of us invited to carry his cross, "et mutaberis in virum alium." We must change not only the figure of the outward senses, contenting ourselves with a composition of the members easy to learn and not that easy to erase. In order to experience the oracle, we must transubstantiate the entire *composto*, the soul as well as the body, until the face is sanctified by the blush of shame, the mind purified by the flames of charity so that it may be said of any one of us: This is one who with his clerical robe has undressed old Adam and who appears with words as well as with facts transfigured "in virum alium."[5]

The basic semantic value of the word *composto*, or, rather, the reference to its nature as a constructed and composite object, is also indicated by its specific usage as an architectural term. The *composto*, or composite order of columns, is indeed characterized by the combining of the Ionic and Corinthian orders, especially in capitals. It is interesting to note that Sebastiano Serlio claims that the fourth order came into being when the rules governing the Greek orders were violated, thus allowing the Romans to create a new rule.

Baldinucci stresses the originality of the Berninian *composto* and insists on the fact that Bernini broke the rules. Here, however, we are not dealing with the rules governing any one art but with the shift from one system of representation to another and from one expressive register to another. In this way, Baldinucci emphasizes the dynamic character of the process that has led us to describe these procedures in terms of montage. We will interpret this notion with all of the theoretical rigor that it assumes in the more mature aesthetic reflections of Sergey Eisenstein—as the shifting back and forth among different systems of representation and different expressive registers.[6]

Thanks to the many possibilities offered by the movie camera, the cinema, more than any of the other arts, may bring about that special composition of sensory, emotional, and conceptual elements that distinguishes the aesthetic object from every other object. Like Bernini, Eisenstein works with leaps from one level to another and with conversions back and forth among disparate components, gauging the pathetic and cognitive effects he will obtain. Like Eisenstein, Bernini understands that the linking together of several arts in a *composto* is successful only when the uniqueness of each one has been preserved in the montage and only when the shift from one to another has been calculated according to the cognitive and pathetic effects that the artist wishes to create in the spectator. The *bel composto*, like Eisenstein's theory of montage but using special and always diverse procedures, is an aesthetic operation in which the heterogeneous multiplicity of the ensemble is taken apart and recomposed by the viewer himself.

Eisenstein's theory of montage is based on an original aesthetic inquiry whose heuristic applicability extends far beyond the realm of cinema. The appropriateness of applying this theory to the study of Bernini's work will be made clearer in our discussion of the three ensembles, during which we will return frequently to the connection between montage and pathos. The application of this theory to the analysis of Bernini's ensembles raises new questions and proposes new answers as to the current methodology in art history today. First, the notion of montage will allow us to examine, with the help of a single model, the disparate elements that constitute an aesthetic unit and will enable us to see how those elements are received and recomposed in the viewer's experience. Second, it implies a dynamic rather than a static theory of reception. Third, alongside the cognitive dimension emphasized by iconography, it restores the dimensions of sensory perception and pathos to the operation of reception. Last, it introduces the principle of the "non-indifference" of materials toward the operations through which they are given form. Indeed, for Eisenstein, the relationship between form of expression and content was by no means arbitrary; it was governed by the predisposition of the materials to welcome the artist's shaping intervention. It is by no means indifferent, for example, if the drapery below the figure of the blessed Ludovica Albertoni is made of reddish jasper full of veins and speckles instead of white marble. Nor is it indifferent that the soul in apotheosis in the Quirinal church is made of stucco. This same principle also applies in a larger sense to the shifting from one element to another in the *composto*. It is not indifferent, for example, that the portrait of Gabriele

Fonseca is a sculpture and not a painting. "Nonindifference," thus, is a specific and basic criterion of the aesthetic object. It is of great heuristic value because it obliges the interpreter to come to terms with a mode of thought "implicit in the objects themselves," a mode of thought that Eisenstein first called "sensory thought" and later defined even more specifically with the aid of Lev Vygotsky's theory of "internal discourse."[7] The dynamics of the *bel composto* in Bernini's chapels cannot be understood or described if we limit ourselves to interpreting the meaning of each component as something fixed, basing our reading on a series of iconographic studies devoted to each element separately. The motifs and figures must, of course, be identified, but we must also reconstruct the mechanisms that allow the shifts from one component to another to occur, thereby influencing the viewer's reception of the *composto*. Most of the existing studies have ignored these mechanisms and therefore reach conclusions that, while not always inexact, are unable to penetrate the veil of excessive generality that tends to hamper most current studies in art history. The identification of a single element must be verified in relation to its adherence to the rules governing the montage of the entire *composto*. When faced with two plausible interpretations, we must give preference to the one that seems to have excelled at taking into consideration the unity of the whole rather than the one that relies on an external source for its elucidation. Otherwise we will find ourselves with a group of identified yet disparate and incoherent figures and forms, which can only lead us to weak interpretations.

If we wish to examine how the *composto* works, we must consider the meaning of each component, the way the components are assembled into a whole, and the sensory, cognitive, and emotional impact they have on the viewer. In other words, beyond the "iconographic" question ("What does it mean?"), the "structuralist" question ("How does it work?"), and the pragmatic question ("What particular devotional practice has provided its context?"), here we are dealing with a "structure of enunciation."[8] The chapel or altar was conceived by someone for someone and therefore is characterized by a number of telltale signs that inscribe the viewer and the situation of reception in the configuration of the montage of the *composto*, especially in its presentation devices. The points of view stressed by the architectural structure of the chapel, the figures gazing out of the paintings, the arrangement of the frames, and the positions of the angels are all examples showing us how the presentation (display) components succeed in establishing a network of positions that may be assumed by the spectator. The spectator's virtual journey through this network is closely bound up with the leaps and

shifts from one component to another that characterize the dynamics of the montage of each ensemble.

I have studied each *composto* as a "theoretical object,"[9] without referring to previously conceived and elucidated theories. Instead I have attempted to explain the theoretical applications implicit in each ensemble. Such a rigorous and inductive approach calls for extremely detailed descriptions while forbidding reckless generalizations. It demands that we stay well within the speculative horizon provided by the object itself, so that each step toward the general may be verified (or even made visible) in the particular. In describing how one of these ensembles works and in showing what effect it was meant to have on the viewer, theory cannot do without history, nor can history do without theory. Theory and history are not rigid frames in which the *composto* must find its place, but the theory and the history produced by the *composto* itself are the coordinates that it indissolubly creates. In this book, my purpose is not to offer a simple iconographic analysis. My aim is perhaps more ambitious: ideally I wish both to analyze each *composto* and to describe in detail how each one actually functions. This type of methodology may lead the way toward a different kind of knowledge and may bring to the surface new articulations from within the objects under study. Furthermore, this method provides a useful tool with which we may test the results of an iconographic analysis.

Previous studies of Bernini's chapels and, more generally, nearly all the iconographic analyses done in the last twenty years, seem to me to overemphasize the importance of the "textual basis," thereby attributing to the visual arts only one type of complexity: the identification of motifs, figures, and iconographic programs. This sort of approach tends to ignore the particular visual richness that every image possesses, its sensory and emotional value, and the way it is actually made. The *bel composto* is an excellent example to show us that the visual arts are never a mere illustration of a literary or written text, for they have their own specific ways of conveying meaning. Nevertheless, this has not kept me from reading and analyzing all seventeenth-century texts that had something to teach me about how these ensembles work. Aside from consulting rare documents concerning the patronage of these works, I have given particular attention to some of the mystical writings of the period in order to identify the linguistic forms and rhetorical figures whose formal configurations have strong affinities with some of the solutions adopted by Bernini. I have also studied texts necessary for the reconstruction of the historically determined models of contemplation that are suggested by each of these ensembles. Finally, I have analyzed

the theological formulations pertaining to the intensity and type of religious experience involved in the different forms of reception of each work.

Throughout this book, I have frequently referred to previous studies by Bernini scholars, particularly to Irving Lavin's study, *Bernini and the Unity of the Visual Arts*. In this book, the very first study to deal directly with the problem of how Bernini integrated the arts, Lavin examines a group of works Bernini created between 1630 and 1647, concluding with the Cornaro chapel of Santa Maria della Vittoria. His studies, so detailed and rich in suggestions, were of great value to my research, but my own quite different methodological approach has led me to elaborate a completely different concept of the *composto*.

For Lavin, the Cornaro chapel sums up the progress achieved in all of Bernini's previous works. He sees Bernini's ensembles as being related chronologically: the solutions found in each work may be explained by the preceding ones. Lavin has followed a strategy of historical or diachronic interpretation rather than attempting a synchronic analysis of each individual *composto*. He always has a perfect answer to the phylogenetic question: "What precedents have made such an original solution possible?" But he rarely answers the structuralist question, "How does it work?" or the pragmatic one, "What effect does it have?" Moreover, for reasons of convenience, he discusses architecture, sculpture, and painting separately. The results of these three separate studies are then pooled to form a vision of the whole. The meaning contributed by each single component is taken into consideration, but not the moments of transition from one component to another. In this way, the static aspect of the *composto*'s structure is stressed to the detriment of its dynamic aspect. Furthermore, Lavin considers only those questions pertaining to the problematic tradition of each separate art form. In contrast, I have chosen a form of exposition based on the problematic points that are different in each *composto*, which do not always correspond to the boundaries dividing the various arts. I have dealt with different and in some cases—entirely new questions. I have emphasized the leaps and transitions, and have tried to show how the various arts come together to surpass their own limits, transcending one into another. This "movement" inherent in the *composto* and the corresponding processes that it elicits in the viewer's reception are not discussed by Lavin or by other Bernini scholars. When these questions are mentioned, they are always subordinate to the preliminary and limiting identification of iconographic motifs based on texts or on other artworks of the same or earlier periods.

The series of ensembles that I have analyzed here, although consisting of

a group of works dating more or less from the same period and belonging to the final phase of Bernini's career, is not ordered chronologically. Each *composto* has been analyzed internally in order to identify a number of invariants and differences. The advantage of this type of structural approach is that it allows one to say, for example, that the sculpture of the soul of Saint Andrew in apotheosis in the Quirinal church functions similarly to the emblem of the flaming heart in the altar of the Albertoni chapel. That is to say, this type of approach offers a variety of formal possibilities and a scheme of transformations that will allow us to compare not only the components of these three ensembles but also how they work. This way of organizing the series of artworks has led me to leave aside the teleological view, originating with Giorgio Vasari, of a history of art arising from itself and concluding in itself along an ascending or descending line of development.

The arrangement of the chapters charts the evolution of my research. I began with the Fonseca chapel and then went on to study the Albertoni chapel in light of the questions that had emerged from my previous study; then I applied what I had discovered to the altar of Sant' Andrea al Qurinale. As my research progressed, the ensembles began to react to each other. The invariants common to all and the unique features of each one grew more distinct in an order that certainly does not correspond to the one Bernini actually followed in creating them, but that does reflect a style of thought that cannot be completely foreign to the way this artist worked. Given the long and partially overlapping realization times, the idea of an artist working simultaneously on three paintings, considering them in their similarities and their differences, is much closer to the dynamics of artistic creation than a strictly chronological scheme would be.

The three sections that make up this book do not claim to be exhaustive monographs, nor do they offer substantially new information of a documentmentary nature. Each section includes a brief summary of the essential documentary data and a discussion of the major interpretations, followed by the elaboration of my own hypotheses. These hypotheses are then verified through an analysis of the mechanisms found in each *composto* and through a study of their reception. This schematic presentation, however, provides only a sketchy outline of the book. The heterogeneous nature of the *composto* and the uniqueness of each of Bernini's ensembles have in fact led me to address the problem in a different way—to follow an oblique and irregular route with many departures and returns, in the very image of the *composto* itself.

ONE | The Fonseca Chapel

THE
DOCUMENTARY
DATA Bernini was commissioned to design the chapel of Our Lady of the Annunciation in the church of San Lorenzo in Lucina as early as 1663. This chapel is noted especially for its marble portrait bust of the Portuguese doctor Gabriele Fonseca (d. 1688) (fig. 1). For stylistic reasons, and also because it receives no mention in a reliable guide dated 1674, Rudolf Wittkower dates this sculpture back to the period 1674–75.[1] Above the altar hangs an oval altarpiece, a copy of Guido Reni's *Annunciation* at the Quirinal Palace (1612) (fig. 5), created for Bernini's *composto* by Giacinto Gimignani in 1664 (fig. 6).[2] Wittkower claims that the shape of the altarpiece was determined by the architectural structure of the chapel, and, as a result, that the plans for the chapel were fairly well advanced by that date. This theory must be accepted with some caution because it excludes the possibility that it was rather the altarpiece that may have influenced the architectural structure. Indeed, it could be argued that the conception and planning of the entire *composto* in the Fonseca chapel had its origins in Guido Reni's painting. We must not forget that this was one of the most admired Annunciations of its time and that the chapel of Our Lady of the Annunciation in the Quirinal Palace offered interesting solutions to the problem of integrating painting and sculpture.[3] We could well imagine that Bernini had the Quirinal canvas copied, modified the format, and then planned the Fonseca chapel around it. This hypothesis may find confirmation in several small yet important discrepancies between the sketch of the altar wall (probably drawn by Bernini's own hand) and the chapel itself (figs. 1 and 2). To explore this possibility more fully, we must ask ourselves what Bernini's reasons were for having Guido Reni's painting copied. But before we can answer this question, we must understand how the copied altarpiece functions within the *composto*. We must also consider the two lateral paintings. According to Judy Dobias's reconstruction, Gimignani's *Elisha Throws Salt into the River*

(fig. 4) was hanging on the left (today it hangs on the right); on the right was a painting by Guglielmo Cortese, *King Ahab and the Prophet Elijah on Mount Carmel*, the original of which has been lost but which is reproduced in an anonymous copy (fig. 3).[4]

RESULTS AND LIMITS OF AN ICONOGRAPHIC ANALYSIS

Identifying of the iconography of these two canvases based on subjects drawn from the Old Testament has led the American scholar Judy Dobias to propose a global interpretation of the Fonseca chapel. Dobias links these two paintings to the profession of their donor, who was the personal physician of Pope Innocent X and a professor of medicine, first in Pisa and later in Rome. Fonseca was one of the most ardent advocates of "Jesuits' powder," the quinine brought back from Peru by the missionaries of the Society of Jesus. In 1657, he gave an exemplary demonstration of the effectiveness of this drug by curing Flavio Chigi of malaria. Fonseca was also the author of two scientific studies on the epidemiology of plagues.

The two lateral paintings represent two miracles from the Book of Kings, both of which are related to water. The Elijah episode illustrates the prodigious return of rain after three years of drought caused by King Ahab's impiety. The other episode tells how Elisha used salt to purify the waters of the River of Jericho, which had been polluted during the time of Ahab. This painting includes a Latin inscription, which is being carried by cherubs: "Non erit ultra in evis mors. lib. Regis cap. 3." For Dobias, the ceasing of the deadly action of the polluted waters of the Jericho river is related to the efficacy of quinine in curing malaria and preventing death. In his last will and testament, in a passage concerning the chapel of Our Lady of the Annunciation, the donor did indeed ask to be remembered as a man of medicine.[5] Thus Fonseca may be identified with Elisha, for he has arrested an epidemic, just as the prophet himself had done. Salt, then, would be the symbolic equivalent of quinine. The triumph of earthly medicine would correspond to the triumph of faith, celestial medicine, which is the meaning traditionally ascribed to the other episode: *King Ahab and the Prophet Elijah on Mount Carmel*. If we consider that, during this century, physical well-being could not be separated from spiritual well-being, the two episodes would be related through their shared reference to episodes of purification: physical for Elisha/Fonseca, spiritual for Elijah.

The parallel relationship between physical health and spiritual salvation and the symbolic replacement of quinine with salt are two quite plausible and historically justifiable operations. The former concerns Italian culture during the seventeenth century generally; the latter, Fonseca's life as an individual. The former is based on the direct relation between the iconography of the two paintings but entails two different levels of interpretation: allegorical for Elijah and literal for Elisha. In order to understand how quinine and salt are equivalent, we must have recourse to outside information. That Fonseca was a physician was a fact known to many, and we cannot question the interpretive skills of Bernini's contemporaries nor their familiarity with the allegorical portrait. Furthermore, the chapel is a semiprivate place, intended, at least in part, for the visitor who was "an insider." However, all this would be valid if in place of Bernini's sculpture there were an inscribed slab. In other words, this interpretation does not take into account the relative positions of the paintings, the altarpiece, and the bust, thereby ignoring the central relationship that the *composto* creates with the beholder. It is quite plausible to identify Elisha as the allegorical portrait of Fonseca, given that the doctor is wearing the robe reserved for the members of his profession, and also that in the original arrangement the prophet was located above Fonseca in the traditional position of the patron saint.[6] Yet we cannot forget that the bust of the donor faced Elijah, who was pointing out to Ahab the cloud rising from the sea—the cloud that would soon bring an end to the drought. If we consider the position of the bust, we realize that the cloud is being pointed out both to Ahab and to Fonseca. The miracle on Mount Carmel was not only a demonstration of the superiority of Judaic monotheism threatened by the cult of Baal, but also represented, according to the interpretation of the Carmelite tradition, Elijah's "vision" of the mysteries of the Virgin Mary.[7] Considering that Bernini has portrayed Fonseca in the act of contemplating an Annunciation, we cannot exclude the references to Mary associated with the Elijah episode. Furthermore, the copy of the painting seems not to place great emphasis on the "triumph of the faith," but rather on the transition from drought to irrigation, a process that in the mystical tradition of the seventeenth century represented the passage from a state of spiritual impoverishment to one of communication with the divine.[8] The expectation of rain could thus in some way correspond to the tension manifest in the pose of the praying Fonseca.

In her interpretation of the altarpiece, Dobias refers to Fonseca's last will

and testament. In particular, she cites a passage in which Fonseca begs the Virgin to intercede for him at the hour of his death, saying, "and I devotedly pray to the Glorious Virgin Mother of God and to her Saints and Angels to ask that they intercede for me at the hour of my death."[9] This phrase does not refer to the chapel; instead it is a stereotyped formula, located at the beginning of the document. Dobias comes to the following conclusions: "The Virgin often takes on the role of the Queen of the Holy Rosary and of the Gate of Heaven. In this case she is presumably likened to the Gate of Heaven, and faith through her leads to salvation, and therefore the subject would have been especially suitable for a burial chapel."[10] Dobias chooses from among the "traditional" and textually verified meanings ascribed to the representation of Mary, and does not consider the complex network of relationships (plastic, spatial, chromatic, narrative) that exist among the altarpiece and the other components of this chapel. In doing so, she reduces the painting to a mere sign of a preexisting "meaning." Furthermore, while her iconographic analysis of the two lateral paintings is partially acceptable, the analysis of the Annunciation as the "Gate of Heaven" is not. The weakness of her interpretation derives from her overestimating the importance of the above-mentioned passage in Fonseca's will. In this regard, it is interesting to observe how this type of iconographic approach reveals itself to be partially valid for the two lateral paintings, which are based on relatively unusual subjects, but quite unsuitable for the central painting with its more common subject matter. This discrepancy is symptomatic of a hermeneutic strategy, very widespread in art history today, that recognizes only one type of complexity and only one way of solving it: that is, to find an iconographic program, possibly written, or at least a "sure textual basis."

THE WINDSOR DRAWING Given the current state of research, it is difficult to establish whether or not the drawing preserved in the Royal Library of Windsor Castle (fig. 2) was done before or after the execution of the altarpiece, copied by Gimignani.[11] As we have already mentioned, Wittkower claims that the painting was commissioned with the architectural plan of the chapel in mind, but the opposite is also possible, that is, that the starting point for this project was the original painting by Guido Reni. In reality, both theories are excessive. Although it is true that the general outlines of the project as recorded in the drawing were indeed later realized in the chapel, it is also true that three major

changes testify to the influence of the painting on Bernini's designing of the *composto*.

The first and most minor change is the absence of the clouds and the little putti from below the frame of the altarpiece. In place of the clouds, but serving the same function of support, Bernini has inserted between the altar and the frame of the altarpiece a large, black-bordered rectangle that reproduces the outline of the altar's shape.[12] In this way, the elevation of the altarpiece, fundamental to the functioning of the chapel, is rendered even more evident. The putti, who have vanished from below the frame, reappear along its upper edge where they extend up into the vault, forming a chain of angels hovering above the Annunciation. To this first change, which depends directly on the painting, we must also add the change in the posture of the two large black angels who are carrying the frame. In the drawing the angel on the right is clinging to the frame with both hands while looking at the altarpiece, whereas the angel on the left is looking down toward the left at the niche occupied by Fonseca's bust while pointing at the painting with his right hand. In the actual chapel, the angel on the left is looking at the altarpiece while the angel on the right is gazing at Fonseca, but instead of pointing at the painting he has placed his hand on his breast.

This change of the angel's gesture is not a simple detail, a mere decorative element of the *composto*. The angel on the right has not assumed just any position; he is imitating Mary's gesture in the altarpiece, which is further intensified by Fonseca's repetition of this very same gesture.

This double repetition of Mary's posture reveals an imitative process that is of great importance for the Fonseca *composto*. The donor is imitating the angel, who in turn has imitated Mary. Considering that the painting is a copy, we may suppose that the black angel's gesture was modified in order to create a link between the painting and the sculpture. We may also imagine that Fonseca's posture in the bust depends to some degree on Mary's gesture in Guido Reni's painting. We will understand more fully what meaning this projection of the Virgin's posture outside the painting may have only after we have studied its meaning within the original painting. Yet we must note that in the Fonseca chapel, unlike the Windsor drawing, a chain of similar gestures connects the donor, the angel, and Mary.

We may admit with Wittkower, however, that the plans for the chapel preceded the selection of the painting destined for the altar, but we must also observe that, at a later moment, the question of integrating the painting

into the *composto* began to play a decisive role, not only in the designing of all the sculpted figures, but also, as we will see shortly, in the configuration of the entire architectural "decoration" of the chapel interior.

GUIDO RENI'S
ANNUNCIATION
AT THE QUIRINAL
PALACE IN
GIOVANNI PIETRO
BELLORI'S
"EKPHRASIS"

In July 1665, while admiring an Annunciation by Guido Reni in Paris similar to the one in the Quirinal Palace, Bernini, with his usual frankness, remarked to his French host that the painting "was worth half of Paris," and then, a moment later, claimed that "it was worth more than Paris." [13] Bernini's use of a copy of one of Guido's Annunciations in his *composto* for San Lorenzo in Lucina not only shows that Bernini felt great admiration for this painter, but also that he had a profound understanding of Guido's "idea" of the Annunciation. In those same years, the Quirinal *Annunciation* was the subject of a subtle commentary by Giovanni Pietro Bellori, theoretician of *Idea del pittore della scultore e dell' architetto* and author of *Le vite de' pittori scultori e architetti moderni* (fig. 5). The passage in this text that interests us appears at the beginning of the chapter on the life of Guido Reni, in a section dedicated to the paintings in the Pontifical Chapel of the Quirinal Palace.

> The chapel is formed by a square amid four pilasters, surmounted by four arches supporting the vault. The formation of the altar is set within the arch facing frontward. In the middle, surrounded by a rich stucco decoration, hangs the painting upon which is painted the mystery of the Annunciation to which the chapel is dedicated. Guido drew his subject from the words spoken by the angel to the Virgin, "The Holy Spirit shall come upon thee and the power of the Highest shall overshadow thee," together with the words of her reply, "Behold the handmaid of the Lord, be it unto me according to thy word."

A description of the painting follows:

> In a chamber steeped in shadow, Gabriel is kneeling humbly before the Virgin, in one hand holding a lily, symbol of Mary's Immaculate Virginity, and with the other hand pointing upward at the great light of the Holy Spirit descending from above as a white dove with five cherubs holding hands and rejoicing for Mary chosen Mother of the Lord. The angel is attired in a robe of gold and a purple cloak fastened on his chest with a jeweled buckle. The Virgin is draped in a blue mantle. Kneeling on a stool, the obedient handmaid

of the Lord folds her arms, casts down the light of her eyes, and receives the divine spirit with which she is now being infused. Her beauty shines forth all the more from the humility in her face, which appears celestial as she gazes upon the ground. Behind her in the shadows dazzling in the chamber, a ray of light falls upon a small table where a book lies open, as though while absorbed in prayer she had suddenly turned to the divine messenger.[14]

Following the fundamental rules of ekphrasis, Bellori uses the present tense in his description of the painting. Furthermore, he "translates" the two verses of the Gospel quoted in the introductory part. Thus "the power of the Highest shall overshadow thee" becomes "in a chamber steeped in shadow," while "the Holy Spirit will come upon thee" is transformed into "[Gabriel is] pointing upward at the great light of the Holy Spirit." These two actions, which were first introduced through Gabriel's announcement uttered in the future tense, without any indication of place, are now occurring at the present moment and in a specific place. The overshadowing is actually taking place in the "chamber," while the light is descending from "above the chamber."

Bellori's text, using the tools proper to written language, illustrates the manifestation and localization in a specific place of the mysterious action of the Holy Spirit described by Gabriel, operations without which it would be impossible to transpose the Gospel text into images. In elucidating Guido's use of mimesis in the *Annunciation*, Bellori states in his introduction that Mary's reply does not come after the angel has spoken but is uttered at the very same moment. However, the "translation" of Gabriel's words into terms of light and shadow shows that, for Bellori, Guido's painting does not simply put two characters in a scene and in a place in order to tell the story of the Annunciation, but records in painting the actual operations through which the "mystery of the Annunciation" became manifest, those very mysteries "to which the chapel is dedicated." Indeed, the two verses Bellori quotes are not the ones that reveal to Mary the secret of the Annunciation, "Thou shall conceive in thy womb and bring forth a son." Instead, Bellori quotes the verses that figuratively describe the mode and manner of this mysterious operation through which God became man. In the Gospel text, Gabriel's "explanation" precedes the actual fulfillment of his announcement by a few seconds and serves to render more accessible to Mary a mystery that by definition is inaccessible to human reason. This mystery is a truth concealed in God, but revealed by Him though it remains hidden behind the veil of faith. The transformation of the two Gospel verses in Bellori's

ekphrasis obeys the same rules as the mystery they must somehow explain. This transformation is based on the relationship between the "Light" of the Holy Spirit, the principle of visibility that renders the mystery perceptible through the form and figure of light, and "Shadow," the principle of invisibility that veils the mystery because it may not manifest itself if not concealed. In the Gospel According to Saint Luke, Gabriel embodies the "verbal expressibility" of the mystery that is about to occur. In Bellori's description, he is associated through his golden robe with the principle of the mystery's visibility and with the light projected into the room by the "white dove." The verbal expressibility of this mystery of the Gospel text has become in the ekphrasis its visibility in terms of light and shadow.

Simultaneously character in the scene and figure of the mystery fulfilled, the Virgin assumes the paradoxical characteristics of the coexistence of opposites proper to the economy of the mystery of the Incarnation: her face "appears celestial as she gazes upon the ground," her body is exposed to the light of the Holy Spirit and yet enveloped by the shadow of the Power of the Highest. But the most striking image of the mystery that informs Bellori's entire description is the image of "shadows dazzling in the chamber," in which shadow, the principle of invisibility, is ascribed the power of illumination proper to light. Here, however, "shadow" has maintained its value as "veil" contained in the idea of "dazzle."

PAINTING THE MYSTERY OF THE ANNUNCIATION Light and Shadow. Bellori's description reproduces Guido Reni's painting not in terms of successive events, but as an integral whole of postures assumed in a room steeped in shadows. Bellori's text invites us to attempt to examine light and shadow, figures and places, beginning with the question implicit in the ekphrasis: how can the mystery of the Annunciation be portrayed in a painting?

In order to answer this question, it is not enough to recognize the postures, attributes, places, and stylistic features of this painting or to find a "textual basis" for it. Rather, we must interrogate ourselves as to how abstract operations may be painted and admit, as Bellori did when he transformed Gabriel's linguistic utterances into light and shadow, that this painting has its own means for representing this mystery so central to the Christian religion.

The figure of Gabriel is composed of the syncretism of three successive moments of his action. The "purple cloak" floating about beneath his arms

corresponds to his arrival, his index finger pointed up at the sky corresponds to his "explanation," and his kneeling position corresponds to his humility before Mary Incarnate, *Regina Angelorum*. The Virgin has assumed the canonical pose of Our Lady of the Annunciation: her halo and the rejoicing of the cherubs confirm the mysterious Conception that has occurred or is in the process of occurring. By syncretizing in a single posture three successive moments of the story, the figure of Gabriel renders the development of the angel's entire action virtually present. Mary, in contrast, has assumed a pose that endures in time without our being able to determine when it began or to follow its development. Unlike many Renaissance Annunciations, here the exposition of the narrative logic of the scene is almost the exclusive task of the figure of the angel. Thus the figure of Mary may concentrate on the conclusive moment in which she "casts down the light of her eyes, and receives the divine spirit with which she is now being infused." Here also Bellori's metaphorical terminology is not without interest. It is almost as if it were necessary for the Virgin to lower her eyes, her own "light," in order to receive the "great light" coming from above, obeying a sort of moral hydraulic law by virtue of which the pouring of light from above to below—*Humilitas*—creates room for the infusion of light from above, *Gratia*. *Humiliatio* and the infusing of *Gratia* reverse the semantic opposition of the moral values traditionally associated with high and low: in Mary we find humility and glory; her face "appears celestial as she gazes on the ground."

In order to represent the "mystery of the Annunciation," Guido Reni has used the three basic topological devices of the painting: the relationship between the placement of Mary's body and that of the angel's body, the relationship between the figures and the background, and the relationship between light and shadow.

Gabriel and Mary take their places on a narrow proscenium against a background of black clouds, upon what remains of a floor in perspective shrouded in shadow. The figure of the angel rests upon a cloud whereas Mary is supported by a "stool." The characteristics of the placement of these two figures are determined by the positioning of their supports on the grid of the floor. The Virgin is kneeling on a solid object of regular shape whereas Gabriel rests upon an evanescent object of uncertain form. The cloud, "a body without substance," can neither be placed on nor measured by the grid; it does not "receive the light," unlike the stool that casts a shadow upon the ground. The cloud absorbs the rays of light and reflects

them in an irregular way, creating nuances of white and gray. The body of the angel, like the cloud, is immaterial, weightless, insubstantial, evanescent. It is a body that cannot be measured or located in a place.[15] Mary instead, like her support, has a material body that can be measured and located in a place.

"SICUT PATET IN NUBIBUS": THE BODY AND THE LOCATION OF THE ANGEL

The respective situations of the bodies of Gabriel and Mary may be better understood in light of philosophical and theological arguments concerning the relationship between angels' bodies and their location in space. Although this question may seem irrelevant, it has a long and important tradition. In fact, it was the subject of a harsh debate between the Augustinian Franciscans and the Aristotelian Dominicans, followers of Saint Thomas Aquinas. Saint Bonaventure, for example, argued against Saint Thomas that no pure form existed in creation and that even the angels were composed of matter and form (hylomorphism). According to Saint Augustine's followers, matter was bound up with the principles of otherness and mutability, conditions proper to created beings. If uncreated being is immutable, then created being, and therefore angels, are mutable. Since matter is the principle of mutability, the angel has a material body.

Rejecting the creationist vision of Saint Augustine, the followers of Saint Thomas Aquinas proposed classifying all creatures according to their operations. Since the operations of angels are not conducted on the plane of material things but on that of intellectual things, angels are neither corporeal (*Summa theologica* Ia. L., a. 1) nor composed of matter and form. Indeed, since substance corresponds to the operations that give it form and the operations of angels are absolutely immaterial, angels are subsistent forms. "Impossibile est quod substantia intellectualis habeat qualecumque materiam. Operatio enim cuislibet rei est secundum modum substantiae eius. Intelligere autem est operatio penitus immaterialis quod ex eius obiecto apparet" (*Summa theologica*, a.2)

This too-brief summary of the medieval debate demonstrates that the question of angels, far from being the sterile quibbling of theologians, involved the very foundation of the Church's theological, cosmological, and philosophical structure. Throughout the Middle Ages, the Renaissance, and up until the seventeenth century, the figure of the angel was a fruitful philosophical tool, for it allowed man to consider himself and his operations

in the virtual state. The language of angels, for example, as Jean-Louis Chretien writes in an interesting article, is like "the nucleus of human language. Human language is the language of the angels plus. . . . Plus corporeality, space, and time, that is, plus sign, mediation, and discursivity."[16] Also, when a relationship does exist between an angel's body and a place, the figure of the angel expresses man's potentiality compared to the actuality of the human condition. As we read in the passage concerning this question in the *Summa theologica* (I, q, LI), which we will briefly summarize, the angel cannot be measured or circumscribed by a place because place is a quantity endowed with position, and the angel, being immaterial, is devoid of quantity. However, being in a place and being in a body are not the same thing: the body can be situated in a place because it applies its "dimensive" quantity to that place "secundum contactum dimensivae quantitas." The angels do not have this quantity, but they do possess virtual quantity, "sed in eis quantitas virtualis." When we say that an angel is in a place, we mean that he has applied his "virtus"—his inherent power and potential—to that place: "Per applicationem igitur virtutis angelicae ad aliquem locum qualitercumque dicitur angelus esse in loco corporeo." By "virtus" here we mean both the logical possibility and the power to produce effects. There is no relationship of matter and form between the angel and the body he assumes to communicate with men. The angel is like a motor for the body; his mobile body is only the outward representation of that motor.

At its ordinary level of dilation, air assumes neither shape nor color, but when it is condensed it may take on different forms and reflect colors, as happens with the clouds: "quando tamen condensatur et figurari et colorari potest, sicut patet in nubibus." Angels form their bodies from the air, condensing it through their divine power until it takes on a form. "Et sic angeli assumunt corpora ex aere, condensando ipsum virtute divina, quantum necesse est ad corporis assumendi formationem." The authors of the voluminous treatises on seventeenth-century Thomist angelology developed the angelic doctor's thesis, drawing a distinction (contrary to the protestant critics of the Holy Eucharist and to modern theories of physics) between matter and substance, using the angel as a paradigmatic figure of immaterial substance.[17] But, most important, at the center of their reflections concerning the bodies of angels and their location in space was the belief that an angel's body was immaterial yet virtually in contact with a material place.

Can this virtual contact between an immaterial body and a place endowed with "quantitas" be pictured in a painting? And, if we answer in the

affirmative, what meaning may this contact have in a painting of the Annunciation?

In Guido Reni's Annunciation, Gabriel's "cloudlike" body and his way of being located in a place are contrasted with the body and location of Mary, now become the mother of God, the human receptacle for the uncircumscribable divine body.

The "virtual quantity" of the angel's body is represented by the contact between the cloud serving as his support and the system of coordinates on the floor upon which he cannot be measured. Gabriel applies his "quantitas virtualis" to a place that can neither measure nor contain him. His immeasurability is the manifest image of Mary's situation—her own material and limited body has now incorporated the divine, immaterial body of God, which may not be contained.

This highly paradoxical condition has been resolved in the Virgin through the intervention of the "virtus" of the Holy Spirit in the Incarnation. The potential localization of the angel in a place becomes in Mary the actual localization of that which cannot be localized, the circumscribing of that which cannot be circumscribed. The comparison of the topological situations of the two figures is one of the devices through which the "mystery" of the Annunciation may be represented. Considered on its own, this way of depicting the Incarnation, which is neither immediately apparent nor particularly original, becomes more original and pregnant with meaning when it enters into relationship with Bernini's *composto*, in which the question of the angel's location is powerfully reformulated following the very model furnished by Guido Reni's painting.

LIGHT AND SHADOW, FIGURE AND BACKGROUND — The two characters in the scene are enclosed within a space compressed by the encroaching shadows, which are "dazzling in the chamber." The light, wedged in between two dark masses of clouds, shines down to the Virgin's head. The ray cast by the white dove illumines Mary's halo in stark contrast to the black background. In the upper half of the painting, the clouds form a screen of shadow; in the lower part they serve as a background for her halo.

The area of transition between the light of the Holy Ghost and the light of Mary is not a well-defined boundary, but rather an area of great chromatic complexity where light and shade mingle. In the upper part of the painting, light is the background where the outline of the shadows appear; in the lower

part, the shadows become the background where the form of the halo's light is inscribed. The background becomes figure and the figure background. The halo is created by this changing of places between light, the mystery's principle of visibility, and shadow, its principle of invisibility. Mary's halo is the cipher of the mystery manifest: a ring of light wrapped in the shadows where the visible is veiled, luminous, and dark.

The encounter of shadow and light in the inversion of figure and background is a genuinely pictorial miracle, a *mirabilis operatio*.[18] The dissolving of perspective space in the violent contrast of shadow and light is perhaps the most original aspect of Guido's Annunciation. The painter has completely occluded the space and transferred the task of determining the depth of the scene to the interplay of light and color. The result is an uncertain space modulated by the chromatic intensity, a space more suited to representing a process in action than a state of being. The halo, for example, is not a circle with a well-defined outline as it is in many Renaissance Annunciations; instead it is an expanding glow, a secretion produced by the contact of light and shadow. This way of representing the "mystery of the Annunciation" is obviously related to what we have emphasized in our comments on the relationship between the figures and their locations. In both cases, the vehicles of Divine Grace are overflowing the limits of terrestrial forms, creating a paradoxical spatiality in which bodies are located in a place without being circumscribed by that place, and in which the place itself is defined as a process of interpenetration of light and shadow rather than as a measurable portion of space. This type of spatiality as process is without doubt what induced Bernini to "transfer," through Gimignani's copy, Guido's Annunciation to his *composto*. Now let us look at how this transfer was achieved and at the effects it has created.

THE
TRANSFERRING
OF THE
ALTARPIECE

If we consider the chromatic qualities—which are infinitely superior in the original—as an abstraction, Gimignani's copy is extremely faithful (fig. 6). Bernini has placed this copy in a large, oval frame of black marble, supported by two large angels of black bronze. The painting is hung high above the altar so that it touches the arches of the vault and its median axis coincides exactly with the top of the capitals of the two pilasters that serve as its frame. In the painting, this central line, marked by the edge of Gabriel's wing and by Mary's head, corresponds to the area where the light of the Holy Spirit mingles with the light of Mary's

halo. This boundary line both separates the celestial world from the terrestrial one and unites the two worlds. Bernini has continued this line outside the painting, extending it across the entire architectural body of the chapel in order to separate the light, white, and luminous stucco of the vault from the heavy, dark red marble of the pilasters.

In this way, two distinct cosmological "regions" have been defined by their distance from the lantern. The white "heavens" of the vault are suspended high above the reddish "earth" of the pilasters and walls. Yet, as in the Annunciation, the contact between heaven and earth, light and shadow, is not a mere juxtaposition of opposite terms. The white, luminous stucco of the "heavens" penetrates into the reddish marble of the "earth," filling the pilasters and walls with white specks and veins. This infusing of light into the shadows, which has been "projected" outside the painting across the entire interior surface of the chapel, is also analogous to the actual illumination of the Fonseca chapel, in which light filters down into the darkness of the chapel from the luminous aperture of the lantern.

In San Lorenzo in Lucina, Bernini has utilized the same architectural solutions that previously had allowed him to integrate the altar into the ensemble of the other components in the Raimondi chapel of San Pietro in Montorio.[19] In fact, a continuous line may be traced along the molding of the lateral walls up to the ledge of the balustrade, connecting the horizontal of the slab of the altar to the base of the pilasters. A second line, lower down, runs parallel to connect the base of the columns to the base of the balustrade. However, neither of these two articulations is marked by a change of material or color. This reinforces the unifying value of the line that crosses through the painting and demonstrates that the veined marble not only serves to differentiate the architectural members but to unite the whole "earthly" section into a single mass. A sort of screen seems to have been cast over the architectural components so that they seem to form a single surface where light is inscribed in the shadows. Thus, the "tectonic" value of the interior architecture is diminished and its very nature as an impermeable "container" of enclosed space challenged. Indeed, the veined marble creates an intense vibration throughout the surface of the chapel, robbing it of both solidity and a sense of enclosure.

The permeability of the wall is manifest even more explicitly around the altarpiece where the bodies of the two black angels seem to be sinking into the wall behind them. In this way, the surface seems to function as a filter that only the vehicles of Divine Grace, the angels, and the light may penetrate.

The bust of Gabriele Fonseca is indeed partly hidden by the wall, but it is placed within a niche resembling a window, creating the illusion that the lower half of his body has been concealed by the space below. The angels, unlike the bas-reliefs, are not set inside a frame where the rules that operate within those boundaries are quite different from those that operate outside. They fly suspended between the interior and exterior of the wall, in a position that brings to mind the theories of the Thomists, who affirmed that the angel was both in a place and the container of that place.[20] Their position is comparable to that of the angel Gabriel: just as the divine messenger cannot be measured by the system of perspective coordinates expressing the rules of the earthly realm, the two black angels cannot be contained by the inner wall of the chapel. In this way, they escape the rule applicable to the human body and assume a position that, being neither inside nor outside, threatens the foundation of one of the constitutive laws of architecture itself. In trespassing these boundaries, the angels are plastically and conceptually associated with light, with both the rays of light filtering down from the lantern and the light congealed in the veins of the marble.

In the painting, Gabriel's paradoxical situation is parallel to that of Mary and visibly represents the different aspects of the problem that has been resolved in the Virgin by the *mirabilis operatio* of the Holy Spirit. In the chapel, the situation of the two black angels contrasts with that of the donor, who is in turn associated with Mary, not in a new Incarnation of course, but in a moment of intense communication with the divine.

Before studying how these four figures are joined, we must note that the structuring—and, in a certain sense, destructuring—action that the painting performs upon the architecture of the chapel is possible only because the painting shows an Annunciation scene set in a space where the architectural interior is about to disappear, engulfed by the encounter of light and shadow. It is this very space defined by a chromatic and luminous contrast that Bernini has chosen for his *composto*: the architectural members are in danger of vanishing behind the variegated screen that has been cast over them in order to welcome the encounter of light and shadow.

Let us now examine the links that further tighten the connection between the painted figures and sculpted ones. The garland of putti in the painting, consisting of five figures, is extended upward outside the painting by a group of five stucco cherubs, who form a symmetrical and inverse curve. This formation of cherubs rushes up into the dome, creating a spiral as it is joined by an additional formation of five more cherubs, these consisting only of heads and wings (figs. 7 and 8). The putto located at the junction of the

vault and the lantern inverts the movement once again toward the calotte, where a glory of tiny angels form a ring around the dove of the Holy Spirit located at the source of light. In the *composto* as in the painting, light streaming down from the zenith is presented as a supernatural phenomenon, a manifestation of Divine Grace.

This spiral of cherubs links the two doves and "stitches" the sky of the painting to the architectural and sculpted heavens of the dome. Looking up toward the lantern, we could even imagine that Bernini rotated the upper part of the painting by forty-five degrees, redistributing the figures starting from the base of the lantern all the way down to the edges of the frame of the altarpiece. As they advance upward, the angles of the curve of cherubs grow increasingly narrow with an acceleration that is accentuated by the progressive decrease of the putti's size and by their arrangement against the checked background in perspective decorating the vault. The progressive diminution of the visibility of the angels' body parts creates the impression that their bodies are gradually being absorbed into the stucco of the dome, which seems to function exactly like a cloud. This dematerialization of the cherubs' bodies is finally brought to conclusion near the source of light.

In the paintings of Correggio or Titian, the bodies of the angels tend to grow smaller and more diaphanous as they approach the divine light until they seem to melt into the clouds and into the light itself. Here, as in other of Bernini's works, the pictorial rendering of diaphanousness corresponds to the gradual absorption of the figure into its support, which reaches an extreme in the calotte, where all that remains of some of the cherubs is half a face. The sculpted and painted garlands of rejoicing cherubs make up a cosmic axis connecting the divine and the human. The proximity of man is marked by a progressive increase in the angels' corporeality. It is by means of this channel that the "rejoicing for Mary chosen Mother of the Lord" may ascend, but it is also by means of this channel that Divine Grace descends, hierarchically illuminating first the perfect and less corporeal bodies of the cherubs, then the angels closer to earth, and last the creatures of earth, Gabriele Fonseca in particular. However, the hierarchical ladder is interrupted by the Annunciation before it reaches Fonseca. Mary and Gabriel do not occupy the places corresponding to their level of perfection. They participate in the event of the mysterious union of the divine and human. Only after the light has been absorbed and reflected by Mary during the moment of redemption does it reach Fonseca, reflected down to him by the black angel to the left of the frame.

The cosmic, hierarchical model of the emanation of the light down through a series of rings composed of creatures relatively capable of conforming to divine intelligence has been reconstructed according to the Neoplatonist tradition by Dionysius the Areopagite in *Celestial Hierarchies*. His theology of light is one of the most important points of reference for the mystics of the sixteenth and seventeenth centuries. According to Dionysius, the deity is a source of light and the angelic intelligences are a series of concentric rings circling the source. The angels are like double-faced mirrors: one side of the mirror returns all the light it receives to its source; the other side allows part of the light to trickle through to the outside where it is received by the next ring, and so on to the outermost ring where the angels then reflect the light to mankind.

In modern devotion, the gnostic conformity to divine intelligence has been replaced by an emotional conformity that values the individual's relationship with the deity above his intellectual participation in the truth of the Supreme Being. Yet the Areopagite's model has been preserved—as the architectural structure of Saint Teresa of Avila's *Inner Castle* shows us—in order to represent the different levels of intensity of communication with God or Christ. The dome of the Fonseca chapel seems to correspond to Dionysius's cosmic model. In fact, the spiral of angels clearly conveys this progressive dematerialization of the body as it approaches the source of light: a diaphanous body is more similar or, better, "conforms" to the light and thus may transmit it more effectively.

The garland of cherubs is not only the representation of the cosmic axis that marks the stages of proximity to the source of light; it is also a channel for the transmission of the light itself. Furthermore, the chain of angels is designed in such a way that it displays the Annunciation to Fonseca's bust. The extreme versatility of this group of figures is due to the great "syntactic" potential of its formal structure. Each arc of cherubs is composed of five interlocking elements. The components of each arc are not greatly individualized, which allows for a more striking collective action: each group of angels constitutes a single jointed figure in which the possibilities of combination with external elements are multiplied by five. Furthermore, the fact that the cherubs are portrayed in flight makes it possible for them to assume all orientations imaginable, both in their bodily positions and in the direction of their gazes and gestures.

The body of each angel may perform several functions: it may entwine with its neighbors, turn toward the outside of the formation, or express an

emotion. The angels seem to be fleeing upward, and the development of the curve of this fleeing formation is composed of repetitions and variations. Some elements echo the preceding segment while others develop the internal movement of the formation. Some angels have only one function, that of forming a link with the others, whereas others serve to capture the beholder's attention in order to teach him, according to the Albertian precept, the proper "emotion" corresponding to the scene: "exultation."

In Guido's five-cherub formation, which Bernini uses as his basic model here, two cherubs are looking at the Madonna, a third is looking at Gabriel, a fourth is looking at the beholder, and the fifth gazing upward. Bernini has grafted the second arc of his spiral onto this last cherub in the painting, who is gazing straight into the eyes of the first stucco putto on the right. The gazes of the other four angels define the enunciation device of the painting (after Benveniste's term "l'appareil formel de l'énonciation"): they are calling attention to the two actors involved in an act of communication and are also signaling to the observer that what is being said in the painting also involves him. The first formation of stucco cherubs repeats these same positions, but the cherub looking outward is no longer addressing a generic beholder. Instead, he is glancing down diagonally at the niche occupied by Fonseca, who in this chapel is the privileged witness of the Annunciation. Assigning the task of establishing contact between the altarpiece and the beholder to the angels on the right, Bernini has redistributed in the three-dimensional space of his chapel the very same positions of the enunciation device found in Guido Reni's painting.

In the group of painted cherubs, the two angels on the left form a couple, bound together by a beautiful knot of blue drapery. One is looking downward, the other upward; one seems to be turning toward the left while the other seems to be attempting to arrest his movement by clutching the hand of his companion. This airy and delicate entwining of cherubs in flight, constructed on a vertical axis around which a rotary movement is taking place, reveals the syntactic and dynamic potentiality of Guido's cherubs. Bernini has used this cherub formation to create a parody of the thrust and counter-thrust of the dome's architectural structure, intensifying its dynamic aspect without destroying its structural principles. We need only note how the first two putti on the right, with the rotation of their bodies, seem to provide a figurative representation of the dome itself; how the cherubs sitting on top of the arch testify to its solidity; and, finally, how the upward movement of the last cherub of the first group enhances the rapid acceleration toward the lantern. The two pairs of angel-minstrels located above the pilasters are also

architectural figures. The couple on the right, hanging suspended in elegant *contrapposto* to the garland, emphasizes the lateral rotation of the dome while the couple on the left further accelerates the movement.

The angels are systematically located in the very places where the architectural members intersect. At the same time, they violate the impermeability of the chapel's surface in several places. This brings about a complex interaction between the architectural structure of the dome and the parody of its structure, created by the angels who form, as it were, a second dome that is superimposed upon the first and yet surpasses it by accelerating its rotary movement and its upward thrust.

Just as the angels are architectural figures of the dome, the dome itself has an angelic quality, and the intimate relationship of the dome to the angels is bound fast by stucco, the material from which both are fashioned. In Bernini's sculptural vocabulary, this plastic material is used for the bodies of celestial beings and for bodies in a state of transition, like the "soul" of Saint Andrew in Sant' Andrea al Quirinale. Stucco is by no means an "insignificant material." Its lightweight, protean, and luminescent properties are invested upon the sculpted figures and the architectural body that lend it shape. The angels and the dome are linked in the expression and articulation of these values. The body of the angel is evanescent and luminous, the "body" of the dome is as permeable, lightweight, and "celestial" as a cloud. Stucco is used to attach the angels to the dome, but it is also being used as a conceptual "solder" to fuse sculpture and architecture, for indeed the dome performs the angelic function of condensing and transmitting light.

THE ANGEL AND
THE FRAME

The ways in which the painting is extended beyond its limits are quite different in the lower half of the Annunciation. In fact, whereas the continuation of the garland of putti up into the vault links the painted sky with the sculpted one, in the lower half of the painting the frame duly performs its function of limitation and presentation. The two large black angels are physically and conceptually in tone with the large dark marble oval and blend in with its shape and color, rendering its function explicit and heightening its effectiveness to an extreme.[21]

According to C. S. Peirce's logical-typological classification, the frame is an index, a type of sign that bears no meaningful resemblance to its referent, refers to a single unit and directs attention to its referent by means of a blind impulse.[22] The frame, like a finger pointing toward imminent danger, is not there to call attention to itself. Often the very repetitiveness of its ornamen-

tation serves to call the viewer's attention to the painting it contains. Indeed the two large black angels carrying the frame are calling Gabriele Fonseca's attention to the Annunciation. Yet while the angel on the left shows all the characteristics of an "index," the angel on the right is attracting attention to himself; moreover, he "resembles" the object to which he is referring. In terms of Peirce's semiotics, we could say that the angel on the right is a sort of "icon" of the painting, a sign that refers to its referent by means of a similarity or analogy. He is, in fact, directly associated with Mary, the position of whose head, arms, and even fingers he has imitated.

The two black angels are a sort of "hypertrophic" doubling of the frame. They are presenting the altarpiece to the viewer, but this is being done so dramatically that they are really presenting themselves. They themselves are on display as they exhibit the altarpiece, placing the emphasis upon the work's intransitive dimension of self-presentation rather than upon its transitive dimension, its reference to the object that it intends to present. In this way the black angels highlight the capacity of the work to reflect upon itself (an element present to some degree in all representations, by virtue of which a work ultimately refers to itself alone), eluding the transparency of communication in order to allow its physical aspect to appear. This effect is reinforced by the fact that the frame is being carried by the angels: the altarpiece has become a heavy object, no longer the Annunciation but a representation of the Annunciation. Yet the angel on the right has an ambiguous semiotic status: he is both an iconic index and an index-icon. In other words, he is a sign in which the index's power of immediate reference is combined with the icon's resemblance to its referent. He is not only exhibiting the Annunciation to Gabriele Fonseca but also representing it for him. According to Dionysius the Areopagite, the function of angels was to make themselves similar to God in order to refer to Him. But the precise meaning of this reference and of this resemblance will become clear to us only after studying the pose of the bust of Gabriele Fonseca, to whom the angel's gesture is addressed.

THE BUST OF GABRIELE FONSECA In his book on Bernini, Wittkower has dedicated a long passage to the bust of Gabriele Fonseca, which has served more or less explicitly as the chief point of reference for all later interpretations (see figs. 9 and 11). Wittkower is a critic of the same stature as Bellori, and his text deserves an equally attentive reading.

Fonseca is leaning out of a niche in an intensely devotional attitude, one ner-
vous hand firmly pressed against his body, while the other clasps the rosary in
a grip as desperately hopeful as that of a drowning person holding onto a life-
saving raft. The patches of dark shadow and flickering light produced by the
deep folds of the gown further support the spiritual agitation, and the almost
coloristic differentiation of skin, beard, and fur heightens the impression of
pulsating life. Fonseca turns toward the altar above which appears the "An-
nunciation" carried by angels. It is this mystery that has called forth his de-
votion and spiritual surrender. An intangible bond between himself and the
altar bridges the space in which the beholder moves, and since Fonseca is so
realistically rendered that he evokes the sensation of being alive, he remains
forever the protagonist of those who worship in the chapel; the intensity of
their prayers is prompted by his example.[23]

Fonseca is in the throes of a religious experience whose intensity is visibly
manifest in the way he is clutching his breast with one hand and his rosary
with the other. The stark contrast between the dark and light areas also
testifies to the intensity of the experience. The internal differentiation of
textures produces a most persuasive realistic effect. For Wittkower as for
Bellori, the object of Fonseca's experience is not the Annunciation, but the
"mystery of the Annunciation." The contemplation of this mystery has cast
him into a state of "spiritual surrender." The worshipper who visits the
chapel is impelled to join Fonseca in prayer, in an effort of imitation facili-
tated by the realistic portrayal of the bust, an effort of such intensity that
the beholder is prompted to take the sculpture for a living person. Implicitly
criticizing Wittkower for his insistence on the "naturalism" of the Fonseca
bust, Howard Hibbard remarks that the donor's physical features are so de-
formed that they border on caricature.[24] This deformation, combined with
the realistic effect created by the differentiation of textures, accentuates the
distinctive features of Fonseca's portrait.

The main limit of the interpretations of Wittkower and Hibbard, and
those of all who have followed them, is their almost exclusive concentration
on the bust, without ever taking into consideration the procedures through
which this sculpture has been integrated into the *composto*. However, three
important characteristics do emerge from their analyses: the bust offers a
model for imitation; it represents an intense spiritual experience conveyed
through the posture of the body; it is the character portrait of an individual
who has surrendered himself to the contemplation of a mystery.

My hypothesis is that these three characteristics are not unique to the
bust but may be found in different forms in the other components of the

composto as well. Fonseca's invitation to the visitor to follow his example and join him in prayer is only the last link in a chain of imitation that connects Mary to the angel, the angel to the bust, and the bust to the worshipper in chapel. The three characteristics Wittkower and Hibbard emphasize are to be found in the chapel in the form of three distinct *processes*, the development of which have had a determining influence on Fonseca's pose. The bust represents an arrested moment in the unfolding of each of these three processes: the process of imitation or conformation, the intensification of pathos, and the process of characterization or individualization. The dynamics of these three processes are governed by a well-knit design. In order to recognize this design we must first specify its function and ascertain its relevance from the historical point of view.

The repetition of Mary's gesture and its transformation through the positions assumed by the other figures in the chapel represents (through the similarity of physical attitudes) a process of "spiritual assimilation," which in terms of seventeenth-century devotional practices we may call "conformation." Of course, the idea that there is a correspondence between the similarity of physical postures and an act of spiritual imitation may seem a bit too literal. Here we are dealing with a different type of relationship than the one created by an iconographic tradition. What we have here is a meaningful correspondence among *processes* of transformation, all of which share a similar intensive dynamic. The *composto*, insofar as it is a montage of disparate elements, may assemble its various components into *series* in which the repetition of a formal configuration makes it possible to pass from one element to another, while the deforming of this configuration through the intensification of certain features will allow us to trace the development of the process.

What serves as a model here is Mary's position, the attitude in which she "casts down the light of her eyes, and receives the divine spirit." In Mary's act of submission, *Humiliatio*, her obedience to the will of God and her receiving of Grace are two simultaneous events that, from the theological as well as from the figurative point of view, tend to blend together into a single process. With this act of humility, the Virgin surrenders herself to God's will; she performs a "passive action" that allows her to be filled with Grace. This spiritual attitude characterizes not only Mary but also, on a lower level, all those who receive the sacraments or who are simply engaged in an act of prayer or contemplation. This form of acceptance of God's will is called "conformation" because, according to a participative theological view, Grace transforms the worshipper, renders him a participant of its own pow-

erful action, and thus similar to, "in conformity to," "in conformance" with God. This process of conformation to Jesus mirrors the corresponding process through which Christ became similar to man.

"Conformation" is the spiritual version of the Imitation of Christ. Mystics at times have pushed it to the extreme of identification of the self with the deity: the "deiformity" that culminates in Caterina Bellinzaga's (d. 1624) *Ladder of Perfection* (first indexed in 1703) and in Meister Eckhart's *De theologia mystica speculativa*. These extremist theologies were the object of repeated attacks by the Church, which feared both their dangerous pantheistic origins and the possibility that they might deteriorate into quietism, a state of extreme passivity in which the individual is induced to abandon all responsibility. At the time of the antiquietist controversy, conducted primarily by the Jesuits, the arguments used to define the limits of passivity became particularly refined and complex. Such arguments led to the condemnation of Miguel de Molinos, who was sentenced to life imprisonment in 1687.[25] Two things emerge clearly from the documents of the trial: the Church's wish to restrict the path of illumination and emotional contemplation to those who have received the gift of spiritual things and its desire to give precise indications concerning the path leading to passive conformity, which culminates in ecstasy. The Jesuits' attack on quietism was consistent with their need to introduce mental prayer to the clergy and laymen who lived outside the bounds of monastic life. Their aim was to preserve their supremacy and control of the initiation into this type of prayer.

It is interesting to observe that the Society's position in the controversy was being formed during the very same years in which the Fonseca chapel was designed and built. Between 1673 and 1675, the first tracts by the theorists of quietism were published: in 1673–74 the works of Petrucci, in 1675 Molinos's *Spiritual Guide* and Giovanni Antonio Salami da Vetralla's *The Easy Way to Attain Quiet in Prayer*. In 1680, the Jesuit Paolo Segneri responded to these works with a pamphlet whose title, *Concordia tra la fatica e la quiete nell' oratione* (Harmony of effort and quiet in prayer), sums up the Society's views on the matter fairly well. Yet during the first half of the century, the process of "conformation" had been identified and studied from the psychological viewpoint of Saint Ignatius of Loyola by Father Le Gaudier in *De perfectione vitae spiritualis* (1643). Le Gaudier's work is of greater interest to us for its clarity of exposition than for its originality. In an article dedicated to "Conformance to the Will of God in Modern Times" in the *Dictionnaire de Spiritualité*, Father Catherinet summarizes what Le Gaudier means by exercising the will in conformation: (1) One must break

away from the natural attachment to earthly things. (2) One must maintain one's will in a state of equilibrium and indifference so that it is as ready to welcome earthly things as to be deprived of them. (3) Through a simple act, one must accept God's will in advance while it is still unknown to oneself, desiring a priori what God wills because He wills it. (4) When it seems that the will of God is being applied to a specific point, then that is the moment to exercise what is known as "conformance."[26]

Le Gaudier writes:

> The impetus of the human will, previously delivered into the hands of God, elevates the human will and concentrates it not only upon the object of divine will, but upon the divine will itself. The human will embraces God's will with such affection and plunges into it so deeply that, morally speaking, it finds its own death, in the sense that it can no longer act toward whatever the object may be otherwise than conform to the divine will. One could say that with this act of acceptance, man helps God to will this particular object, as if there were only a single will, a single cause, a single affection. This total entrusting of our will to God cannot occur without an act of the human will. Yet the aim of this act is to exclude all other acts from the human will in order to receive only that form which in a certain sense has been given it by the divine act. It is a question of man's freely depriving himself of his own will, as if, having no will of his own, he could use God's will to will or not to will what God wills or does not will. It is into the created will, which is subordinate to the divine will, that God's will pours its own acts, rendering the created will perfectly similar to itself.[27]

This text not only describes the dynamics of the relationship between the human will and the divine will, and the effects of assimilation and conformation; it also specifies that the acceptance of God's will is sealed by affection. In fact, according to the theologians and spiritual seekers of this era, the sphere of the affections corresponded to the realm enclosed between willing and being acted upon by God's will. The emotions belong to the sphere of the will, the power or faculty that, by means of the intellect and the imagination, allows human operations to take place. The obviously passional nature of Fonseca's bust must now be understood within the context of devotional practices that make use of the emotional sphere and subject it to a specific discipline. The high value that some of these practices place on the worshipper's emotional investment is the horizon upon which the characterization of the Fonseca portrait becomes clearly intelligible.

The figure of Mary in the Annunciation provides the model to which the angel, the donor, and the worshipper conform. Her posture is composed of

an ensemble of features in which it is difficult to distinguish between those representing the configuration of *Humiliatio* and those referring to the reception of Grace. This intimate confusion of the two configurations should not surprise us because, as Le Gaudier would say, *Humiliatio* is the act through which Mary, relinquishing her own will, assists in the fulfilling of the divine act. The Virgin kneels and bows slightly toward the ground, her left arm almost totally hidden in her robe while her right hand rests lightly against her breast. Like all gestures, this one should not be considered apart from the intricate totality of features comprising her figure. However, in this case the isolation of the gesture is by no means arbitrary, because the repetition of the posture "arm pressed against the breast" in the other figures in the chapel not only removes it from Mary's ensemble of gestures but also creates a special interpretation of that gesture. Fonseca's passionate gesture resonates together with Mary's more moderate one, exalting the value of the gesture's emotional dimension to the detriment of its narrative value. An integral part of the *composto*, this gesture is that of a person pressing hand to breast, the hidden dwelling of pathos, the place where the effects of Divine Grace are felt most intimately.

Mary is without sin and "full of Grace." She has already reached a high degree of spiritual perfection and can accept the will of God without great effort. Thus her gesture is light and "graceful." The analogy between the effect of Divine Grace upon the human figure and the gracefulness of the body's gestures is a constant feature in both Guido Reni's painting and Bernini's sculpture. This gracefulness characterizes a type of pose devoid of physical tension, ranging from Mary's passive yet contained attitude to the sensual self-surrender of the saints' bodies in ecstasy: gracefulness of the body is an expression of the emotional state created by Grace.[28]

In transferring the pose of Mary's right arm to the left arm of the angel holding up the frame, Bernini reproduces with perfect accuracy the curve of her wrist, the position of her fingers, and the pressure of her hand against her breast. The angel is imitating Mary, thus becoming for Fonseca a mirror of the Virgin exercising its angelic power upon the donor, "rendering him similar to itself," as Bernini's great friend Father Giovanni Paolo Oliva said in one of his sermons given at the Vatican in 1659.

> As they cannot create imitators from among their own kind in heaven, the angels agree to abandon the realm of God and to dwell for a time in the mire among the wayfarers of this world, so that through their assistance, remind-

ing, and prodding, they may render us similar to themselves in the candor of their existence, the ardor of their love, or the loftiness of their understanding.[29]

In transferring the physical attitude of the Virgin's submission from Mary to the angel, the gesture is removed from the narrative context of the Annunciation and presented to Fonseca on its own. This removal and transfer correspond to those hermeneutic procedures that disregard the historical character of events in order to attribute to them a symbolic value that is valid and meaningful for the present day. The angel "sets aside" for Fonseca that aspect of the Annunciation that remains eternally present: the sacramental power of the mystery of the Incarnation and the possibility of redemption it offers to the man who freely submits to the will of God. The angel is not communicating a piece of information but transmitting an attitude, a way of being affected by deep emotion that the donor may imitate within the limits of his possibilities, which are hampered by his condition as a sinner. Fonseca's posture, in fact, oscillates between the characteristic poses of contrition and repentance: between the palm pressed against the breast of the fallen Eve and the painful reception of the fruits of contemplation. Man's effort to accept the will of God clashes with the power of sin within him; the temptation of dissimilarity resists conformation.

Indeed Fonseca's body is full of tension, which is absent from the bodies of Mary and the angel. His right hand violently clutches his breast while his left grips the rosary. Gabriele Fonseca repeats the angel Gabriel's greeting to Mary, adding in his own Hail Mary a request for her assistance at the hour of his death. But this interpretation, which is based on the fact that Fonseca and the angel share the same name, Gabriel, does not take into consideration the pathos markedly evident in the composition of the portrait bust or its integration into the *composto*.

The bust of Fonseca is the portrait of a man in a state of emotional and physical disarray, a portrait in which the subject is not characterized by one of those forms of self-control that exalt the dignity of his social position. On the contrary, he is characterized by his self-surrender, his yielding to an emotional impulse, or, to put it in seventeenth-century terms, to the movements of the soul. The portrayal of this Portuguese doctor is not that of a man about to leap into action, unlike most examples of Renaissance portraiture, but that of someone who is being acted upon by a force beyond his control. The hand grabs the chest, pressing the heart. From here we follow the sinuous curves of the folds of his robe as they trace a sequence of ever-

widening ripples, moving down the arm and flowing into the tension of the hand. The inclination of the bust as it leans out of the niche, the half-gaping expression of the mouth, and the staring eyes all contribute to the "pathetic montage" of the figure. In all these components we find a conversion of physical movement into emotional expression.[30] It seems as though Fonseca is about to climb out of his niche, and the arrested force of his movement is transformed into the power of emotional expression. The folds of his robe, for instance, are not the record of a movement of the body, nor do they merely fall with the weight of the fabric; rather, they develop independently into an intensive series that tends toward paroxysm.

The "effect of spiritual agitation" that Wittkower has described is produced by the composition of intensive series consisting of pairs of opposites. The series tending toward contraction culminates in the left hand, the one tending toward self-surrender has its apex in the half-open mouth. Is Fonseca experiencing pain or joy? Will the abandoned attitude of his head be extended throughout his body, or will tension finally prevail? His eyes, fixed on the angel and the altarpiece, may give us no single answer to this question, indicating only that the intensity of his emotion and the object of his gaze have something in common: we are reminded of a situation typically seen in horror films, where the terrified eyes of the victim are united with the knife flickering in the darkness.

The quality shared by the donor's emotion and the objects he is contemplating can be seen clearly in the similarity of his pose to the poses of the figures he is viewing. But in order to include the figure of Fonseca "in a series" along with the figures of the angel and Mary, and to describe this movement from the angel to man in terms of the intensification of emotion or the expression of pathos through the body, we must imagine the existence of an external eye, the eye of the beholder, who asks himself what meaning lies behind the similarity of the angel's graceful pose and the donor's contorted one.

The sequence of similar poses has its origin in the painting. It is developed in the "relief" sculpture of the bronze angel and culminates in the round with the Fonseca bust. The progression toward three-dimensionality and the intensification of emotional expression are parallel processes that have come together in a way that is by no means arbitrary. Indeed a figure sculpted in three dimensions is more effective in engaging the beholder's sympathy and solicits his emotional conformation more persuasively. The sculpture reacts to changes in lighting and point of view, creating a relation-

ship with the beholder that is based on its multifaceted appearance and on variations of intensity, and is thus particularly suitable for the expression of emotion.

The meaning of the posture shared by the three bodies becomes clearer if we study the altarpiece, where Mary's attitude is not isolated but instead inserted within a narrative context: Mary obeys the will of God and becomes the body of the Incarnation. However, as we have seen, the "story" told by the painting is a mystery that cannot be understood by the intellect but only contemplated with faith and emotion. This is just what Fonseca is doing in inviting the worshipper to join him in prayer.

IMAGE, IMAGINATION, AND THE APPLICATION OF THE SENSES
In the preceding pages we have traced the general features of the process of spiritual conformation and stressed the importance that this question had at the time the chapel was constructed. This has allowed us to describe the similarity of the figures' postures as a process of spiritual assimilation. Now we must ask ourselves if it is possible to identify a specific form of devotional practice in Bernini's portrayal of Fonseca in contemplation. If so, we then could better describe how the *composto* works and determine more precisely what effect it was intended to have on the beholder.

Among all the diverse forms of prayer practiced during Fonseca's time, we will examine the *Spiritual Exercises* of Saint Ignatius of Loyola, which combine the mobilization of the emotions with a specific use of the senses. Fonseca is in the throes of some powerful emotion while he "is looking at" an image to which he is attempting to conform. This model does indeed correspond to the one provided by the *Spiritual Exercises*. Before giving a more detailed description of the characteristics of this model, I would like to emphasize the fact that I am not interested in knowing whether or not Gabriele Fonseca actually practiced Loyola's exercises or whether or not Bernini was "influenced" by the Jesuits. My sole concern is to discover what devotional model is being expressed in the Fonseca *composto*. With regard to this aim, the relationship between the Portuguese doctor and the Jesuits of the Collegio Romano during the malaria epidemic or the close ties of friendship between Bernini and Giovanni Paolo Oliva are extraneous and insignificant details that may help to confirm the validity of my hypothesis but by no means provide the basis of my argument. Conversely, if we find grounds to affirm that the bust of Fonseca has been included in the *composto* in order to stimulate in the viewer a movement of the imagination, emotions,

and senses similar to those prescribed in the *Spiritual Exercises*, we will by no means have proved that Garbriel Fonseca actually practiced these exercises. What is important here is to see if a relationship exists between the way the *composto* works and the way the *Spiritual Exercises* work. If this comparison enhances our understanding of the *composto* and helps us to describe it better, we will have no need of further proof and will have attained our aim.

These exercises are a methodical series of psychological experiments that lead the subject to develop an emotional attitude in which he strives to conform to the will of God. In order to progress in this direction, he must learn to recognize his own "mociones," the movements of the soul, which may be good or bad, depending on their source (the subject himself, God, the devil) and on the reaction of joy or sorrow they produce. The practitioner is not asked to combat his passions but to use them in order to remold his spiritual self. The involvement of the subject's passional nature is strictly connected to the involvement of his physical nature through the application of the senses in contemplation. This component of the *Spiritual Exercises* appears in three different stages of the worshipper's journey, accompanied each time by different characteristics. Let us see how a Jesuit has explained these differences.

> 1. Among the *modes of prayer* we find the description of a form of prayer that consists in examining before God the activities of the five bodily senses in order to learn to conform the use of these senses to the examples of Our Lord and the Holy Virgin. In this case, the *senses* are only a means of considering and not a tool of prayer.
>
> 2. What happens in the "Meditation on Hell" (the fifth exercise of the first week) is quite different: the subject is not only required to reflect methodically on the pain of the senses but also to participate with his imagination in the torture of the damned, *to see with the eyes of imagination, to hear with his own ears, to smell with his own sense of smell, to touch with his own sense of touch.* This time we are truly being asked to apply the "five senses." This simple exercise of the imagination should inspire wholesome thoughts.
>
> 3. Of a more delicate theoretical interpretation is the application of the senses that has as its object a mystery of the Gospel or an episode from the life of Jesus, to be practiced more or less daily from the second week on. During the morning the practitioner has contemplated the Incarnation and the Nativity, then he repeats these meditations twice. In the evening *before dinner* he will apply his five senses to the subjects considered during the day: "*After the preparatory prayers and the three preludes, he will find it to his benefit to go over the material of the first and second contemplation, applying the five senses. The first point consists in seeing the figures with the eyes of the imagination, meditating and contemplating in detail the circumstances concerning them, and drawing*

> *benefit from this vision. The second point consists in listening to what they are say-*
> *ing, or what they could say, then reflecting upon oneself and seeking to benefit*
> *from this. The third point consists in smelling and tasting with the senses of smell*
> *and taste the infinite delightfulness and sweetness of the divine nature of the person*
> *contemplated, or of his soul and its virtue, and so on for all the rest, depending on*
> *the conditions of the person contemplated, reflecting upon oneself and benefiting*
> *from this. The fourth point consists in touching with the sense of touch, for ex-*
> *ample, embracing or kissing the place where the people are standing or sitting, and*
> *striving to obtain some benefit from this exercise."* [31]

The application of the senses is thus the work of the imagination in service to the emotions and tends to excite the feeling that the object of contemplation is present before one. It becomes possible only after the "visual composition of the place," which consists in "seeing with the eye of the imagination the physical place where the object one wishes to contemplate may be found." Meditation with the application of the senses must be done according to subject matter: "If one is contemplating the Resurrection, one is to seek joy with Christ's joy, if the Passion, then pain, tears, and torment with Christ's torment." Observing the rule of subject matter is nothing other than the methodical practice of emotional conformation. The exercises in which the practitioner imagines the required place or setting may help us to define the nature of the relationship that links the donor's bust to the Annunciation scene in the altarpiece, which may be a representation of a picture that Fonseca has composed in his mind while contemplating. In this case, applying the rule of subject matter, Fonseca may be rendering himself "humble with Mary's humility."

Yet we must not forget that the painting represents one of the mysteries upon which the adept of the spiritual exercises is to meditate. Thus, we must also consider the third type of application of the senses, which is "of a more delicate theoretical interpretation." This type of contemplation was handled with great caution, as we may learn from numerous comments following the death of Saint Ignatius of Loyola, because it opened the door to passive contemplation, a door that the founder of the Society had left only slightly ajar for pedagogical and strategic reasons.[32] In this particular exercise, the subject allows himself to be informed by the mysteries of Christ's life in order to receive benefit from their sacramental power. For those who contemplate the mystery, it becomes an impelling and real experience through which they are transformed and rendered similar to the object of their contemplation.

The meditation on the Incarnation, to which the first day of the second week is dedicated, consists of a series of contrasting images: the damning of mankind through sin and its salvation through the intervention of the divine personages.

1. *First preamble*: I summon to mind whatever it is I must contemplate, in this specific case, how the three divine persons looked down upon the plain or upon the rotundity of the earth teeming with human beings, and how, seeing that all of them were destined for hell, they decide in their eternity that the second person should become man in order to save mankind, and how in the fullness of time, they send the angel Gabriel to Our Lady.

2. *Second preamble*: A visual contemplation of the place. Here one must picture the vast capacity and rotundity of the earth where many, many different peoples are to be found, and then in the same way one must visualize in particular Our Lady's house and room in the city of Nazareth, in the province of Galilee.

3. *Third preamble*: I must ask for whatever it is I am seeking. Here I must ask for the inner knowledge of the Lord—who for my sake became man—so that I may follow him and love him more.

Note. It must be said at this point that this same prayer, without modifying the way it is formulated at the beginning, and these three preambles are to be practiced during this week and the following weeks, changing the form according to the subject matter.

The first point: See the various people.

—First, all those on the face of the earth in all their variety of clothing and gestures, some white and others black; some at peace, others at war; some who are weeping, others who are laughing; some healthy, others ill; some being born and others dying, etc.

—Second, see and consider the three divine persons on their royal thrones as they gaze down upon the entire face and rotundity of the earth at all the people dwelling in utter blindness, dying and descending into hell.

—Third, see Our Lady and the angel greeting her. Reflect on this and draw some profit from this vision.

The second point: Listen to what the people on the face of the earth are saying, that is, how they are speaking to each other, cursing and blaspheming. In the same way listen to what the divine persons are saying: "Let us redeem mankind," etc.; then to what the angel and Our Lady are saying. Reflect on their words and profit from them.

The third point: Look at what the people on the earth are doing: how they are wounding and killing each other, going to hell, and so on. In the same way look at what the angel and Our Lady are doing, how the angel is fulfilling his task as messenger and Our Lady is performing an act of humility, rendering thanks to the Almighty, and then reflect on each of these things and try to profit from them.

Colloquy. In conclusion there must be a colloquy. I must reflect on what I

> must say to the three Divine Persons or to the Eternal Word made flesh or to
> Our Lady the Mother of God, asking for whatever I feel most intimately I
> need in order to better follow Our Lord recently Incarnated, and say a Pater
> Noster.[33]

If we agree to view the Fonseca *composto* as a representation based on the
application of the senses to the mystery of the Incarnation as described
in the *Spiritual Exercises*, we must conclude that the donor not only has
"humbled himself with Mary's humility," but is also in the process of attain-
ing, within the limits of his possibilities, "the inner knowledge of the Lord."
We could say that Fonseca "is receiving an Annunciation with our Lady of
the Annunciation," that he is "incarnate with Mary incarnate." A weak re-
flection of the miracle realized in Mary has reached Fonseca, "in a minor
key" as it were, in the form of a "contemplation infused by Grace." This
interpretation is confirmed by the gesture of the left hand; indeed one of the
beads of the rosary is used to remind the worshipper of "the joyous mystery
of the Incarnation." The instructions of Ignatius of Loyola, recorded in the
fourth part of the fourth chapter of the *Constitutions*, prescribe the use of
the rosary in the meditation of the mysteries that it contains.

Fonseca's conformation differs radically from that of the angel because his
body invests its human sensibility in the act of conforming, thereby setting
the emotions in movement through the imagination and generating the
"mociones." In these Jesuit practices more than in any form of prayer, the
sensibility of the body is not opposed to the spirituality of the soul but is
rather its imaginary extension. The intensification of the "mociones" in
prayer, however, causes a notable deformation of the physical features,
which, in the case of Fonseca, serves to render his portrait unique and un-
mistakable. In conclusion, the reference to the mechanism of contemplation
in the *Spiritual Exercises* elucidates more clearly the relationship between
contemplation and the "spiritual surrender" discussed by Wittkower.

Fonseca's conformation to the angel and to Mary is a particular configu-
ration of the more general process of infusing light into the shadows, which
Bernini has developed in various ways using the altarpiece as his starting
point. His interpretation of the painting has authorized our initial descrip-
tion while our analysis of the techniques of Jesuit mental prayer practices
has allowed us to reconstruct the three processes: imitation, the rendering
of pathos through physical posture, and individualization, which together
constitute the basic mechanism of the *composto*. The portrait bust represents
but an isolated moment in the unfolding of these three processes.

d with dimensions 12 in. by 20 in. by cutting
of side x at each corner and then folding up
figure. Express the volume V of the box as a

charges two dollars for the first mile (or part
) cents for each succeeding tenth of a mile (or
e cost C (in dollars) of a ride as a function of
veled (in miles) for $0 < x < 2$, and sketch the
ction.

try, income tax is assessed as follows. There is
e up to \$10,000. Any income over \$10,000 is
10%, up to an income of \$20,000. Any income
taxed at 15%.

raph of the tax rate R as a function of the

shown.

(a) Complete the graph of f if it is known that
(b) Complete the graph of f if it is known that

65–70 Determine whether f is even, odd, or neithe
graphing calculator, use it to check your answer vis

65. $f(x) = \dfrac{x}{x^2 + 1}$

66. $f(x) = \dfrac{x^?}{x^4}$

67. $f(x) = \dfrac{x}{x + 1}$

68. $f(x) = x\,|$

69. $f(x) = 1 + 3x^2 - x^4$

70. $f(x) = 1$

It is impossible to determine whether Bernini deliberately exploited Saint Ignatius's text on the Incarnation, or whether he had become so familiar with the Jesuit imagination that it intervened in his creative process at the unconscious level. Yet the discovery of a relationship between the *composto* and the *Spiritual Exercises* must not lead us to view the Fonseca chapel as the mechanical illustration of a text. Jesuit meditation furnishes a frame of reference for the development of a technique of "imagining in the presence of an image," a technique with which we are no longer familiar. This way of conforming through prayer, however, was the common heritage of the faithful in the seventeenth century. In the Loyola text, it assumes a specific form very similar to the one suggested in the *composto*.[34]

THE ALTARPIECE AND THE BEHOLDER'S ITINERARY At this point in our analysis, we may once again shift our attention to the altarpiece and attempt to determine the status of the painted image used in the *composto*. We are not interested in ascertaining its "level of reality," which is an irrelevant question, or its power of illusion, an effect that was clearly not intended. Instead we want to specify, within the limits of possibility, whether the painting is to be viewed as a representation of a mental picture created in Fonseca's mind or as an independent representation, a painted object displayed by the angels.

If we accept the first hypothesis, it becomes difficult to explain adequately the continuation of the line of cherubs outside the altarpiece, unless we consider a mental image as having no precise boundaries.[35] Nor can we justify the marked accentuation of the physical aspect of the painting. If we accept the second hypothesis, we cannot explain why Fonseca, in reality, can see the angel much better than he can see the painting. Furthermore, whereas the first hypothesis places the image within the specific context of "creating a mental picture," closely linking contemplation, imagination, and image, the second hypothesis does not imply any particular intention on the part of Fonseca.

In order to deal with this question, we must take into consideration the four elements that contribute in contrasting ways to define the status of the altarpiece: (1) the relationship between spatiality in the painting and the spatiality of the walls; (2) the ways in which the Annunciation is expanded beyond the limits of its frame; (3) the effects produced by the way the painting is presented and displayed; (4) the beholder's situation.

The permeable space of the wall where the oval altarpiece hangs rein-

forces the solidity of its large marble frame, accentuating the value of the frame as a limit. However, as we have seen, the upper part of the painting extends beyond this limit and seems to melt into the "sky of the dome." Below, the black angels who are holding up the frame and displaying the painting to the viewer isolate it from the surrounding wall. But the angel on the right, imitating Mary, repeats her gesture in a new enunciation context addressed exclusively to Gabriele Fonseca.

The time of "heaven" and that of "earth" are not the same. The timeless, nameless angels rejoicing as they witness the Annunciation may be grouped together with the timeless, nameless angels of the dome, without disturbing the temporal dimension of the scene. But in order to associate the Portuguese doctor Gabriele Fonseca, who died in 1668, with the event of the Annunciation, we need a bridge connecting the time of the Annunciation with a moment in Fonseca's life. It is the angel who provides this bridge across time, displaying the Annunciation "packaged," as it were, in a sort "box," presented within a new context contemporaneous with the donor's own lifetime. This new context is the manifestation of the mysterious power of the Incarnation to be present in the here and now, acting upon a particular person at any given moment in time (figs. 11 and 12). However, and here we come to our last point, Bernini has provided a third "box" that contains the first two: the relationship between the bust and the worshipper who attempts to conform to Fonseca's model.

The beholder's situation is not exactly parallel to that of the donor. Fonseca participates in the exchange between Mary and the angel Gabriel through the meditation of the black angel, while the beholder is excluded from the face-to-face contact occurring between the bust and the angel. To overcome this exclusion, the worshipper may identify himself with the donor, kneel outside the balustrade, lean forward, and join Fonseca in contemplation. The modalities of this act of conformation are of the same order as those that characterize Fonseca's conforming to the angel, and that of the angel to Mary. Thus, in order to be fully realized, the worshipper's participation requires a sacramental act through which he will be able to benefit from the eternally present power of the Incarnation.

However, the mechanics of imitation function only if the believer desires it. Those who do not want or who do not know how to perform this act of will remain in an extraneous position of exclusion that the *composto* has already anticipated, since the beholder has been purposefully left out of the

exchange taking place between Fonseca and the bronze angel. However, when the worshipper conforms to Fonseca's example, the ternary structure of the device is left intact: the observer may enter into the dialogue between the donor and the angel, but he may also decide to remain aloof.

Thus we may distinguish two stages in the worshipper's itinerary. In the first position, he is excluded from the process of conformation while in the second he conforms to Fonseca. These two possibilities help us to understand the contradictory status of the painting.

If, in fact, the altarpiece represents an imaginary picture in Fonseca's mind, one would think that the image would be located "in his head," and so there would be no need for it to be hanging before his eyes. But in order for it to be clear to the beholder that the donor is imagining a picture in his mind, it is necessary to represent a subject looking at an image. The altarpiece is not being displayed to Fonseca, who indeed cannot see it very well from where he is placed, but rather to an outside viewer, so that he may understand what the donor is doing. This outside viewer is none other than the worshipper who has not yet conformed, the external observer who has been excluded from the redeeming effects of contemplation. According to this interpretation, the transition from exclusion to conformation requires that the worshipper compose an image in his mind. In order to render himself permeable to the infusing of Divine Grace, the worshipper must perform a spiritual exercise similar to the one being practiced by Fonseca.

If these theories are correct, the altarpiece should be visible only to those who are excluded from the mechanisms of contemplation evinced in the *composto*: it is not a mental picture created either in Fonseca's mind or in the mind of the worshipper; rather, it is an exemplary substitute, a representation addressed only to the external observer. This observer is the one who must ask himself what meaning lies behind Fonseca's intense emotional state and who, following the line of Fonseca's gaze, must try to understand how the process of conformation (in which he is being urged to take part) works.

We may ask ourselves how a mental image, such as the one the *Spiritual Exercises* prescribes for the contemplation of the mystery of the Incarnation, may be represented if not by means of a substitute, by a fixed image that, although inadequate in itself as a representation of the many speaking and moving images visualized in the practitioner's mind, may combine with the other elements of the *composto* to form a series, to reproduce the scheme of the worshipper's own creation. The image to which the worshipper is being

asked to conform is not a painted image, or rather, it is such only in the eyes of the observer not yet in conformance. For the worshipper who conforms, his link with Christ through Mary is forged within the depths of his soul. Despite the fact that Ignatius of Loyola insists on the intervention of the visual imagination, he does not recommend the worship of images and assumes an attitude bordering on iconoclasm. The mental pictures produced by the imagination are merely tools; they serve only to activate the process of contemplation through the emotions. The progress of the soul through the *Spiritual Exercises* is, in fact, a journey of purification in which images are used to "purge" the practitioner of all other images that gradually have accumulated in his mind. In the end he is freed even of the images he has created while practicing the exercises, attaining a level of meditation devoid of mental pictures very similar to the mystic's contemplation of the Unrepresentable.[36] As the painting is a substitute for a mental image, it may be viewed as an artifact, a picture in a frame, with its own weight and substance, displayed to the visitor in the chapel.

This interpretation would be completely satisfactory if the relationship between the painting and the dome did not necessarily attribute to the painting a status that is incompatible with the above reading. In order to discover why, let us reverse the order of our first analysis. Let us think of the painting as an extension of the "sky of the dome." The altarpiece then becomes part of a cosmic structure consisting of the lantern, the source of light above, and the "earthly" elements of the chapel's interior decoration below. As we have already seen, the hierarchical cosmic axis that unites the "heavens" and the "earth" by means of the chain of angels is interrupted by the scene of the Annunciation. From that point on, the emanation of light no longer follows a hierarchically regulated course. Instead the light is being offered to all who are able to experience it. In this way, Bernini has grafted the basic mechanism of modern devotion—a mode of prayer that allows the subject direct experience of the divine—onto the neoplatonic cosmic system of a tradition dating back to the Areopagite.

Two possible itineraries are offered to the external observer, the worshipper not yet "in conformance." The first itinerary allows him to understand the principle underlying the spiritual exercise, thanks to which Fonseca is receiving the redeeming effects of the mystery of the Incarnation, inviting worshipper to do likewise. The second reveals to the worshipper the place assigned to him according to Christian cosmology. These two itineraries are not contradictory, but rather endow the painting with a twofold status. In

the first itinerary, the Annunciation is an exemplary substitute for an image existing in Fonseca's mind; in the second, it is a representation of an event that allows the flood of luminous Grace to reach man.

BEL COMPOSTO I Now, in light of our description of the chapel, let us examine two texts that discuss Bernini's concept of the *composto*. The first is Filippo Baldinucci's biography of Bernini, which we have already mentioned; the second is a biography written by Bernini's son, Domenico Bernini. The fact that the expression *bel composto*, attributed to Bernini, is quoted by both authors in an almost identical way has led Irving Lavin to believe that the phrase was indeed coined by Bernini himself.[37] This likely hypothesis suggests, however, either that Domenico Bernini has recorded his father's words somewhat more imprecisely than Baldinucci or that the latter has added something extra of his own. Both hypotheses are plausible: Domenico Bernini's account is intended as an apology and fails to mention several important things; moreover, Baldinucci, aside from being generally more accurate, was also endowed with greater critical capacities. The current state of research does not allow us to resolve this problem at the present time, but this by no means influences negatively the value of either text, nor does it detract from Bernini's great capacity for synthesis—for it was the artist himself, it would seem, who first elaborated the basic core of the formula *bel composto*.

> The opinion is widespread that Bernini was the first to attempt to unite architecture with sculpture and painting in such a manner that together they make a beautiful whole [*bel composto*]. This he accomplished by removing all repugnant uniformity of poses, breaking up the poses sometimes without violating good rules although he did not bind himself to the rules. His usual words on the subject were that those who do not sometimes go outside the rules never go beyond them.[38]
>
> We can only say that it is universally held, though this is not easily proved, that he was among the first, even in past centuries, who knew how to unite the arts of sculpture, painting, and architecture, and of these he created a wonderful ensemble [*maraviglioso composto*], and possessed them all eminently. He attained this perfection through tireless study and by sometimes straying from the rules without ever violating them. It was one of his mottoes that he who does not stray from the rule will never go beyond it.[39]

In these two passages, the traditional question of "the rules of art" yields its place to a new problem concerning the interrelationship of the "rules of

the arts." By breaking the rules governing each of the arts individually, Bernini succeeded in combining architecture, painting, and sculpture in a new relationship. But what does "straying from the rules without ever violating them" actually mean? It may suggest a slight infringement of the rules, or a form of violation that consists in pushing the rules governing a given art to their extreme limits, creating a sort of trespassing zone in which one may begin to apply the rules of another art in a new way. And this is what happens in the lower part of the architectural decoration of the chapel, where the "permeability" of the wall represents the infringement of a basic rule of architecture. It is through this violation that the architecture of the chapel becomes permeable to the infusing of Divine Grace, represented in the painting in various ways. Likewise, Fonseca's caricatural posture infringes the rule of sculptural portraiture, thereby making it possible to integrate the bust into the *composto*. This tendency toward infringement of the rules is thus the vehicle that carries the emotional configurations, the conceptual operations, the narrative structures, and the enunciation devices forward throughout the different levels of the *composto*.

The new rule of the *composto* not only governs the visible relationships among the arts, but also unites what they represent into a "beautiful" or "wonderful" whole. In modern terms, we would describe the fusing of the physical and conceptual heterogeneity of the arts as an "aesthetic" process. Likewise, we would identify a basic aesthetic intention in the beholder's reassembling of the *composto*. That we are dealing with an aesthetic process in which the beholder reassembles the *composto* is confirmed by the theories concerning the interaction of intellect and will in contemplation, such as that of Jérôme Nadal:

> Contemplation occurs when the object of meditation is seen as a whole, unified by what has preceded this moment. What happens is similar to when one steps back from a picture in order to see it more perfectly and completely. In this way, through contemplation, one achieves one's aim gradually. One could say that contemplation exists when one grasps the whole as far as is possible through an act of the intellect. Contemplation is thus an act of intellect. Yet it must be done in such a way that the will participates and joins with the intellect. Then both faculties are united in the act of contemplation. Such is the practice of all saints.[40]

Without seeking in this text an anticipation of Kant's theory of the "free play of the faculties" as a condition of the reflecting judgment, we cannot deny that the unification of the object in contemplation shares the emotional

and intellectual character of the same type of aesthetic process as in the *composto*.

Here Baldinucci's remark that Bernini "did not bind himself to the rules" adds an important extra meaning to our definition. The rule originating from the violation of the rules of art is not absolute and general, but must be discovered anew each time: it is the individual and unique solution to the questions posed by the physical and conceptual characteristics of each *composto*. It is not a question of a universal principle, but an aesthetic regularity embodied in a single object.

Baldinucci claims that aside from breaking the rules without violating them, Bernini also knew how to remove the repugnant uniformity of poses, or "attitudes," in order to create his *bel composto*. In his *Dictionary of Design* (1681), Baldinucci defines "attitude" as "the act, action, or gesture performed by a figure, standing still, bowing, or moving in any way so as to express the emotions that the artist wishes to represent."[41] The invention of new poses or compositions for a figure's actions or emotions is thus a decisive component of the *composto*. The description of the chapel has shown us that in the *composto* a physical attitude may become an autonomous configuration, a component that may be transferred from one figure to another. The transferring of Mary's attitude to the angel, and then to Fonseca, not only serves to fuse the arts of painting and sculpture, but also to draw the beholder into the *composto*.[42]

Bernini's "motto" thus summarizes, though very succinctly and none too explicitly, the theoretical basis of the *bel composto*, undermining the widespread belief that Bernini was an artist incapable of formulating his own original concept of art.[43] Of course, in order to understand the meaning of the formula, we have had to apply what we learned from the description of the chapel. But this in no way denies the originality of the idea behind the *composto*. In creating the Fonseca chapel, Bernini did indeed have to elaborate a theory of how it would work. Here we are probably dealing with an intellectual reflection intimately bound up with the actual realization of the chapel, an idea implicit in its execution that can be understood only through the description and examination of the *composto* itself. The true theoretical artists are not those who have left us theoretical studies, but those whose works involve an original theoretical reflection. During important social occasions, Bernini was in the habit of satisfying his public by repeating the dominant academic theories of his times. He never bothered to produce a consistent intellectual synthesis of what he was doing.[44] The originality of

his ideas is not to be sought in his official speeches, but in his works and "mottoes," where the theory implicit in his works is rendered evident.

What is most striking in the Fonseca *composto* is the richness and complexity of its design, which is composed of many different forms united by a single constructive principle: the incorporation of Divine Grace. As Bellori's description of Guido Reni's Annunciation shows us, this constructive principle not only assumes the form of the canonical narrative configuration, but manifests itself in the form of light penetrating into shadow and in the form of an immeasurable distance between the bodies of celestial beings and those of earthly ones. The "permeability" of the wall and the representation of light in the chapel are manifestations of this same principle. But what is even more extraordinary is the series of devices, beginning with the Annunciation scene, that enable the worshipper to receive this same infusion of Grace. By opening the scene enclosed in the painting toward the outside to include both Fonseca and the beholder, Bernini has created a game of Chinese boxes in space and time. The posture of Mary Incarnate at the time of the Annunciation assumes a "relief" form beyond human time in the angel, which then is transferred to the Fonseca bust in the round at a precise moment in time, and then is projected upon the body of every future beholder in flesh and blood. The viewer's intellectual and emotional transformation in conforming to the "spectacle" of the *composto* is quite similar to Eisenstein's theory of montage, to which we will refer at greater length in the next chapter, dedicated to the Albertoni chapel.

TWO | The Albertoni Chapel

THE The recumbent statue of Ludovica Albertoni and the
DOCUMENTARY niche designed for its display in the Altieri Albertoni
DATA chapel of the Franciscan church of San Francesco a
Ripa in Rome (fig. 13) were created by Bernini on com-
mission from Cardinal Paluzzi degli Albertoni Altieri. The cardinal was
descended from Ludovica Albertoni (b. 1473, d. 1533), daughter of a noble
Roman family, who took Franciscan orders after the death of her husband,
Giacomo della Cetera. The project for the redesign of the chapel was in-
tended to honor her beatification, which occurred in 1671, and was probably
part of the cardinal's campaign to get her canonized, which would have en-
hanced his own spiritual ascendancy and the political success he enjoyed as
the pope's nephew.

The chapel, founded by the Cetera family at the end of the fifteenth cen-
tury, was first restored in 1622 under the orders of Marquis Baldassarre
Paluzzi Albertoni, who entrusted the project to Pier Francesco Mola and
assigned the pictorial decoration of the chapel to the Jesuit Gaspare Celio.
Celio's works in the chapel include the frescoes portraying Saints Cecilia,
Agnes, and Francesca Romana, the two frescoes depicting Ludovica and
Saint Clare (located on either side of the altar), a portrait of Carlo Borromeo,
and the altarpiece showing the Virgin, the holy infant, and Saint Anne, to
whom the chapel previously had been dedicated.

Bernini had the altarpiece removed while the chapel was being remod-
eled. He replaced it with a painting of the same subject by Giovanni Battista
Gaulli (fig. 16).[1] Wittkower dates Bernini's work on the chapel to the period
between 1671 (the year Ludovica was beatified) and 1674 (when Giulio
Cartari mentions it in a letter).[2] Two autograph sketches have been pre-
served in the Stadtbibliothek in Leipzig: one shows the hands and drapery
of the statue, the other the frame of the altarpiece.[3] A drawing by Gaulli of
the sculpture also exists: it is not only remarkably accurate in its rendering

of the figure, but also indicates the exact position of the altarpiece (figs. 17 and 18), attesting to the intense collaboration between these two artists.[4] Two terra-cotta models, or *bozzetti*, of the statue have come down to us. One is preserved at the Hermitage in St. Petersburg, the other at the Victoria and Albert Museum in London.[5]

In addition to the proceedings of the apostolic hearing concerning Ludovica's beatification, two other documents testify to the new cult devoted to her. One is a Franciscan biography by Friar Giovanni Paolo of Rome (1672), the other a Carmelite panegyric by Bernardino Santini entitled *I voli d'Amore* (Flights of love), dedicated to Cardinal Altieri and published in 1673.[6] The biography praises Ludovica's virtues and good works, especially her charity and assistance to the poor of Rome, while the panegyric exalts her gift for contemplation, comparing her to Saint Teresa of Avila and Maddalena dei Pazzi. This distinction between Ludovica's active life and her contemplative life had already been anticipated in Celio's frescoes, in which she is portrayed wearing the robes of the Poor Clares (the nuns of the second order of Saint Francis) and distributing bread to the poor. Ludovica is thus juxtaposed to the figure of Saint Clare, who is displaying the host of the Eucharist. Bernini's sculpture tends decidedly toward the portrayal of mystic ecstasy, toward the new Carmelite devotion expressed in Santini's poem rather than the traditional Franciscan attitude.

Unlike the more complex project undertaken for the decoration of the chapel of San Lorenzo in Lucina, Bernini's work on San Francesco a Ripa is limited to the niche enclosing the altar, statue, and altarpiece, and the monumental frame. Bernini opened up the back wall, probably modifying the perspective of the arch, in order to create a "chapel within the chapel" whose contours are defined by the frescoed pilasters placed exactly on the horizontal axis that extends along the ground from the base of the altar, by the barrel vault contained within the two pilasters, and by the arched entrance to the niche. A jasper drapery joins the altar to the statue, which is illumined by two windows located above her head and feet. These windows are hidden by the two pilasters and are invisible to the viewer standing directly in front of the niche. Two flaming hearts in gilded stucco decorate the base of the windows. A similar heart in metal appears on the front of the altar-sarcophagus that once contained Ludovica's ashes. A branch of pomegranates decorates the panel that provides the background for the statue. The frame of the altarpiece rests upon two pillars decorated with funeral candelabras, which in turn are supported by two sculpted heads of the

Roman god Janus. A pair of vases full of roses in gilded stucco decorates the vault where the dove of the Holy Spirit appears in the apex, as in the Fonseca chapel. The supernatural character of the lighting in the chapel is confirmed by the stucco cherubs that are placed along the axes of the two windows in order to guide the light to the body of the blessed Ludovica.

No One Goes To Ludovica's pose has created a great deal of embarrass-
Bed Wearing ment among art historians, who are divided into two
Shoes camps: those who claim that she is in agony and those
 who claim that she is in ecstasy. Of particular interest
for our interpretation is the reading of Frank H. Sommer, who attempts to explain the statue through a study of how Bernini represents the emotions.[7] Sommer reminds us of the strong ties of friendship between Bernini and Urban VIII and of his close association with the Jesuits. According to Sommer, Bernini could not have been unaware of the existence of the seventeenth century's most popular devotional book, *Pia Desideria* (Pious desire), published in 1624 by the Flemish Jesuit Hermann Hugo and dedicated to Urban VIII.[8] This volume is divided into three sections corresponding to the three ways to salvation: the way of purification, the way of illumination, and the way of union, or, to use the author's terms, "Gemitus Animae Poenitentis," "Desideria Animae Sanctae," and "Suspiria Animae Amantis." The book consists of a long series of emblems, engraved by Boethius a Bolswert, together with Hugo's Latin verses elucidating the meaning of each emblem and a brief anthology of quotations drawn primarily from the Church fathers and the Scholastics.

The third part, largely based on the Song of Songs, describes the journey of the soul through the various phases of divine love, from simple desire to mystic ecstasy, ending with the attainment of final union with God after death. The thirty-second emblem illustrates the verse of the song that reads, "Fulcite me floribus, stipate me malis; quia amore langueo" (fig. 14). The soul, symbolized by a young girl, is lying in a swoon on the ground while two daughters of Jerusalem, who have come to assist her, are filling her lap with flowers and fruit. In the accompanying poem, Hugo stresses the heat love creates in the "bowels of the soul."

> O Amor! o quantis populas mihi viscera flammis
> O Amor! o animi blande Tyranne mei!
> O Amor! ah tantos quis pectore comprimat ignes?
> Parce, vel in vapidos dissoluor cineris . . .[9]

O Love, with fire have you consumed my bowels
O Love, O sweet tyrant of my soul
O Love, who can restrain such ardour in the breast?
Spare me, or I shall be reduced to a pyre of ashes . . .

According to Sommer, these lines refer to an "abnormal psychological phenomenon" known by theologians as *incendium amoris*. This was a phenomenon experienced by many mystics during the seventeenth century, among whose ranks we may include Stanislaus Kostka, to whom a chapel in Bernini's church Sant' Andrea al Quirinale was dedicated, and Philip Neri, founder of the Oratorio Romano, the order to which one of Bernini's favorite nephews belonged. The artist, then, must have been very familiar with the characteristics of this vehement flash of inner heat. Furthermore, notes Sommer, as the fruit portrayed in the emblem is the pomegranate, and as pomegranates appear in the decoration of the chapel, we may conclude that the emblem culled from *Pia Desideria* provides the "basis for the statue."

The bed itself is the clue to the understanding of the pedestal. The bed on which the "Beata" lies is made up of a mattress covered by wrinkled sheets. Her head lies lightly on an unwrinkled pillow (decorated with a magnificent lace). She has not "gone to bed," (so far as I know, no one, even in the seventeenth century, ever went to bed fully clothed and wearing shoes); rather feeling faint, she has lain herself down like St. Philip Neri. The red marble "drapes" cascade out from under the mattress. How can we explain them? If we read them as a blanket, the meaning of pedestal and action becomes clear. The reader will remember that the poem and commentary which we argue are the basis of this statue place particular emphasis on the heat experienced by the languishing and loving soul. Ludovica has been attacked by languor. Swooning, she has lain down to rest, pulling the blanket over herself. Suddenly she experiences a sharp attack of the *incendium amoris*. She writhes in pain, grasping her side, twisting and turning on the bed. She wrinkles the sheets, throws the blanket to one side to hang in a cascade to the floor, still pinned to the bedframe on one side by the weight of the mattress and her body. At the same time, her head and neck are bent rigidly back and barely touch the pillow. She is in the throes of what looks much like an epileptic fit; yet her face is calm and peaceful, for she is flooded by the Divine Light symbolized by the physical light coming from the concealed window on the left, and she is consoled by the apples represented in the background. The pomegranates of the frame, the red blanket of the pedestal, the action of the actress together find their explanation in Hugo's poem and its commentary. Frame, light, statue and pedestal are woven together to make one complete whole, each part of which helps us understand the others, to see that Bernini intended Ludovica's action to represent religious ecstasy. The scene in San Francesco a Ripa, like the Teresa of Santa Maria della Vittoria, shows us Ber-

nini the psychologist studying the effects of the "passions" of the body. In this case, the passion is divine love, or more specifically, the physiological heat experienced in the phenomenon of *incendium amoris*.[10]

Despite his attempt to analyze Ludovica's attitude within the context of a codified gestural tradition, Sommer limits himself to furnishing a "textual basis" that may "explain" both the blessed's attitude and the use of the sacred emblems scattered throughout the chapel. The relationship between body and emotion, deliberately ambiguous, has been resolved on the firmer ground of the emblems rather than through a study of how the *composto* functions. In his ekphrasis, somewhat less subtle than Bellori's, the author focuses on the convulsed figure of Ludovica. She is seen as a victim of the same suffering that afflicted Saint Philip Neri. Sommer calls our attention to the fact that she is wearing shoes as evidence that will help us solve the enigma: Ludovica is in ecstasy, not in agony.

Like Judy Dobias's article, Sommer's article is a good example of the methodology current in art history today. The poses of the painted and sculpted bodies are treated as though they were real bodies in flesh and blood, not as figures intended to be representations. According to this methodology, written texts are considered more "objective" than plastic representations, although written texts are also forms of representation. Moreover, the work as a whole is interpreted on the basis of its more codified components, without considering the possibility that its various registers of meaning may conflict.

Curiously, Sommer does not discuss either the roses being tossed to the ground by the angels or the roses on the vault or the thrice-repeated symbol of the flaming heart. The association of roses, hearts, and pomegranates reinforces the hypothesis that the *composto* may be linked to the Song of Songs and to the emblem of *Pia Desideria*. However, the emblematic components of the chapel are not united into a single, homogeneous representation, as they are in Bolswert's engraving, but are scattered among the disparate elements of the *composto*. Thus, we must not only investigate the source of the emblems in the chapel but also their role in the "montage" of the *composto*.

LUDOVICA AND "CARITÀ ROMANA"
Karen Shelley Perlove's detailed study devoted to the Albertoni chapel is of interest to us here for three reasons: first, because this scholar takes into account the relationship between the painting and the statue; second, following a trend very widespread among American art historians, the

author relies heavily on theology for the basis of her interpretation; last, her study also considers the role of the spectator.[11]

Perlove's analysis is constructed on the "textual basis" provided by Giovanni Paolo's biography and Santini's panegyric. Together these works tell the story of the blessed's life as the perfect realization of charity in its dual aspect: love of God and love of one's neighbor. Perlove claims that Gaspare Celio's fresco to the left of the altar represents the concept of charity to one's neighbor while Bernini's sculpture represents love of God. According to Perlove, charity is also the subject of Gaulli's altarpiece. The love of God is suggested by Saint Anne's gesture as she reaches forward toward Mary to take Jesus in her arms. This gesture would also serve as a reference to one of the prayers of the rosary of Saint Anne, composed in the sixteenth century by the abbot Trithemius, which was still very popular during the seventeenth century.[12] This prayer included Mary's exhortation to Saint Anne to clasp the child to her bosom. The physical contact with the Holy Infant is described in terms of a mystic union. Perlove rightly observes that the only reason why Saint Anne appears dressed in the robes of a Poor Clare in Gaulli's painting is to create a link between her garments and the robes Ludovica wears both in the fresco and the sculpture, for in both cases Ludovica is dressed as a Poor Clare. This establishes a connection between the blessed and the saint. In Perlove's view, Bernini has exploited the image of the offered breast in his sculpture, which Perlove places in the iconographic tradition of "Carità Romana." This gesture is both an offering and a manifestation of Ludovica's inner state.

According to Perlove, Ludovica is being associated with Mary here through the reference to the Christian virtue of charity. Just as the Virgin is offering Jesus to Anne, Ludovica offers her breast to her divine lover. Thus Bernini has linked the three female figures of the chapel through different manifestations of the same holy virtue: *Caritas*. The figure of Saint Clare to the right of the altar embodies Faith while the worshipper in the chapel personifies Hope. Perlove comes to the following conclusion about the fusion of architecture, sculpture, and painting:

> Seen through an arch, the shape of which is repeated in the altarpiece, the figure of Ludovica seems to be lying in an intermediary space between the "door" leading to the niche and the divine realm represented by the altarpiece. The statue is situated on the threshold of an enormous illusionistic space that opens behind her: a pictorial space that appears ethereal, without substance when compared to the real space of the niche.

> In order to enter the celestial world of the painting, Ludovica must pass between the two pilasters of the frame that mark the entrance to the supernatural pathway.[13]

In Perlove's theory, the blessed is suspended between earthly life and the celestial life of the painting. The idea of a passage from one world to the other is confirmed by the serpents entwined around the heads of Janus, "the god of all entrances and exits." In the painting, Mary, the Gate of Heaven, is the last door leading to salvation.

This interpretation, of which I have given only a brief summary, may seem very convincing at first because it traces the origin of various aspects of the *composto* back to a small nucleus of principles. However, Perlove's reading, like that of Sommer, also raises the problem of method, although for different reasons. The first reason concerns the relationship between religious art and theology, and leads us to ask ourselves under what conditions a painting, sculpture, or work of architecture may be "explained" by a theological principle. This is a question that I cannot hope to resolve entirely, but it is extremely relevant today because in recent years theologically based interpretations of artworks have burgeoned without the methodological implications of such an approach ever being discussed. In many cases, a summary theology replaces a summary iconology, with the same function of denomination: the immense wealth of stories, interpretations, ideas, and principles culled from the theological and exegetic tradition is used as a huge dictionary in which the names and functions of religious figures may be found, just as the mythological traditions of ancient Greece and Rome are used to explain a large number of Renaissance works. However, as Michael Baxandall has recently pointed out in a book dedicated to the limits of "applied" iconology, the Greek and Christian traditions taken in their entirety are so vast and have developed over such an enormous arc of time that they make an infinite number of interpretations possible.[14]

Perlove thus risks burying the figures of the Albertoni chapel under the heap of names found in the "dictionary." Mary, for example, is both a "Carità Romana," the embodiment of the Christian virtue of charity, and the Gate of Heaven. By relying on an overgeneralized concept, this "application" of theology unfortunately glosses over the disparate nature of the various elements of the *composto*. The association of the three female figures under the heading of "charity," for example, erases the differences among their individual and specific postures while attaching no significance to the

movement from one figure to another. The use of theological references poses the same problems as the use of "applied" iconology. Instead of saying how a painting succeeds in conveying a story from the Gospel, a mystery, or a spiritual process, the theological interpretation limits itself to identifying a story or a figure, as if it were merely a replica of a preexisting story or figure. At the origin of this type of "forced" interpretation we will always find an overestimation of the "textual basis" and an underestimation of the autonomous power of the visual arts to express meaning.

Perlove's insistent search for figures embodying *Caritas* has certainly been prompted by the frequent allusions to this virtue in Ludovica's biography and in Santini's panegyric *I voli d'Amore*. Her unlikely identification of Ludovica's posture as a representation of "Carità Romana" may be based on the introductory verses of the panegyric.

> Spos' a Santi Imenei
> De l'amato suo ben l'aure più belle
> Sul giglio Nazaren Sue Rose inesta
> L'Eroe de Semidei
> De' raggi arresta
> Sul crin di casta Ninfa oro di Stella
> LODOVICA al diletto
> Offre il sen, dona il cor, riposa in petto.[15]

> Bride wed in Holy Matrimony to her beloved in the gentlest breezes joins her roses to the lily of the Nazarene. The hero of celestial semigods covers the hair of the chaste nymph with stardust. To her beloved, Ludovica offers her breast, yields her heart, and rests in his bosom.

Perlove's study, although it shares the limitations of most current research in "applied iconography," does possess the merit of considering how the figures in the *composto* are related to each other. I am indebted to her for pointing out the close link between Anne and Ludovica created by the similarity of their clothing and also for identifying Anne's gesture as pertaining to the Carmelite devotional tradition, which plays a major role in the economy of the Albertoni chapel.

It is harder for me to accept the idea that the painting represents the kingdom of God to which the blessed is destined. The scene Gaulli has painted is taking place on earth, and there is no concrete clue that may lead us to imagine that Ludovica may somehow enter the world of the painting. For Howard Hibbard, who is elaborating on an idea of Irving Lavin's, the

altarpiece is presented as though it were an object of personal devotion hanging in Ludovica's room.[16] The blessed is lying on her bed between the image of the Madonna and the altar crucifix, as in the engraving illustrating the tracts on *ars moriendi*. These two interpretations seem to imply that there are only two possible ways to view the relationship between the sculpted and painted figures. In the first case, when the painting is interpreted as the imaginary extension of real space, the sculpture may be allowed to enter the illusionistic space occupied by the painting. In the second case, when the painting is interpreted as a painted object, that is, as a picture hanging on the wall, it must be interpreted only as the object of the statue's perception or devotion. In reality, as we will see shortly, Anne and Ludovica are linked in a relationship of a third type, similar to the one connecting Fonseca and Mary, a relationship characterized by the repetition and transformation of a physical attitude. Here once again, in order for this transformation to work, we must imagine the presence of an external beholder who assembles the painting and the statue in montage. In reading the niche as the blessed's room, Hibbard reduces the spatial ambiguity of the *composto*—yet this ambiguity is intentional, just as Ludovica's pose is intentionally ambiguous.

THE THEORY OF ECSTASY

It is the bed, which is the only well-defined element in the *composto*, that creates the spatial context of the scene. For this reason, many art historians feel obliged to remind the reader that Bernini was a deeply devout man and that his female figures are great mystics and not extremely sensuous women. The undeniable eroticism of this statue seems to some to be in stark contrast with the holiness of the place where it is on display (fig. 18). But we must not forget that in the seventeenth century the boundaries between the spirit and the senses were not drawn according to the Victorian criteria that we have inherited from the nineteenth century. In Bernini's era, both body and soul took part in the life of the spirit, although in different ways. We have already seen in the *Spiritual Exercises* of Ignatius of Loyola how the senses were involved in the contemplation of religious mysteries. In the experience of mystic ecstasy, things are much more complex and far less controlled. In the Song of Songs, the soul's progress is described as the union of the lover's imaginary body with the beloved's imaginary body. One example of this type of personification of the lovesick soul may be found, as we have already seen, in *Pia Desideria*, in which the soul is symbolized by a young girl swooning under the effects of passion (fig. 14). Yet mystics generally de-

scribe the physical body's participation in ecstatic phenomena in terms of more or less serious forms of discomfort.

In a plastic or pictorial representation of ecstasy, the distinction between a "real body" and an "imaginary body" becomes problematic. In order to convey outwardly an inner spiritual state, the body represented may express only the pathological side effects experienced by the "real" body or assume the erotic configuration of the "imaginary" body. In his portrayal of Ludovica, Bernini has hit upon a synthesis of these two extremes: Ludovica's body writhes with the convulsions produced upon her "real" body by the spiritual experience she is undergoing, yet at the same time she has assumed the pose of her "imaginary" body's sensual self-surrender to the divine lover. The deformation of the suffering experienced by the "real body" is used here to represent the "imaginary body" that both suffers and experiences pleasure. The hesitancy on the part of art historians to interpret Ludovica's pose is the result of this clever montage of opposite terms: tension and surrender, activity and passivity, pain and pleasure. This same paradox underlies the mystical experiences described in the writings of the great mystics, especially those of the Carmelites on the subject of the "mystic marriage," to which Bernini's Ludovica seems to be closely related. In *Spiritual Relationships*, Saint Teresa of Avila writes:

> The ordinary impulse is characterized by the desire to serve God with great tenderness and flowing tears, since one yearns so strongly to leave this place of exile. But since the soul is free and may consider that it is God's will that we continue to go on living, we must resign ourselves, offer our life to the Lord, implore him to use us for his glory, and this will give us serenity. Yet there is another way: a sort of wound that seems to have been made in the soul, as if someone had plunged an arrow into the heart or into the soul. One experiences a pain so intense that one cries out, but at the same time it is so delightful that one wishes it would never end. It is not a pain of the body or a physical wound. It has nothing of the body; it is all within the soul. These things cannot be expressed except by means of comparisons, and the ones I know how to use are all too coarse for my purposes, for these things can neither be described in words nor discussed. Only those who have experienced them directly can understand them.[17]

But these great difficulties of expression did not discourage the saint who, in *Reflections on the Love of God*, where she comments on the verse from the Song of Songs that we have already quoted ("Fulcite me floribus, stipate me

malibus; quia amore langueo"), attempted to describe her spiritual experiences to her disciples:

> Daughters, do not think that it is an exaggeration to say that the soul is dying. That is indeed what is happening, because, as I have already told you, love operates with such force at times that it seizes control of all human faculties.
>
> Someone I know once heard in prayer the singing of a beautiful voice. She claims that the joy and delight she experienced at the sound was so excessive that she felt that her soul was in danger of being separated from her body. And that is what would have happened if the Lord had not made the voice fall silent. For she easily could have died while in that state, and never have uttered a word to make the voice be silent. Indeed, outwardly she was completely powerless and immobile. She understood the danger she was in, but she was like a dreamer in deep sleep, who dreams she is in danger and desires to save herself but despite her efforts cannot manage to utter a word.[18]

Teresa of Avila's comparisons are less coarse than she would have us believe: the impossibility of expressing these things in words is conveyed figuratively by the dreamer's involuntary muteness. In reality, Teresa cannot recount her own spiritual autobiography without continually overstepping the rules of this genre through the use of images, similes, and anecdotes in which her own experiences are projected upon another character, assuming a paradoxical form. The pain is both atrocious and delightful. The sweetness of a voice may be a deadly threat.

In many passages scattered throughout her writings, Saint Teresa, aside from telling her own personal story, attempts to elaborate a theory of ecstasy, relying on categories drawn from the scholastic tradition. Thomas de la Cruz has summed up her theory as follows:

> In its minimal form, ecstasy consists in concentrating one of the human powers (one of the faculties: intellect, will, imagination) on a simple and specific act, on a definite object, and in excluding from the field of action of this power all other objects or possible acts. In this type of ecstasy, the power in question is suspended and is bound to a single act and a single object. The other powers are partially suspended and their activity is diminished. Thus there is no ecstasy in the absolute meaning of the term, but the novelty of the phenomenon is perceived by the subject as a suspension and thus as an ecstasy.
>
> In this minimal form we note that the suspension is produced by a sort of functional paroxysm: the faculty chosen by ecstasy is elevated to such an operative intensity that a breaking point is reached, and as a result it loses its

> ability to act. Teresa of Avila writes, "se pierde la potencia misma." This total suspension may be extended simultaneously to all the powers of the mind and to all of the senses until the subject begins to lose the awareness of his own body and may have the impression of having surrendered himself, of being inanimate, or even of his soul and body being separated.[19]

The acceptance of God's will increases the functional capacities of the faculties involved in contemplation until a change of register occurs—a transition from the intense activity of the mental faculties to a sweet and delightful state of union with Christ. The fulfillment of this process is an elevated form of conformation.

"Generally," writes Thomas de la Cruz, "the most intense ecstasies are intermittent. When the powers have reached the intensive breaking point, they fall into ecstatic suspension and remain there simultaneously for a short time, at the most for half an hour. Then one of the powers returns again only to yield slowly once more to this suspension, and so on and so forth in a sort of rhythm."[20] While Teresa's stories describe the mystical union as a unique experience that cannot be related except through imperfect and contradictory images, her "theory" attempts to explain the dynamics of ecstasy, insisting on its intensive, paroxystic, and intermittent movement.

It is obvious that neither Teresa's stories and anecdotes nor the Carmelite theories of ecstasy furnish the Albertoni *composto* with a "textual basis." They are not "sources," but models explaining its mechanisms. They are general enough to be applied to nonlinguistic objects yet specific enough to correspond to a historically determined way of considering the transformation of an inner state of being. Teresa's stories and theory of ecstasy can help us to understand what meaning mystic union had in the Carmelite spiritual tradition to which the seventeenth-century cult of the blessed Ludovica belonged. But in order to understand how ecstasy is represented in the *bel composto*, we must analyze the way architecture, sculpture, and painting are linked together in the chapel.

LIGHT, ANGELS, AND ARCHITECTURE In comparing the architectural style of the Albertoni chapel with that of the Cornaro chapel, Howard Hibbard observes that the tectonic rigor of the former contrasts sharply with the inclined planes, curved surfaces, and broken pediments of the latter. In the Albertoni chapel, the three horizontals of the altar, the bed, and the base of the frame combine with the verticals of the arches to create a rather rigid structure in which every slight

deviation acquires a marked emphasis.[21] This is indeed the effect created by the oblique lines of the floating cherubs attached to the sides of the frame. Initially, in an earlier design, these cherubs were placed along the arch of the frame in order to join high and low (fig. 17).[22] The change of location was probably due to a modification in the plans for the lighting in the chapel. In the modified plan, the light came not from the zenith, as in the original design, but from the sides. Here once again we find an extremely close connection between angels and light, for which the angels serve as "reflectors" (fig. 20). Here, too, the angels and the light challenge the architectural space as a closed container: light streams in from a hidden source concealed by the pilasters as if it were penetrating through the walls themselves while the angels seem to be sinking into the frame upon which they are fastened.

The architecture of the niche is an analogy for the body it has been built to enclose: an interior penetrated by the light and by the presence of the angels. Yet, unlike the Fonseca chapel, the walls of the Albertoni chapel are not divided into two opposing zones, the celestial and the earthly. The frame, pilasters, and vault are all uniformly gilded and covered with decorative elements in relief. This lack of differentiation in the architectural articulation of the niche diminishes the value of the pilasters as a support, creating the effect of an intensely luminous whole enhanced by the beams of light streaming in diagonally from the sides. The light takes on a gold tinge and is reflected in the indentations of the white folds of the statue's gown and on the reddish relief of the drapery. In this fluid ensemble of light and rippling undulation, the overall effect is enhanced by every slight variation of intensity of light or point of view. In order to heighten the illusion of pulsating space in the niche, Bernini has concealed the two lateral walls, thereby disturbing the definition of the depth and introducing a sort of diminishing perspective in the size of the folds of the drapery and the gown. Here the depth of the niche is not fixed and determined by the syntactic organization of its architectural members. On the contrary, it seems to expand and contract with every change in the light and with every change in the beholder's position, according to the time of day. We could describe the chromatic and luminous spatiality of the niche as "pictorial," but in doing so we are in danger of ignoring the great impact that even the slightest change in the beholder's point of view may have. The visitor to the chapel may view the niche from a very close distance. Leaning over the altar, one can almost touch the sculpture. The blessed seems to move with the viewer and draws him into the *composto*. In my opinion, the contrast between the

fluid elements of the chapel and the rigid architecture in which they are contained does not create a separation between architecture and sculpture. On the contrary, this juxtaposition defines an architectural space modulated by the movement of the body of the worshipper inhabiting it.

SAINT ANNE AND
LUDOVICA

Gaulli's violent *cangiantismo*, his skill in passing rapidly on a small surface from the palest pink to the most intense violet, is indeed a stylistic trait that the painting shares with the "quick" chiaroscuro of the sculpture and its niche. However, the relationship between these two elements of the *composto* is not merely a formal one. Indeed the dedication of the chapel to both Ludovica and Saint Anne seems to have been one of those stimulating restrictions that Bernini would have had to invent if it had not already existed. The "idea" of the painting has been conceived in such a way that it creates a relationship between the Virgin and her mother that is analogous to the one joining Saint Anne and Ludovica, painting and sculpture. Anne is reaching out to gather Baby Jesus in her arms. She is preparing to become another Mary, conforming to the Mother of God (fig. 16). The fusion of the two figures is conveyed by the way their bodies seem to fit together and by the way their skirts entwine in the foreground (figs. 16 and 17).

There are many hagiographic similarities between Anne and Ludovica. Both were exemplary mothers and irreproachable widows. However, the connection between these two figures is not based on these similarities, but on the fact that both are engaged in an act of receiving. Like Anne, Ludovica is receiving Christ (fig. 15). Ludovica's conformance to Saint Anne is similar to the process through which Fonseca conforms to the angel and to Mary in the Fonseca chapel. Yet while the line of Fonseca's gaze indicates to the viewer the precise figure he is imitating, Ludovica's eyes are blank. She is utterly absorbed in her feelings and sensations. In an even more striking way than in the Fonseca bust, the figure of Ludovica is composed of many tiny movements, which in turn generate an equal number of folds in her gown. These are organized into series of increasing or decreasing intensity. Thus the paroxystic impulses at work within Ludovica's soul are manifest on the surfaces of her body.

Saint Anne's act of receiving is set in a specific place and scene while Ludovica's receiving of Christ is not connected to any narrative context of space or time. Just as in a close-up shot in a film, the emotion she is experiencing is reinforced by the isolation of her figure and at the same time

is open to many possible associations.[23] In a film, a close-up of the protagonist's emotions may be followed by various types of images that attempt to convey all the potential "conjunctions" (or associations) expressed by the isolated face.

Part of the disturbing ambiguity of this statue lies in the fact that its great potentiality for association is suspended. This absence of any specific narrative context is related to the figure's almost total passivity: in being transferred from the painting to the sculpture, Anne's action has been transformed into passion. Anne reaches out to receive while Ludovica reclines on her bed, surrendering herself to her inner experience. Anne's gesture of receiving finds its culmination in Ludovica's experience. Here the receiving of Christ is completely internalized. Ludovica is infused with Christ.

The transformation of Saint Anne's physical attitude into Ludovica's pose of surrender is much more violent than the transformation of the gesture linking the three figures in the Fonseca chapel. The fact that both figures are clothed in Franciscan robes is an indication of the close relationship between them, although this is not immediately evident. Moreover, the action unfolding in the altarpiece is not the cause of Ludovica's ecstasy, as was true for Fonseca. Anne's action furnishes the viewer with an explanation of what is happening to Ludovica, creating a sort of model, a prototype for the receiving of Christ. Yet the ambiguity remains, and the observer is urged to solve it by relating Ludovica's experience to the other elements of the *composto*. Before going on to examine these supplementary relationships, we must pause a bit longer on the sculpture.

THE STATUE OF
THE BLESSED

In 1674, the year in which the altar of the sacrament was unveiled, Bernini finished another important work, the figure of the Blessed Ludovica Albertoni in San Francesco a Ripa.

Shown in her last earthly moments, she presses both hands against her body; her lips are parted in the last sigh, while her head with dying gaze sinks back on to the high-piled pillows. The figure is lying on a couch, and its outstretched horizontal is an important element of the composition. Emphasis on horizontals and verticals is an important characteristic of Bernini's late style. The diagonal, so important for the expression of emotion during his middle period, has disappeared and all the significant movements are emphatically angular, an angularity which contrasts with the supple modelling of an almost Correggiesque delicacy. The pang of death is apostrophized in a masterly fashion in the motif (above the left hand) of the vertically erected fold of the mantle, intensified in its effect by the horizontal staccato of deeply undercut parallel folds, which in turn dissolve into the long horizontal piece of drapery between the legs. The violence with which these basic directions come together tends to increase the passionate spirituality of the figure.[24]

For Wittkower, Ludovica's pose represents the final moments preceding death. This interpretation is most likely based on the presence of the funerary elements surrounding the statue, most notably the altar, shaped like a sarcophagus, that once held Ludovica's remains, and the two candelabras of the frame. In my opinion, there is no intrinsic element in Ludovica's pose that may allow us to affirm beyond doubt that she is in the throes of death. Wittkower's description is very subtly constructed. As the text proceeds, the contortions he describes, which are produced by the suffering of her physical body, are imperceptibly transformed into the expression of a spiritual experience. In this passage, Wittkower uses the same device that Bernini has used in composing the figure of Ludovica: the superimposition of an "imaginary body" upon a "real body." We must not forget that death and ecstasy are intimately related to such an extent that we might say that the death of the "imaginary body" is the supreme culmination of ecstasy.[25] But what interests us most in Wittkower's description is his use of musical terminology in analyzing the relationship between the tense and relaxed parts of the figure. The basic opposition of vertical to horizontal is not presented as a stable relationship, but as a "leap" that has been prepared for by the accumulation of tension in the staccato of the horizontal folds of the drapery. Indeed, even more so than in the Fonseca bust, the figure of Ludovica is composed of folds arranged in series tending toward paroxysm.

The tension of the composition arises from the simultaneous presence of two series of opposing signs.[26] The first series, that of the folds of Ludovica's robe, consists of irregular and compressed ripples that explode near her left hand and cheek, and then flow along her right arm and down between her legs (figs. 15, 18, 25). The second series, appearing in the uncovered areas of the body, runs from the clenched left hand up to the reclining head and half-open mouth. The right hand occupies an intermediate position between the lowest degree of contraction and the beginning of physical surrender. Both series are composed of tense vertical parts as well as more fluid parts denoting surrender, but whereas surrender prevails in the series appearing in the uncovered areas of the body, tension dominates in the folds of her gown. In both series we find a point of maximum tension and a rapid progression of intermediate phases, but their two culminating points are in opposition. In both, the gradual progression of intensity concludes with a leap from tension to surrender: in the drapery this threshold is located between the last vertical fold, elongated to an arc at the point where it joins the left leg, and the first horizontal fold. In the other series, the transition occurs between the right hand and the head.

These two critical thresholds, representing a transition from the vertical to the horizontal, have the same formal configuration as the "intensive breaking point" in Saint Teresa's theory of ecstasy, when one of the powers of the mind is suddenly suspended during ecstatic contemplation. However, due to the simultaneous presence of both series, it is impossible to determine the direction in which the process is developing—that is, we cannot say whether it is moving from tension to surrender or from surrender to tension, or whether it is intermittent, as in the Carmelite theory. The formal correspondence between the "emotional" composition of the sculpture and the religious writings of this spiritual tradition becomes even clearer after reading a few pages of *I voli d'Amore* by Bernardino Santini. A description of Ludovica's mystic union with Christ emerges from a remarkable and bizarre jumbling of characters and biblical quotations in the paradoxical conjunction of life, love, and death.

> Observe (if you please) LUDOVICA rising from the earth and embracing Jesus on the Cross, and see if the strength of Samson could tear them apart, or if the wisdom of Solomon could untie the knot, or if Alexander with one stroke of his sword could cut the Gordian knot in two. Come, kind spectators. If only Rome in the scenes of its artful theaters could witness such a miraculous flight of love! Great was the impiety of Ezzelino, who united the dead with the living so that the living would die. Great was the piety of LUDOVICA, who united herself living to her dead beloved so that through her ardor he might be revived. This is the phoenix that flapped its wings of desire in the ribs of the Redeemer, as it burned to ashes on its own pyre, *In nidulo meo moriar* (Job 29) ["I shall die in my nest" (Job 29 : 18)]. This is the eagle that spreads its wings and stares its Divine Sun in the eye. The more excited it is, the more beautiful, the redder the blood on the eve of death, the more auspicious the omen for happier things to come. This is the dove that having nowhere to rest flies up toward the rainbow of safety. When this bird of love is in flight, no one should marvel at the genius of Archita, who made wooden doves fly. LUDOVICA ALBERTONI PALUZZI ALTIERI before Jesus Christ! Six are the stars shining in the brow of Taurus symbolized in Deuteronomy: *Quasi primogeniti Tauri pulchritudo eius* (Deut. 33) ["His glory is like the firstling of his bullock" (Deut. 33 : 17)]. They are the weeping Pleiades—according to Ovid, *quae septem dici, sex tamen esse solent* [those that are said to be seven are often six]. May the Zodiac hide the sign of Gemini when these twins appear. Here we have not the fabled and the false but the true, and mysterious sign of Castor and Pollux, one living and the other dead. But the living conveys life to the dead, though the one who is dead has sacrificed his being and his life for the living one. Between these two persons there is only one death, yet both have died of love: *fortis ut mors dilectio* (Song of Sol. 8) ["love is as strong as death" (Song of Sol. 8 : 6)]. Between these two subjects there existed only one life, nor can more than one life exist where the heart reigns undivided. But if *con-*

glutinata est anima David animae Ionathae, et anima Ionathae animae David.
That is, Ludovica dies with her expired beloved while the bridegroom dwells
in her bosom. Thus either both are living or both are dead, or one is living
and the other dead; just which one is living and which one is dead you must
guess, because I do not know. Neither life nor death can separate the lover of
God from God, so says the apostle: *neque vita neque mors* [neither life nor
death]. I do not dare distinguish an inextricable point between life and death.
Let us leave the knot untied, the phoenix on its pyre, the eagle in the sun, the
Pleiades weeping before Taurus, Gemini in the Zodiac, Castor and Pollux
sharing the days of one life. I should have said it in a few words. Let us leave
Ludovica with Jesus, as though alive, spreading her wings toward the object
of her love: *Vado ad eum, qui misit me,* if she is dead, hers will be a sweet
sleep, *in pace in idipsum dormiam, & requiescam* (Ps. 4) ["I will both lay me
down in peace and sleep" (Ps. 4:8)]. Silence! Do not wake her, for it is
sweeter to die than to live without; *ne suscitetis neque evigilare dilectam, donec
ipsa velit* (Song of Sol.) ["Stir ye not up nor awake my love, till he please"
(Song of Sol. 2:7)].[27]

Unlike the other interpretations we have mentioned, Santini declares that
he is unable to untie the inextricable knot of life, death, and love that binds
Ludovica to the object of her contemplation. His text is a free poetic com-
position and does not refer directly to the sculpture. But it is interesting to
note that Bernini's statue of Ludovica—through the use of the means
proper to sculpture—is composed of a similar paradoxical combination of
contradictory elements. Every slight shift in the beholder's point of view
and every small variation in the light creates a redistribution of the rapport
between smooth surfaces and contracted ones, modulating the expression of
emotion. As a consequence, the values invested by the beholder in contem-
plating Ludovica vary. Pain may prevail over pleasure, life over death, sur-
render over strain, and vice versa. These perceptual and semantic variations
move through an intensive series toward a culminating point in such a way
that neither of the two poles prevails to impose the untying of the inextri-
cable knot. Caught up in this "pathetic montage," the beholder asks himself
what is happening inside Ludovica's body. Is she experiencing suffering or
pleasure, is she alive or on the verge of death? "Her heart burns with divine
love." This answer may be found "written" on the altar in the sacred em-
blem of the flaming heart set within the marble.

The heart, hidden dwelling of pathos, has been brought out into plain
view on the surface of the sarcophagus-shaped altar while the body that
expresses the heart's emotion is hidden from sight, enclosed in its tomb. If
the heart, emblem of divine passion, is displayed outwardly, then the body

(which is by no means the emblematic but rather the unique and unrepeatable expression of this passion) must be concealed. This movement of display and concealment exemplifies the relationship that binds the emblematic components to the other elements in the *bel composto*.

AMORIS DIVINI
EMBLEMATA

The sculpture and the emblems scattered throughout the chapel do not express their meanings in the same way, but belong to two different systems of representation. The meaning of the sculpture is not determined by a code. It is unique, and it is this very uniqueness that allows the sculpture to represent adequately an unrepeatable event. The emblems belong to a system in which the relationship between signifier and signified is much more stable: these are signs that, to a certain extent, may be repeated in different situations or even combined to form other signs. The emblem of the flaming heart is a kind of pictogram for spiritual passion. It does not stand for Ludovica's sudden and unique emotion but generalizes it and gives it a name, rendering it accessible yet at the same time dissimulating its uniqueness as an event. This shift from the emblem to the sculpture could be described as a translation. The emblem translates the sculpture into the language of concepts and allows it to be "assembled" as in a montage along with the other emblems of the *composto*. In fact, we must read the three emblems of the flaming heart together with the other sacred emblems in the chapel: the vases on the vault; the roses tossed by the angels down upon Mary, Saint Anne, and the baby Jesus; and the pomegranates behind Ludovica's bed (figs. 21, 22, 23, 24).

As Frank Sommer has observed, fruit, flowers, and divine love are closely associated not only in the verse he quotes from the Song of Songs, but also in Boetheis a Bolswert's engraving, where we find both pomegranates and roses depicted.[28] It remains to be seen how this traditional group of emblems fits into the *composto*.

The roses that the angels are strewing upon the group of figures in the painting may be compared to the rain of roses pouring down upon Saint Teresa in the Cornaro chapel, where they both signify and celebrate her marriage to Christ.[29] In the Albertoni chapel, the angels are depicted in such a way that the roses also seem to be raining down on the reclining Ludovica, who would thus be portrayed in a manner similar to Saint Teresa. The pomegranate has various symbolic meanings. Among the meanings scholars have used to interpret the chapel we find "the immortality of the soul" (Hib-

bard) and "Christian perfection" (Perlove).[30] In the *Spiritual Canticle* of Saint John of the Cross, a poem based on the Song of Solomon, the Bride offers the nectar of the pomegranate to the Bridegroom.

> Gocemos Amado
> Vamos a ver en tu hermosura
> al monte o al collado
> do manna el agua pura;
> entremos mas adentro la espesura
> Y luego a las subidas
> cavernas de la piedra nos iremos
> que están bien escondidas
> y alli nos entraremos
> y el mosto de granadas gustaremos.[31]

According to the poet's own commentary on this poem, the juice of the pomegranate symbolizes the fruitfulness and delight of divine love. The plural "gustaremos" ("we will taste") indicates the exchange of nectar—offered by the Bridegroom to the Bride and by the Bride to the Bridegroom.[32]

The spiritual eroticism of this poem would seem to suggest that the semantic field to which the pomegranate refers is quite close to the one to which the nuptial roses and flaming heart refer. Of the four fruits on the panel, the two smaller ones are closed while the larger ones have burst open. I will not insist here on the erotic configuration of these pomegranates, but I would like to point out that Bernini has depicted them in such a way that they form a series that goes from closure to explosion, passing through an intermediate phase. This is a pattern that we have already seen at work in the other elements of the *composto*. The structure of the emblem, rigid and codified by definition, is thus rendered so dynamic and animate that it comes to represent an intensive process. The emblem of the heart on the sarcophagus-shaped altar was also "animated" in a similar way: a lantern was once kept inside the altar; it cast a flickering light through the grate, illuminating the edges of the bronze heart that seemed to expand and contract and to change shape with the guttering of the flame. Yet, despite their animation, the sacred emblems of the chapel maintain a singleness of meaning that allows them to name and to generalize, though their rigidity has been challenged. They remain on this side of the threshold, beyond which they might have acquired the same rich semantic ambiguity as the sculpture but would have lost the power to crystalize the different aspects of the blessed's passion

into three codified metaphors: marriage to Christ, the delights of this union, and Divine Love.

The term *emblem*, of Greek derivation, signifies in classical Latin "incrustation, intarsio," something added on, brought from elsewhere. The three emblems of the Albertoni chapel are a sort of incrustation applied to the painting, the sculpture, and the architecture in order to form a chain of signs that help to "stabilize" the meaning of the more ambiguous components of the *composto*. The tendency toward explicitness created by the emblem is matched by an opposite tendency toward implicitness, created primarily by the sculpture. We will see shortly that this double movement, in which the emblem reveals and conceals what the montage of all the other elements conceals and reveals, is a constituent part of this *composto*.[33]

THE JASPER
DRAPERY

As in the painting, the foreground of the sculpture is occupied by the undulating folds of a mass of drapery.

A block of red Sicilian jasper conceals the base of the bed and joins it to the altar with a fluidity of form that contrasts dramatically with the rigidity of the architectural members (fig. 18). The delicate bronze fringe that defines this mass of rock as a piece of fabric does not share the morphological and chromatic variations of the stone, whose entire surface is covered by a finely veined and intricate network of reddish, white, and tawny streaks and is flecked with iridescent milky speckles. In contrast to the naturalness of the drapery, we must note an equally striking yet artificial effect—the hardness of the stone does not lend itself to the carving of such deeply excavated and angular folds. A closer examination will reveal that the drapery was first molded in stucco, then covered with wedges of marble.

As in the sculpting of Ludovica's gown, but in a more obvious way, the movement in the drapery is not produced by the natural movement of the fabric as it falls. In those areas where the weight of the fabric encounters an opposing force, the drapery folds and creases, assuming a form that does not denote any logical movement of extension. This suggests that we are to interpret its morphology in terms of pure emotion. Yet, while the gown shows us a deep and hidden agitation brought to the surface, the drapery is purely a surface for the inscription of pathos. Aside from the link between the folds of the drapery and the folds of Ludovica's robe, there is no contextual element to furnish us with an explanation of its nature or function. This detachment from a specific space-time context intensifies the emotional power

of its "potential associations." The drapery is "open" to the other elements of the *composto*, which may help to reduce the ambiguity of its meaning and also to "receive" the emotional power it generates.

We may view the entire drapery as an enlargement of one single fold of Ludovica's gown. Indeed, the morphology of the folds in the gown, which are broken at the corners, is similar to those of the drapery, where the dimensions have been increased approximately sevenfold. The shifts in size of the elements of this *composto* are structured in such a way that they seem to draw the spectator closer and then push him away, for though the viewer may remain standing in the same spot, he changes point of view three times. As we move from the painting to the sculpture, the dimensions of the figures are doubled; as we move from the statue to the drapery, one detail is enlarged by a factor of seven. The beholder is thus transported from the point of view from which he first observed the painting to a closer point of view from which he observes the sculpture, and then to an even closer point of view from which he observes the drapery. These quick variations in viewing distance show us how the action of observing the sculpture proceeds by "leaps." The guiding principle is by no means arbitrary here. In fact, the device of bringing the viewer closer is one way of conveying pathos. Those components closest to the beholder are the ones most charged with the power of emotion. The processes of isolation, intensification, and enlargement characterize both the movement from the painting to the statue and the movement from the statue to the jasper drapery. This movement is accompanied by three chromatic changes: from the intense polychrome painting to the white monochrome sculpture, and then to the vibrant color of the tawny jasper.

The overall undulating movement in this mass of stone is characterized by the juxtaposition of relaxed and tense areas, creating an effect similar to the one created in the gown. However, we may identify two folds that show a marked linear development. The first is a horizontal fold that traces a horizontal line parallel to the bed, the second a diagonal that reproduces in the most rudimentary and schematic way the outline of Ludovica's form in relation to the horizontals of the bed and the altarpiece frame.[34] Although we may identify the drapery as a piece of fabric, it traces the outline of the body to which its emotional configuration refers. Of Ludovica's figure, only the barest outline, simplified and abstract, remains in the sculpted jasper, while the series of folds conveying the emotions that have overwhelmed her are now freed from the figurative limits of her body and may follow their own

extreme, autonomous development. The drapery would seem to be a sort of double of the statue in which the outline of her body appears in its most reduced form while its emotional components are developed in the folds and condensed in the morphological and chromatic structure of the stone. The infusion of Divine Grace, which has triggered the crisis of emotions expressed by Ludovica's body, is represented in the drapery in its purest form—as in the reddish marble of the Fonseca chapel—by the penetration of light into stone and by the creation of an iridescent effect. The folds, speckles, and veins vibrate together, varying with the changing of the light and with every shift in point of view, echoing the chromatic and morphological variations in the folds of Ludovica's gown.

As in the movement from emblem to statue, the movement from the sculpture to the block of jasper represents a change of level, an exchange between two different registers of expression. The sculpture goes beyond its figurative limits, at least as far as the seventeenth century is concerned, and is transformed into something that is neither sculpture nor figure: an element that fulfills the architectural function of a juncture yet is not an architectural member, that at the same time is an intense chromatic value yet is not a painting. We might say that the drapery is the sculpture that has "gone outside itself," or, to use Eisenstein's expression, it is a typical detail in which the structural principle of an entire work is generalized, in this case, the infusion of light throughout a surface upon which opposing waves of tension and surrender are manifest. The recumbent statue of Ludovica has been assembled in montage between a painting that provides the prototype for the experience it represents and a typical detail in which the representation of the effects of this experience reaches its high point.

In the *composto*, the role of the drapery is not limited to its relationship with the sculpture. The drapery also maintains an important link with the altar and with the emblem of the flaming heart decorating the altar. We have seen that the transition from the sculpture to the emblem is a process in which emotion is "formed into a concept."[35] The emergence of the flaming heart of Divine Love from within the altar-sarcophagus is accompanied by the dissimulation of the body insofar as it is a surface upon which a particular figure of pathos has been inscribed. The drapery participates in this movement of dissimulation and revelation. In fact, the emblem brings Ludovica's inner experience to the surface, giving it conceptual form, while the dramatic configuration of the drapery conveys her experience as pure emotion. Although her body is concealed from view, the hidden depths of her

soul come forth from within the soul's inner sheath (Eckhart) to become visible on the exterior. *La intima sustancia del fondo del alma, lo interior, lo de mas adentro, lo escondido* [The intimate substance of the depths of the soul, the interior, the most inward, the hidden] (Saint John of the Cross), *esta cosa muy honda* [this deeply profound thing] (Saint Teresa of Avila), comes to the surface in the emblematic form of a flaming heart and in the emotional form of a colorful fabric.

The movement from the depths to the surface is also found in the lexical and conceptual configuration of the soul's structure according to many mystical traditions. In these various definitions we find the attempt to locate the point where the grace of union occurs.[36] In the tradition of intellectual contemplation deriving from Neoplatonic sources, the semantic series "peak," "culminating point," and "spark" prevails, while in the tradition of mystic ecstasy the series "depths," "hidden," "interior" dominates. For Richard de Saint Victor, for example, the culminating point of the soul is to be found at the very bottom of its depths: "In humano procul dubio animo, idem summum quod intimum, et intimum quod summum" [Undoubtedly, in the human soul, what is deepest is highest, and what is highest is deepest].[37] The image of the mirror corresponds to the "peak" series while "imprint" is the traditional figure representing the "bottom/depths" series. The drapery sparkles like the surface of a mirror and is full of creases and folds like an imprint.

The emblem and the drapery are two equivalent elements existing on two different planes. Both represent the depths of the blessed's soul brought to the surface and are the products of a process of abstraction originating in the sculpture itself. Both maintain a visible relationship with Ludovica's body in different ways, however. The emblem appears on the sarcophagus where Ludovica's ashes are contained while the configuration of the drapery follows the schematic outline of her form. Both have extracted from the sculpted figure only its emotional content (fig. 19). Yet these two representations of pathos follow different and, in a certain sense, opposite paths: the emblem provides a name for the emotion and generalizes it while the drapery represents this emotion as a unique, fleeting moment in the present. The opposition of these two elements in the *composto* is a dialectical juxtaposition: what the generalization of the emblem conceals is revealed by the drapery. What is incommunicable in the drapery's inimitable uniqueness is successfully conveyed by the emblem, however. What counts here, what makes the *composto* "work," is not the complementary nature of these two

elements, but the tension of their dialectical rapport. The drapery and emblem remain on two different planes. The emblem cannot express the uniqueness of the event without forcing it or, more precisely, switching it from one system of representation to another. The shift from the general to the specific corresponds to the shift from the intelligible to the sensible and concrete. In fact, while the emblem provides a conceptual representation of Ludovica's emotion, the drapery provides a very concrete one, transforming the depths of her soul into an extremely sensitive membrane full of folds and creases, covered by a sort of flushed epidermis streaked with a tangled network of veins. If the drapery represents the very depths of Ludovica's soul through a surface, if it represents the immaterial through the concrete, if it literally and in its purest form corresponds to Henri Bergson's definition of emotion as "a motor tendency in a sensible nerve," if it brings to the surface what Saint Augustine called the "abstrusior memoriae profunditas," it is because it has been "assembled in montage" in such a way that it gives form to a "pathetic construction" composed of a structural organization and a dynamic principle that proceeds by means of leaps and reversals.

THE PATHETIC As we have seen, the texts we have read by Baldinucci
MONTAGE and Domenico Bernini stress the idea that Bernini created a new rule to give unity to his works through a new interrelationship of the arts. The two passages we have examined do not concern any one particular work but a more general question of aesthetics: how unity is created from the multiple and heterogeneous elements of a work of art. In Baldinucci's definition, the *bel composto* is a general principle, the starting point from which every *composto* is created anew. The specific problem of the "Albertoni *composto* is the forming of a single unit from its conceptual elements and its concrete, sensorial ones in order to represent a transformation that, due to its ecstatic nature, lies beyond the limits of the representable.

In order to understand the dynamics of the Albertoni chapel, we must distinguish between the pathos of the theme, Ludovica's ecstasy, and the pathos generated by the ecstatic (as in "ex-stasis") way the components of the *composto* are related to each other in the functioning of the whole. These components are linked by a succession of leaps in which each element, pushed to its extreme limit, culminates in an explosion in which its dimensional, chromatic, and conceptual equilibrium is broken, at which point another element comes to the fore and carries on.

In *Nonindifferent Nature* (1945–47) Sergey Eisenstein compares this type of composition to a rocket propelled forward by a series of explosions that seem to originate one from another. Eisenstein's theory is not limited exclusively to film. Like Baldinucci's formula, it addresses "the question of the recomposition of disparate materials into the unity of a structural feature common to all."[38] Compared to other more limited theories of cinematographic montage, Eisenstein's theory represents a more general aesthetic inquiry. Moreover, as we have said, it deals with how heterogeneous materials may be combined in a work of art in order to convey emotion. Pierto Montani emphasizes the specifically aesthetic intent of *Nonindifferent Nature* in his introduction to the Italian edition, where he reminds us that Eisenstein

> develops the theory that there exists a structural correspondence between works of art and organic phenomena, in the sense that both conform to the universal principle of movement in matter: evolution through leaps, the shift from quantity to quality. The power of a work of art derives principally from this correspondence.[39]

The debatable ideological premises underlying this theory do not keep Eisenstein from identifying a category of works of art that give expression to the structural laws inherent in organic phenomena. He defines this class of artworks as "pathetic works." After specifying that by the term "structure" Eisenstein means something roughly equivalent to the traditional concept of "composition," that is, the system of unity created by parts of an object in relationship to the whole, Montani summarizes the characteristics of the "pathetic" or "organic" work of art as described in *Nonindifferent Nature*.

> According to Eisenstein, a work of art may be considered organic when its structural organization allows for a motivated system of qualitative leaps, or, more precisely, a system of transitions or shifts from one expressive register to another (for example, from an image to music, from music to color, from color to space, from space to figure, from figure to narration, and so on).
>
> Yet these shifts, which are made possible by the coherence of the work's composition, depend in turn upon a model that is no longer static and spatial but dynamic and temporal. Eisenstein describes this model with the term "ecstasy," intended literally as *ex-stasis*, "gone outside itself." Thus the structural organization of the work itself determines at what point the intervention of the dynamic model, the "ecstasy" of the expressive model, must occur, or, in other words, at what point a given system of representation must "go outside itself" to make room for another system. This means that the overall structure of the work (its construction, its being, its *stroeni*, to use Eisenstein's term) is dual, as it is the product of the cooperation between a static model

and a dynamic one. The analogy with organic phenomena thus appears even clearer: the work of art gives expression to a particular dialectic of permanence and transformation, of continuity and change.

It is decisive that this particularity should derive from these shifts in expressive registers and in systems of representation. It is decisive because the special emotional power of the work is created by these shifts. The "ecstasy" of expressive registers imposes upon the receiver a certain emotion (*oscuscenie*) of transformation that is resolved in an analogous "ecstatic" operation (for example, the passage from the predominantly acoustic to the visual, from the visual to the purely chromatic, etc.).

This departure from one sensorial condition in order to enter another, argues Eisenstein, represents an emotional experience that we may call "pathos." Thus the organic nature of the work, intended as the dynamic concatenation and concurrence of many different registers within a fixed structural organization, provides the basis for the pathetic character of its reception.[40]

The relationship between the "ecstasy" of the expressive register and the "ecstasy" created in the beholder seems to grant absolute privilege to the sensorial elements of reception and to exclude intellectual and cognitive components from both composition and fruition. In reality, as Montani reminds us, after *Montage of Attractions* (1923), a manifesto for a theater of agitation, Eisenstein sustained that in order for a work of art to be emotionally effective, it had to produce an *effect of consciousness* upon the viewer. The propagandist implications of this concept, originally elaborated for the theater, lose some of their heavy connotations of manipulation if we reduce them to the fully acceptable proposition that consciousness is not something purely intellectual, but is also a process involving the "lively interplay of the emotions."[41] The idea that "attraction" is a molecular unit, a formal rather than a material component of representation, already appears in *Montage of Attractions*. Light, sound, color, movement, and narrative subject matter may constitute interconnected autonomous formal units independently of the materials to which they give form. But in the twenty-two years that elapsed between *Montage of Attractions* and *Nonindifferent Nature*, Eisenstein's radically formalist views underwent a total transformation. In his notes for the mise-en-scène of Marx's *Das Kapital* (1927–29) he stresses the difference between the structural equivalence of elements and the "semantic series" of their meanings. Eisenstein sets forth the theory (later to be developed in *Nonindifferent Nature*) of the "precedence of meaning with regards to which form (images and their organization) can *only be partially indifferent*."[42]

The precedence of meaning and the nonindifference of materials selected to convey that meaning are the two basic laws that Eisenstein used to replace the absolute formalist criteria of randomness expressed in *Montage of Attractions*. This means that not all objects are suitable for the purposes of a particular representation. Thus, for each representation the artist must find materials that are not indifferent to the meaning they are to convey. Here Eisenstein attempts to develop the theory that a work of art, and film in particular, proceeds by means of "sensorial thinking"—a "prelogical" way of thinking that is more clearly bound up with objects than, for example, scientific thought, and that cannot occur without taking into consideration the nonindifference of objects. This "prelogical" thought assumes some of the characteristics of the internal discourse which had been described in those years by Vygotsky, a close friend of Eisenstein's. According to Eisenstein, it is an "ascent along the lines of the highest explicit levels of consciousness and simultaneous penetration through form into the deepest layers of sensorial thought."[43] In this dialectic, in which consciousness is impossible without construction and vice versa, art is a "field of conflict" in which a regressive movement comparable to the primitive, infantile impulse to create objects and relationships between them is opposed to a forward movement that gives value to the intellectual and cognitive aspects arising from that primitive act. It we are struck by a work of art, it is because the two movements (cognitive and constructive) appear together in an object or in a representation.[44]

Organic or pathetic works of art are more powerful than inorganic or nonpathetic ones because they unite concrete, sensory elements with cognitive ones in accordance with the "nonindifference of nature." This theoretical proposition will allow us to describe in more precise terms how the "Albertoni *composto*" works. But before we can judge the appropriateness of applying this theory to Bernini's *composto*, let us see how Eisenstein used this model in a sequence from his film *The Old and the New* (figs. 26a, b, c, d):

> Until the moment when the first drop of milk falls into the pail below the centrifuge, the interplay of tension is structured through the use of all the means and procedures of montage.
>
> Hope and doubt, certainty and diffidence, mere curiosity and sincere emotion alternate within a series of close-ups that keep growing larger and larger: close-ups of groups of figures, of two or three characters, of individual characters. This series of faces is interpolated with shots of the heroine Marfa

Lapkina, the farmer, and Vasja, as they turn the handle of the centrifuge faster and faster.

Almost imperceptibly, quite unintentionally, the tonality of the sequence echoes the interplay of hope and doubt. Almost imperceptibly, as if quite unintentionally, the shots of rising hopes become more luminous while the shots expressing diffidence gradually grow darker. Parallel to the accelerating rhythm, the sections of the montage grow shorter and shorter while the alternation of light and dark shots grows more intense. The disks rotate faster and faster, and behind them the luminous breaks in the montage are transformed into a flickering effect, which is visible in the close-ups (this effect was created by rotating a multifaceted, spherical mirror).

Then, at the right moment, this system of pieces of montage is interrupted by the image of the spout of the centrifuge. For a while it is empty. Then a drop begins to form along the edge—for as long as necessary (close-ups of the faces alternate at full speed). The swollen drop trembles (the disks of the centrifuge are rotating at great velocity).

The drop is about to fall.

Then it falls!

It breaks into a crown of tiny droplets as it plops down into the empty bottom of the pail.

Then suddenly a thick white stream of cream pours through the spout of the centrifuge with a violent pressure and begins to fill the bottom of the pail. The squirting jet and spray of milk now mingles—through the montage— with the torrent of triumphant faces in close-ups. The cream spewing forth is like cascades of milk as white as snow, silvery fountains, impetuous streams, an unending display of fireworks.

Then suddenly, as if in response to this unintentional metaphor after the explosion of the first stream of milk, the montage alternates the flow of milk with images of an extraneous substance: sparkling columns of jets of water splashing in fountains.

Once again, as in *Potemkin*, metaphor interrupts the action. Here the metaphor of the *fountains* of milk spurting out of the centrifuge brings to mind an image found in folktales of *rivers of milk* flowing *between white banks*, a symbol of material prosperity.

And once again, as in *Potemkin*, parallel to the increase in size that has shifted to another order of scale (the jets of water are more forceful, vivid, and luminous than the splashing milk), a similar leap from one dimension to another occurs in the narrative method: from an exposition of the object to a metaphorical explosion (*fountains of milk*).

But the montage does not stop at this. Another transition is made, another leap into another dimension: the image of *exploding fireworks*.

The sparkling jets of water, far more intense than the streams of milk, are now taken up once again in the montage and elevated to a new and higher level of intensity: they become sparkling fireworks that not only explode into light but glow with a thousand colors, assuming a new quality—color. But the frenetic montage of this scene does not stop here. After sparkling for a

while on the screen, these colorful sequences once again yield to the colorless. In fact, the shift from a colorful sequence to one devoid of color is once again a leap in quality! Even more so, given that in this case we do not return to the grey of monochrome photography.

The colored sequences go beyond this to a new system, which though it may be devoid of color has been constructed in such a way as to separate the two uniform components of the grey tonality of monochrome photography: a blinding white outline traced on a completely black background.

If we wish to make another comparison with *Potemkin*, we might mention the nonfigurative *suprematist* solution used in the scene of the night watch that precedes the encounter with the squad. Here we find this same doubling of grey tonality physically manifest in the white reflections of the lights at night on the black surface of the water.

The Old and the New, however, goes even further. In these graphically abstract sequences, the white zigzags on the black background grow larger bit by bit, becoming successively more and more complex.

From a plastic point of view, this offers a new solution regarding color. Once we have colored monochrome photography, we do not go *backward* to the uniformity of grey but go *forward* to the pure graphics of black and white.

But here even the plastic system has moved from the *figurative* plane to the opposite plane of the *nonfigurative*: the pure graphics of white zigzags on a black background.

Finally, these plastically nonfigurative white zigzags of increasing size express a new quality: the idea of increase conveyed not through the quantity of objects represented but through the conceptual meaning (*smysl*) of the sign. The increase occurs not only in the size of the number symbols appearing on the screen but also, and more importantly, in the value of the quantities designated by the series of Arabic numerals $5-10-17-20-35$. In these figures, the increase of numerical quantity corresponds to an analogous increase in the actual size of the outlines of the individual number-signs, accompanied by a triumphant roll of the drums announcing the ever-growing number of new members joining milk cooperatives.

The drumroll effect was created in the montage by alternating the dynamic, *fluid* sequences of the sparkling jets with the rapid bursts of *static* fragments: the *immobile* numbers appearing one after another in an abrupt rhythm.

Once again a transition and a leap to the opposite! This is most remarkable if we look closer, because the highest point of dynamism corresponds here to the rapid bursts of fragments of the montage cut into tiny pieces, and thus immobile and static in themselves!

In the finale of this scene, in which the dynamic succession of white zigzags of growing dimensions conveys the same content (the idea of quantitative growth) in both the size of the number-symbols and in their numerical value, we find the fundamental nature of pathos rendered explicit: the unification of a common impulse in the spheres of sensibility (*custvo*) and of consciousness (*soznanie*) created in the viewer through the ecstatic condition.

The final and abstract notion of the figure signifying the number of new milk cooperative members once again returns to explode in a concrete representation. Thus, if we consider the development of the entire scene, we may say that this notion has developed through the following phases: from fact to image, from image to notion.

In other words, this notion projects the spectator out of the sensible world of the concrete into the conceptual world in order to reunite both spheres later in a single "pathetic" condition.

Thus, insofar as it reproduced in a brief section of this film the real process through which emotion is formed into a concept, the finale of this scene could not but have a powerful and irresistible impact on the viewer's perceptual and emotional sensibility and on his consciousness.[45]

I have included this long quotation from Eisenstein's writings here because when a theory is illustrated with concrete particulars, it acquires a weight and depth that no summary can possess. Eisenstein's analysis of the centrifuge sequence shows us in an exemplary way how the intensive dynamic of qualitative transformations may associate leaps in emotional content (doubt, expectation, hope, joy) with leaps in the form of expression (images, metaphors, numbers, size, color, black and white, figures, and nonfigures). This way of composing is very similar to the method Bernini adopted in his Albertoni *composto*, in which leaps in content (pleasure, pain, life, death) are associated with leaps in the form of expression (story, emblem, pose, folds, size, color). Eisenstein's theory of "the pathetic condition" seems to furnish our analysis of the Albertoni *composto* with an applicable theoretical model: the idea that a work of art is a field of conflict where the concrete and the conceptual stand in opposition to each other and then are reunited by means of a chain of conversions into a syncretic dimension.

But before we can carry our argument further, four things must be clarified. The first concerns the appropriateness of comparing the montage of this film with the "montage" of this *composto*. Eisenstein himself tested his theory by applying it to two paintings by El Greco, to the architecture of the Parthenon, and to two engravings by Piranesi. In his view, film occupies a privileged position among the arts because it employs a greater number of materials (images in movement, noises, music, etc.) and more effective syntactic procedures (varied camera angles, montage). Film is the pathetic work par excellence, because in cinema the instrument of montage—which painting, engraving, and architecture already possessed in embryonic form— reaches its expressive and structural high point. The idea that the arts have

evolved is, of course, debatable, but it allows us to consider the arts of the past in light of the modern interrogatives to which the advent of cinema has given rise. The effect that Eisenstein's intentionally anachronistic analysis has had on El Greco's paintings, on the interpretation of the architecture of the Parthenon, or on Piranesi's prints is not without interest for the very reasons mentioned in the introduction to this book. Eisenstein's theory prompts us to study works in a series and to concentrate our attention on the transformations that occur in passing from one element of a series to another. But the *composto*, where these conversions and transformations occur within an ensemble uniting architecture, sculpture, and painting, is more suited to this type of analysis than are the individual arts taken singly. Reading between the lines of Baldinucci's definition of the *composto* and considering how this concept finds expression in the Albertoni chapel, one has the impression that Bernini's proud satisfaction at having created the first *bel composto* derives from the very same reasons that prompted Eisenstein to rate cinema above all the other arts. The insistence on creating new relationships among the arts meant, for Bernini, that the *composto* was more evolved than all other art forms: like film, it employs a greater variety of disparate materials and forms of representation. This heterogeneity is to be found most particularly in those places in the *composto* where the artist "broke with the rules" in order to graft on new relationships that combine to create the *composto*.

The second thing that needs to be clarified is the difference between a film and a *composto*. While in film the "qualitative leaps" follow one upon the other in an order fixed by the succession of images upon the screen, in the *composto* all the components are present at the same time. Thus the transformations and conversions are created in the beholder by the dynamic solicitations potentially at work within a perfectly static whole. Of course, as we have already pointed out, Bernini makes the beholder move around the sculpture and even makes the marble seem to move with changes in the light. But whereas in film the associations suggested to the viewer are powerfully elicited through the film's montage, in Bernini's *composto* such associations are left up to the sensory, intellectual, and emotional activity of the beholder. This by no means obliges us to postulate hypotheses impossible to verify about which "path the eyes should take" because, whatever the viewer's sensory, intellectual, and emotional approach may be, the "ecstatic" composition of the *composto* guides him in moving from one element to another. This means that although the proper sequence from one component

to the next can at most be only suggested, the ways in which they are associated can be programmed.

The third thing we must clarify is the relationship between the example of the centrifuge and this particular *composto*. Indeed, while Eisenstein's theoretical model aspires to a widespread, general application, *Nonindifferent Nature* is dedicated to the definition of a particular category of works of art: "pathetic works." This type of work, of course, is exemplary of the work of art in general, but it must be distinguished from other types, for example, from the nonpathetic (and therefore less successful) and from the comic, characterized by a break between sign and meaning. What this film sequence has in common with the Albertoni chapel is the fact that both belong to the class of pathetic works in which the uniting of sensorial elements with intellectual and cognitive ones is achieved through a violent shock—by a paroxystic mounting of tension and by a series of conceptual, dimensional, and chromatic leaps from each element to its opposite. Our analysis of the *composto* has shown, in fact, that the tensive dynamic and the simultaneous presence of opposite terms are indeed the two faces of the one structural feature that unites the different parts of the Albertoni *composto* into a whole.

The last thing we must clarify is the difference between this film sequence and the Albertoni *composto*. Eisenstein chose the centrifuge scene as an example of pathetic construction because (unlike the equally famous scene of the Odessa stairway in *Potemkin*) the theme, namely the transformation of a drop of milk into a drop of cream and the possibility of mechanizing an agricultural economy, was in itself devoid of pathos. Indeed, it is this absence of pathos that allows Eisenstein "to lay bare the very nature of those procedures through which pathos is created." In the Albertoni chapel, on the contrary, the pathetic structure corresponds to the pathetic content: the ecstasy of the expressive registers is employed to represent ecstasy. Ludovica's "going outside herself" is represented by the continual "going outside themselves" of the elements that make up the *composto*. The pathetic structure is appropriate to the representation of ecstasy because it continually refers to something that lies beyond the scope of each individual element and even beyond the possibilities of representation itself. The tension of representation to "go outside itself" produces the sublime effects of pathos that lie far beyond the scope of image and concept.

The devaluation of concept and image implicit in this "ecstatic aesthetic" brings to mind the mystical tradition, with which Eisenstein was very familiar. In the writings of Saint Teresa of Avila, the effects of pathos created

by the continual trespassing of autobiography into metaphor, story, and image is juxtaposed to her recognition of the total inadequacy of words and also to her union with Christ.

THE OBSERVER In the Fonseca chapel, the enunciation device of the *composto* conveys the two possibilities open to the beholder: the role of the "conforming worshipper" and that of the "nonconforming worshipper," thus indicating two stages in a journey of initiation. In the Albertoni chapel, there is no figure who, like Gabriele Fonseca in the Fonseca chapel, represents this device within the work itself.

In fact, although we were able to identify the process of conformation in Ludovica's imitation of Saint Anne in the act of receiving Christ, the beholder is not invited by a mediating figure to imitate her spiritual attitude. The worshipper is invited to do so, however, in sacramental form at the moment of the Eucharist, becoming one with Christ through Holy Communion. While the blessed, who is infused with the ecstasy of Divine Grace, has internalized the Christ whom Mary is offering to Anne, the believer may, within the limits of his possibilities, conform to Ludovica in the act of communion. In displaying the sacred host, the figure of Saint Clare confirms and reinforces the importance of the moment of the Eucharist in the worshipper's prayer in the Albertoni chapel. And it is interesting to note that the "going outside oneself" experienced to different degrees by Saint Anne, Ludovica, and the communicant always corresponds to the incorporating of Another within oneself: Christ.

The conclusion of the process of conformation on the ritual plane of the Eucharist confirms the specifically sacramental value of this spiritual process. The conformation of the beholder to the canons of sacrament is yet one more leap in register in the "pathetic" structure of the chapel. The beholder is in fact transported from the "aesthetic" plane of contemplation of the *composto* to the ritual plane of communion. This is, of course, the same conclusion to every mass. In the Albertoni *composto*, however, the links between the preparatory phases preceding Holy Communion and the moment of its realization have been rendered in such a way that the worshipper's feeling of harmony and participation arising from this sacrament is accompanied on another plane by a similar feeling of harmony and participation arising from his attempt to reassemble the heterogeneous elements of the *composto* into a whole.

We have already described the possible stages in this process of recom-

position, and we would like to stress that it does not correspond to any specific form of seventeenth-century contemplation. While Fonseca may be imitated through the practice of a difficult spiritual exercise, no codified practice will allow us to imitate Ludovica's ecstatic experience. Hers is indeed a unique and inimitable experience, for which the Eucharist represents a sort of doorway. As far as the observer/worshipper is concerned, this tension in imitating the inimitable corresponds to the sublime dynamic of the *composto*'s pathetic structure.

BEL COMPOSTO 2 While the location of Gabriele Fonseca's bust is set within a cosmic order whose coordinates are plotted in the altarpiece, the location of the statue of Ludovica is self-determined. We might say more exactly that the statue occupies an undetermined location, and that this very vagueness allows it to create a tightly woven network of relationships with the other components in the *composto*. The transformations within the sculpture thus involve all the components of the chapel. Here, in the Albertoni chapel, the sculpture performs the function of "generator of place," a role played by the painting in the Fonseca chapel. Not only are the width and depth of the niche determined by the dimensions of the blessed's body, but the semantic value of light and shadow depends upon the location of the sculpted figure.

Although differing from a generative point of view, the two altarpieces are comparable in that both function as paradigms. The *Annunciation* and the *Virgin with Holy Infant and Saint Anne* are narrative scenes that to a certain extent furnish the key to our understanding of the sculpted figures' poses. Ludovica's attitude may be viewed as a transformation of Anne's attitude, and this confirms the importance of the posture's autonomy in the *composto*.

The links through which the elements in the chapel are connected not only occur in their chromatic, functional, narrative, semantic, or conceptual aspects, the position they occupy, or the materials from which they are made; these links are also forged through the association of multiple syntactic and semantic modalities. The roses in the vases decorating the vault and the roses in the painting that the angels are strewing upon the figures below are an example of visual anaphora: an object, the rose, is repeated in a new context—the painting. But both types of roses bring an extra semantic value to the relationship created between the painting and the vault. It is raining roses in the painting, and as rain this symbolizes the "marriage to Christ."

The roses of the vault are associated with the other gilded figures in relief, namely the sacred emblems. Thus the emblematic value of the rain of roses is confirmed by the fact that the roses in relief are part of the group of emblems.

The Albertoni *composto* is thus characterized by the rich and multiple relationships existing among its varied elements. The cohesion of its parts is the static condition of the dynamic processes that knit the components together through a series of leaps from one level to another. The breaking of rules, so essential to the *composto*, is of even greater importance here than in the Fonseca chapel. We need only emphasize how the heart and the drapery, by exceeding the constitutive limits of sculpture, resolve questions regarding the pathetic montage of the statue, although in opposite ways. The same thing occurs with the principle of "nonindifference" of materials, when, for example, in order to give concrete expression to passion, a type of marble has been used that is highly sensitive to light.

The interplay of conceptual and material components has prompted us to compare the *composto* with Eisenstein's "pathetic work" on the theoretical plane and to apply to our analysis of the Albertoni chapel questions and solutions posed by the Russian director's theories more explicitly than in our discussion of the Fonseca chapel. It is my opinion that this "eidetic variation" helps to shed light on Bernini's concept of the *composto*, which will find further elucidation in our description of the altar of Sant' Andrea al Quirinale.

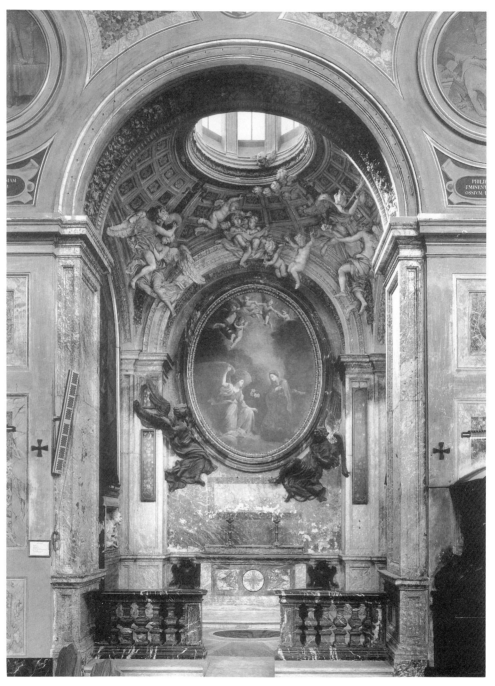

1. The Fonseca chapel, San Lorenzo in Lucina, Rome.

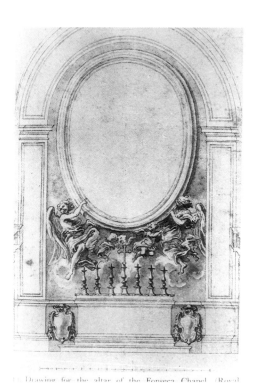

2. Gian Lorenzo Bernini, drawing for the altar of the Fonseca chapel. Royal Library, Windsor Castle.

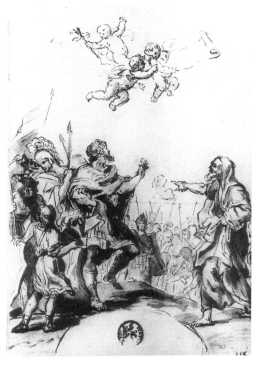

3. Anonymous, *King Ahab and the Prophet Elijah on Mount Carmel*, copy of a painting by Guglielmo Cortese originally located in the Fonseca chapel. No trace of the painting exists today. Künstmuseum, Düsseldorf.

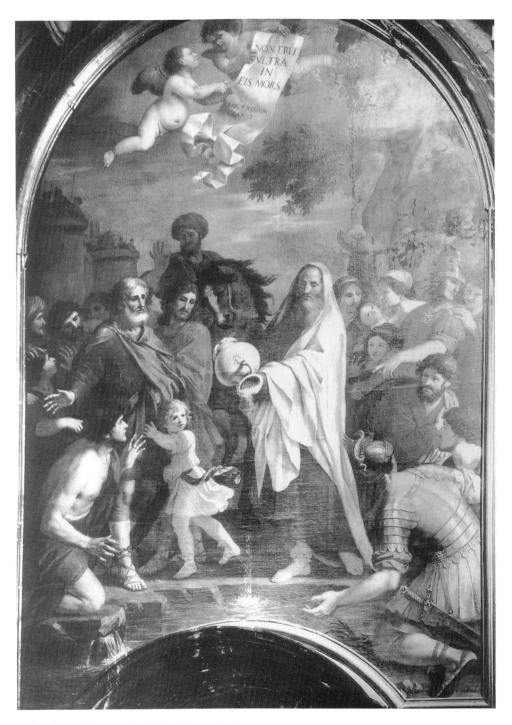

4. Giacinto Gimignani, *Elisha Throws Salt into the River*, 1664, Fonseca chapel, San Lorenzo in Lucina, Rome.

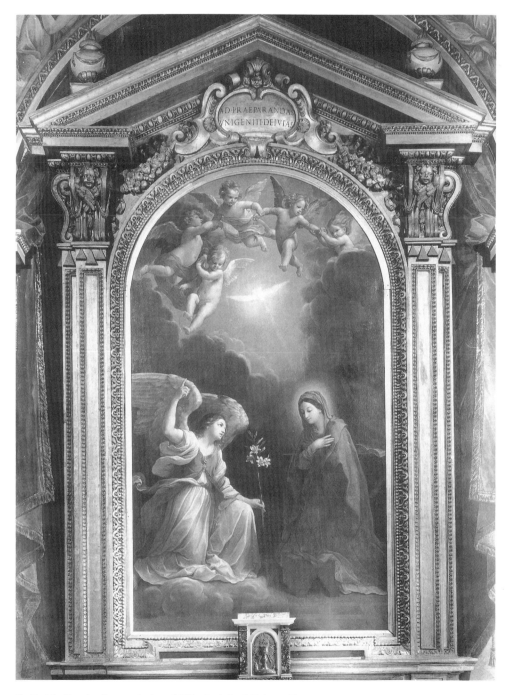

5. Guido Reni, *Annunciation*, 1612, Quirinal Palace, Rome.

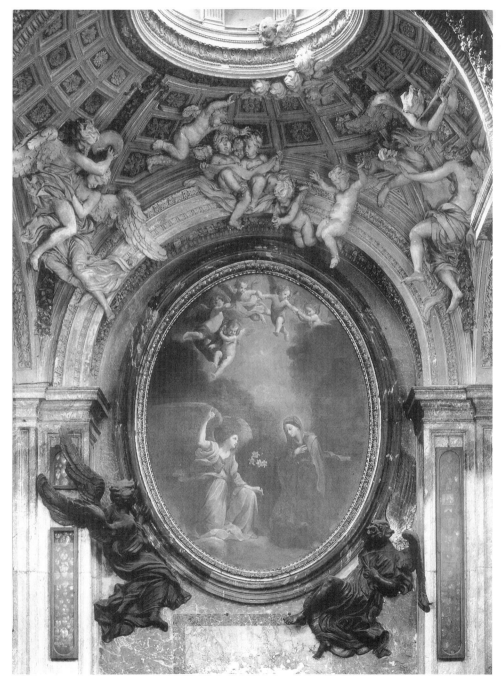

6. Giacinto Gimignani, *Annunciation*, 1664,
Fonseca chapel, San Lorenzo in Lucina, Rome.

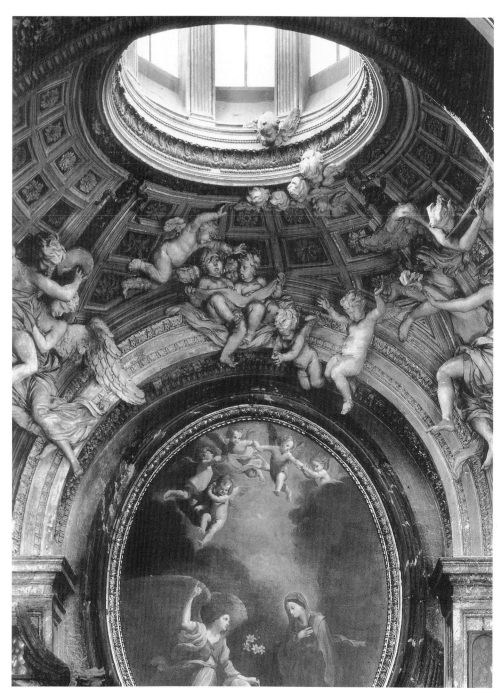

7. The Fonseca chapel, altarpiece and dome.

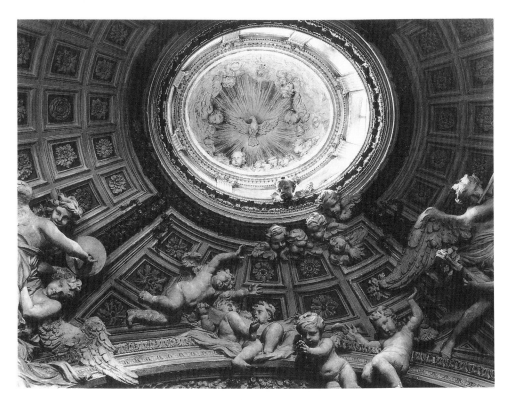

8. The Fonseca chapel, dome.

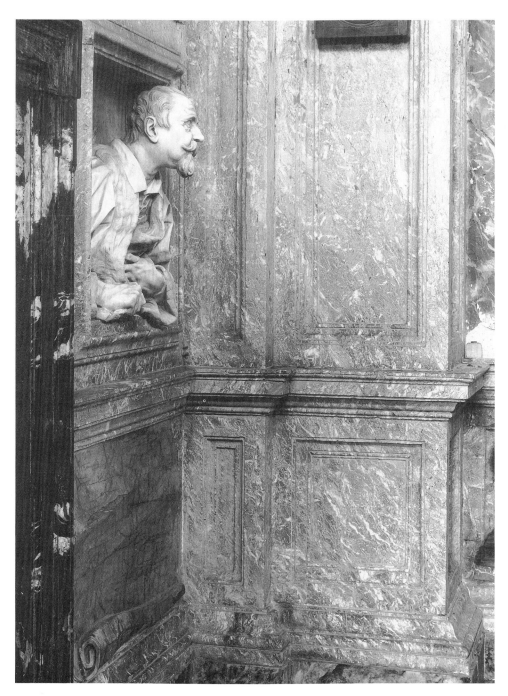

9. Gian Lorenzo Bernini, *Gabriele Fonseca*, 1674–75, profile.

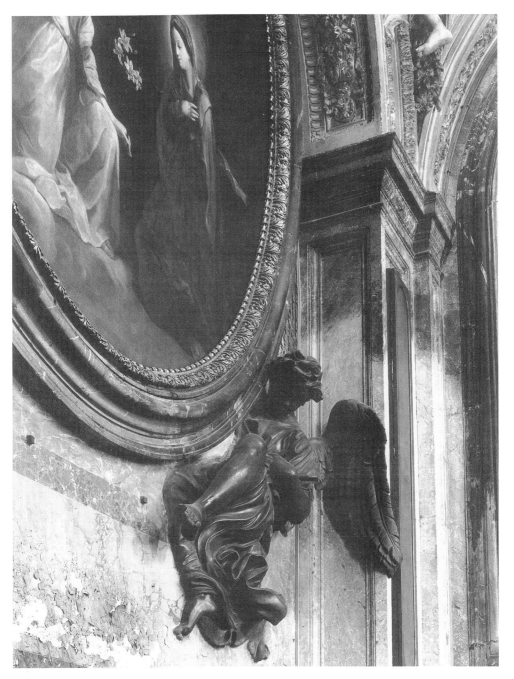

10. The Fonseca chapel, the angel on the right of the frame
as seen from the sculpture's point of view.

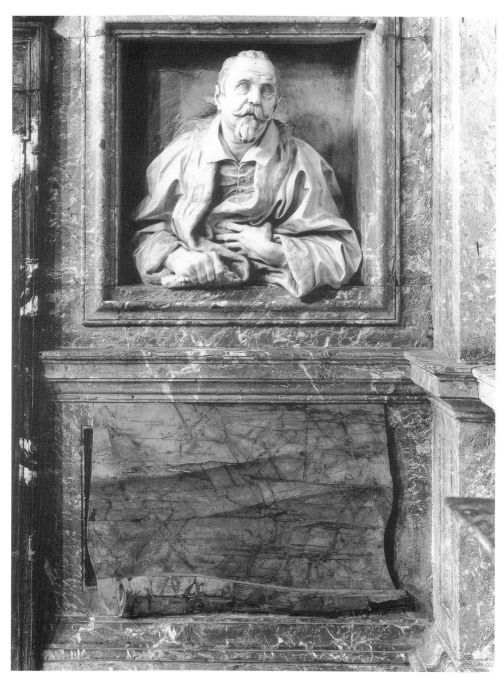

11. Gian Lorenzo Bernini, *Gabriele Fonseca*.

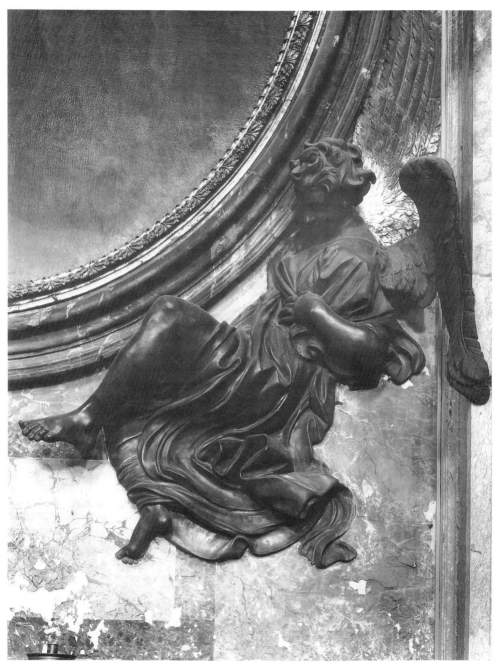

12. The Fonseca Chapel, the angel on the right of the frame.

13. The Albertoni chapel, San Francesco a Ripa, Rome.

Fulcite me floribus, stipate me malis, quia

14. Boethius a Bolswert, "Fulcite me floribus, stipate me malis; quia amore langueo," in H. Hugo, *Pia Desideria* (Antwerp, 1624), plate 32.

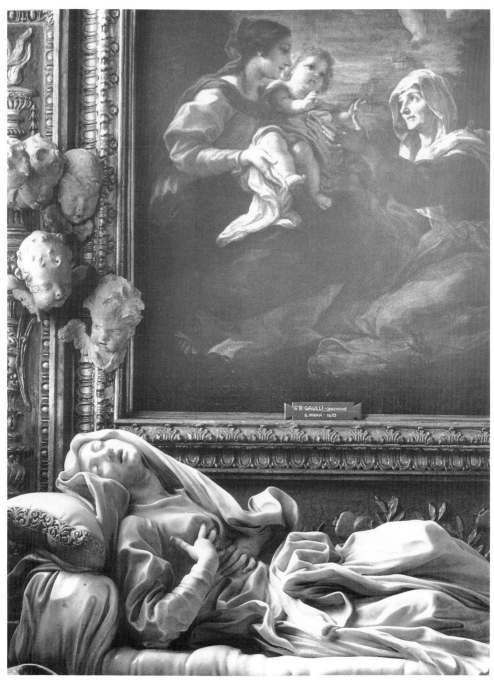

15. The Albertoni chapel, sculpture and altarpiece (detail).

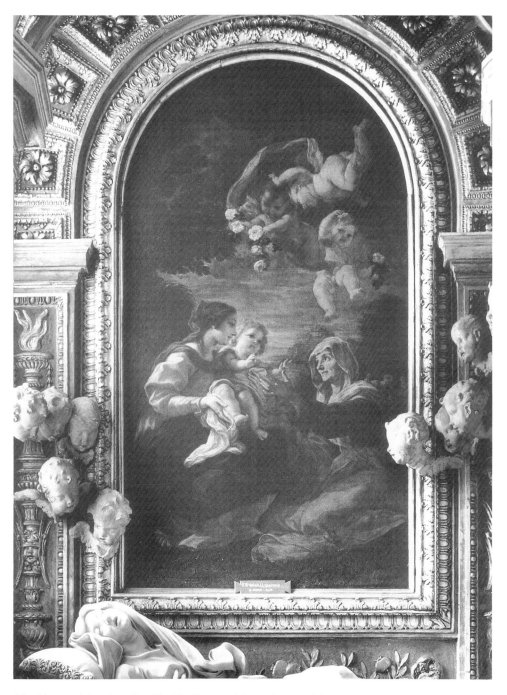

16. Giovanni Battista Gaulli, *The Virgin, The Infant, and Saint Anne*, 1674–75, Albertoni chapel, San Francesco a Ripa, Rome.

17. Giovanni Battista Gaulli, drawing of Bernini's *Blessed Ludovica Albertoni*, Musée Atger, Montpellier.

18. Gian Lorenzo Bernini, *The Blessed Ludovica Albertoni*, 1674.

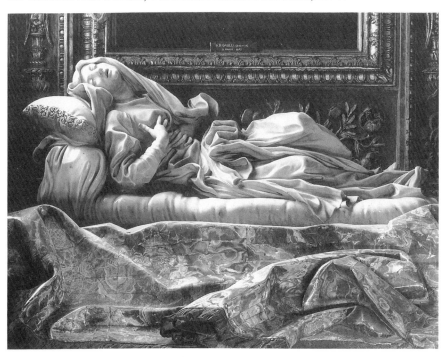

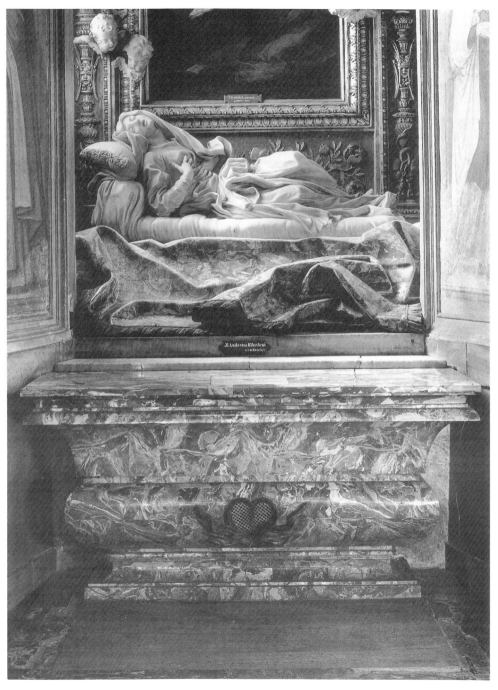

19. Gian Lorenzo Bernini, *The Blessed Ludovica Albertoni* with the altar.

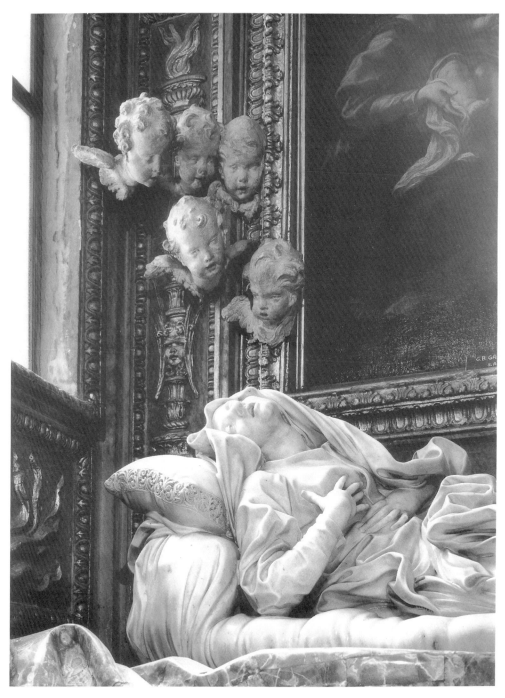

20. The Albertoni chapel, detail.

21. The Albertoni chapel, emblem of the heart located at the foot of the sculpture.

22. The Albertoni chapel, emblem of the heart set within the altar.

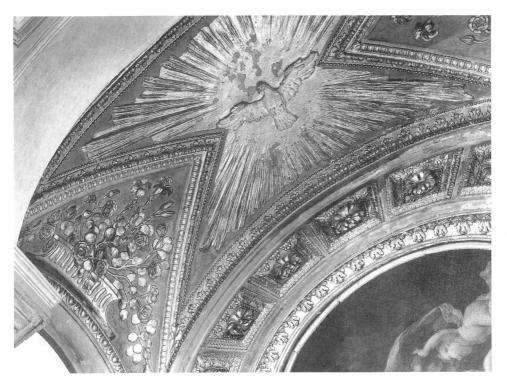

23. The Albertoni chapel, the roses on the vault.

24. The Albertoni Chapel, the pomegranates behind the foot of the sculpture.

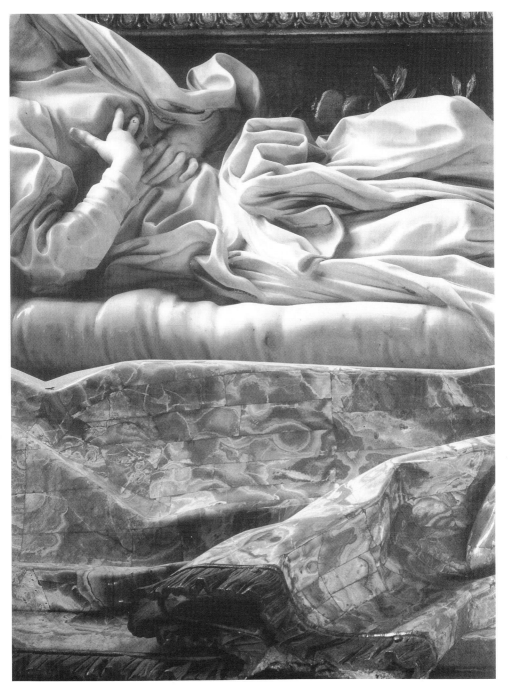

25. The Albertoni chapel, detail of the folds in the robe and the drapery.

26. a, b, c, d. The centrifuge scene from
S. M. Eisenstein's film *The Old and the
New*. These frames, selected by Pietro
Montani, were published in the Italian
edition of Eisenstein's *Natura non indif-
ferente* (Venice: Marsilio, 1981).

A

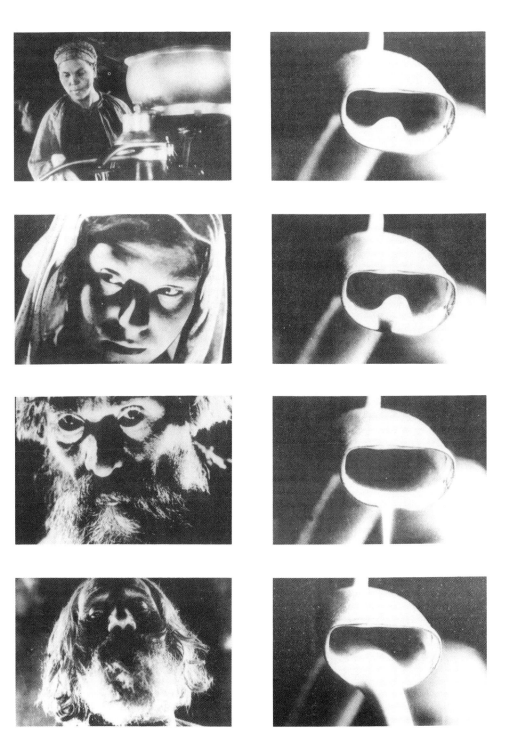

B

C

D

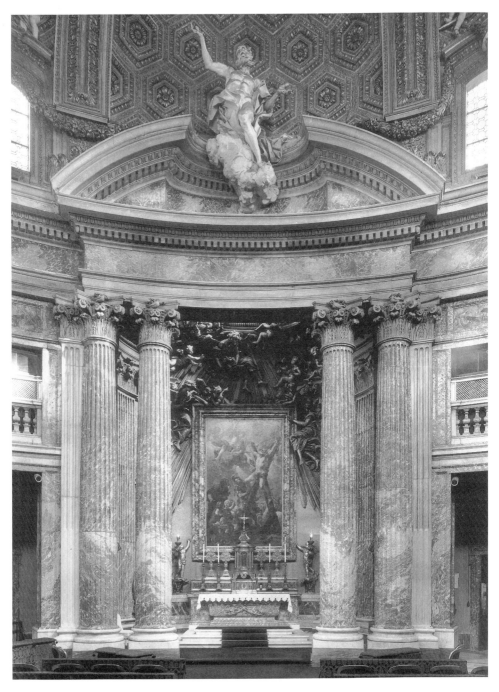

27. Gian Lorenzo Bernini, Sant' Andrea al Quirinale, the high altar.

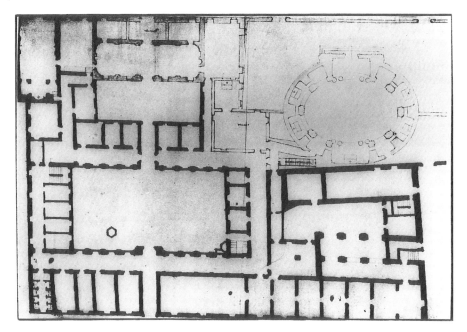

28. Sant' Andrea al Quirinale, original project (Vatican, cod. Chigiano 79 B).

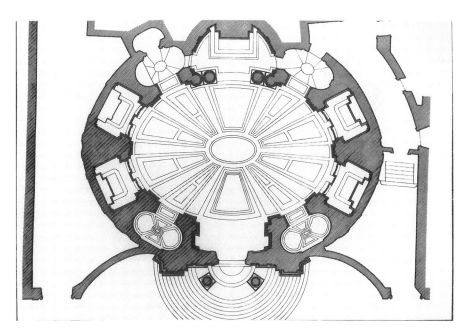

29. Sant' Andrea al Quirinale, plan by Franco Borsi, 1966.

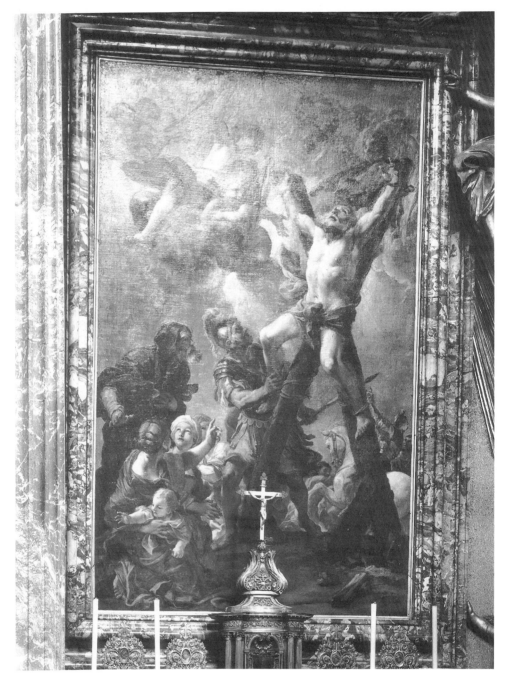

30. Guglielmo Cortese, *The Martyrdom of Saint Andrew*, c. 1670.

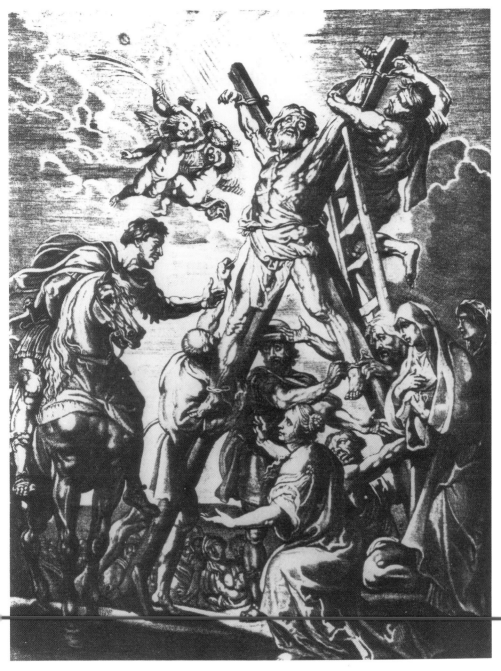

31. J. Dierckx, *The Martyrdom of Saint Andrew*, print copied from the painting by Rubens.

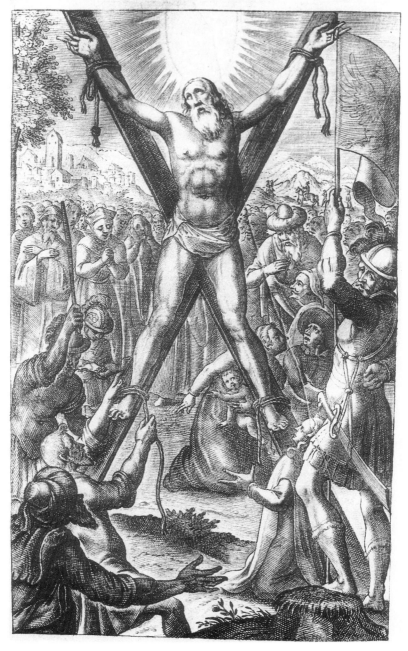

32. *The Martyrdom of Saint Andrew*, anonymous frontispiece from the first
volume of L. Richeome's *Livre de la peinture spirituelle* (Lyon, 1611).

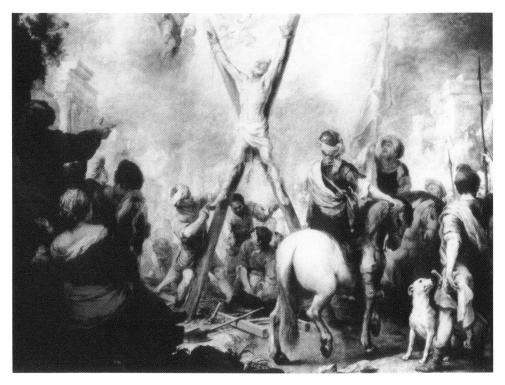

33. Bartolomé Esteban Murillo, *The Martyrdom of Saint Andrew*,
c. 1670, Museo del Prado, Madrid.

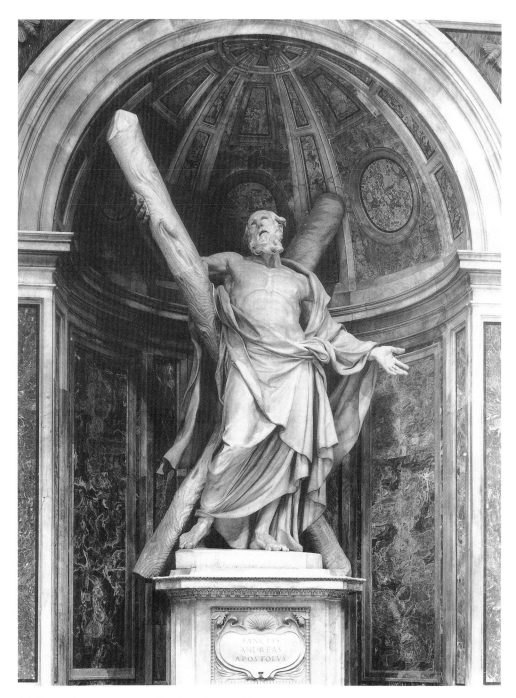

34. François Duquesnoy, *Sant' Andrea*, 1630, Saint Peter's, Rome.

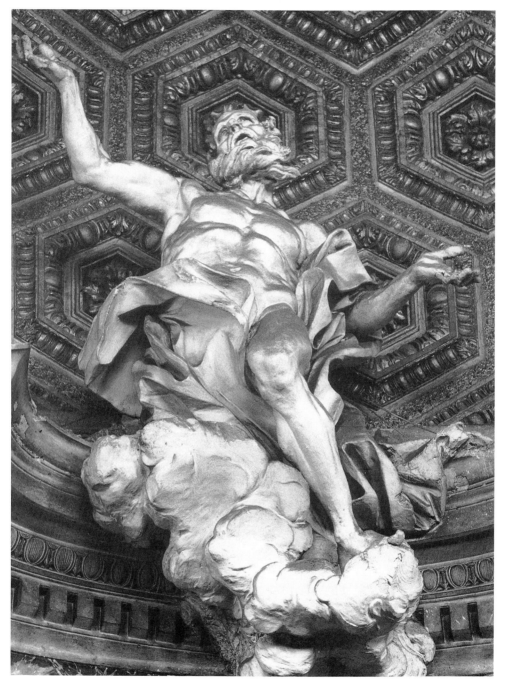

35. Antonio Raggi, *The Soul of Saint Andrew*,
after a Bernini drawing, Sant' Andrea al Quirinale.

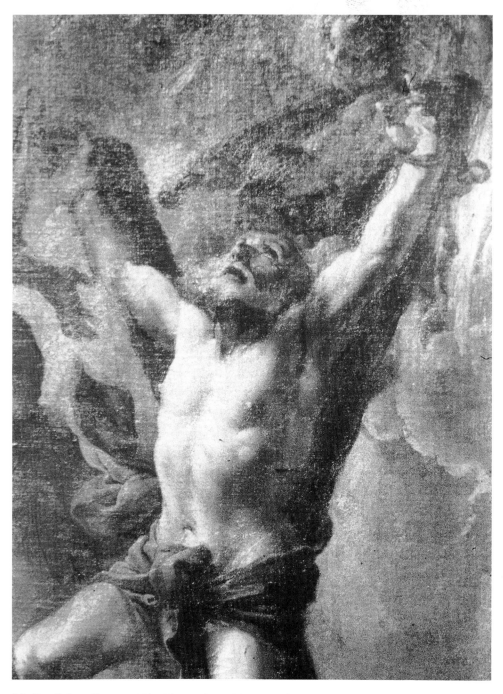

36. Guglielmo Cortese, *The Martyrdom of Saint Andrew*, detail.

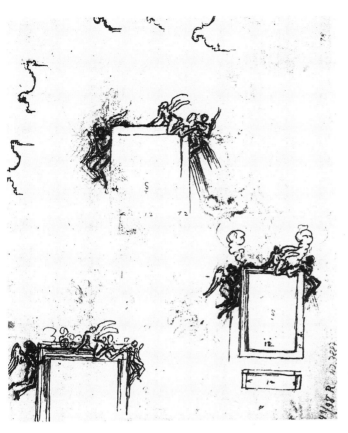

37–38. Gian Lorenzo Bernini, sketches of the angels for the altarpiece of Sant' Andrea al Quirinale. Museum der Bildenden Künste, Leipzig.

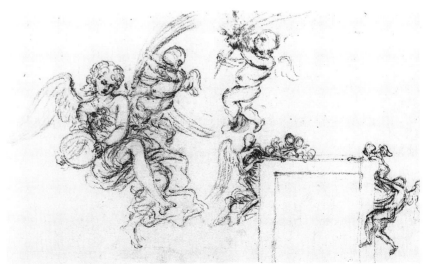

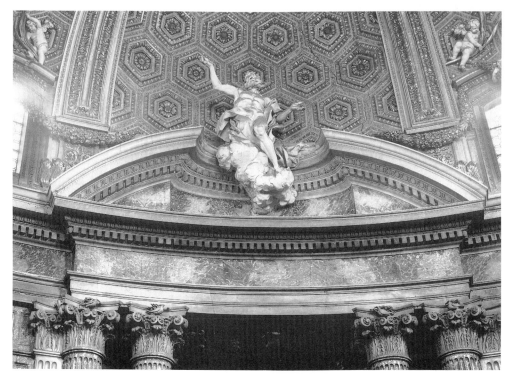

39. Sant' Andrea al Quirinale, the pediment.

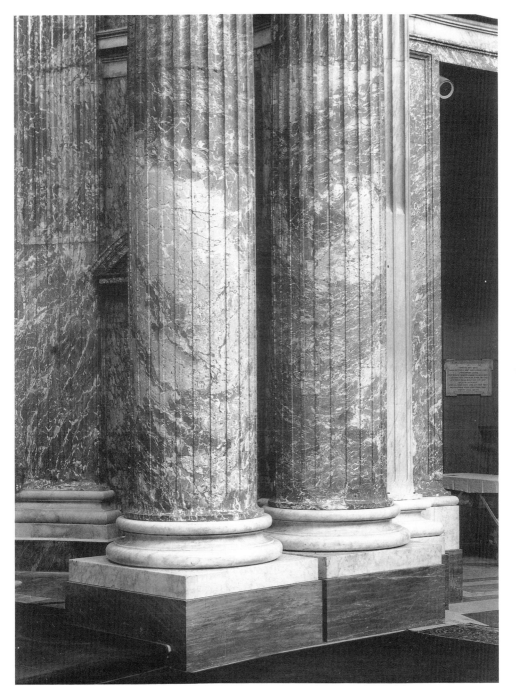

40. Sant' Andrea al Quirinale, the presbytery columns.

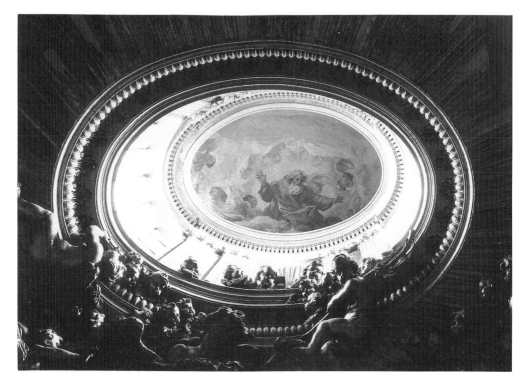

41. Sant' Andrea al Quirinale, the presbytery vault.

| The Altar of
Sant' Andrea al Quirinale

Unlike the Fonseca and Albertoni chapels, the church
of Sant' Andrea al Quirinale has been the focus of many
studies, especially by architects and historians of archi-
tecture. Although in limiting my analysis to the high
altar I may appear to be contradicting my own insistence in the previous
chapters on the need for a detailed yet all-encompassing approach, this ex-
ception to my self-imposed rule may be justified by a number of reasons.
First, my own contribution to the already copious mass of material concern-
ing Sant' Andrea intends to focus particularly on the church's original pur-
pose: its function as a part of the very first Jesuit edifice consecrated entirely
to the initiation of novices. This function is represented in the church pri-
marily by the passage leading from the door to the high altar. In addition,
the high altar is the only one in the church where sculpture joins with paint-
ing and architecture to create a *bel composto*, and it is precisely the sculpture
that allows the *bel composto* to dominate the entire architectural structure far
more powerfully than the lateral chapels can. I am not proposing here an
overall study of the church, but rather an analysis of how the *composto* works
and how it is integrated into a larger whole.

Sant' Andrea al Quirinale was constructed on the site that had provided
the location for the first Jesuit novitiate, founded in 1566 by General
Francesco Borgia. On this land, which the Bishop of Tivoli donated to the
Society of Jesus, there stood a small church dedicated to Saint Andrew,
erected in 1227. The dedication to Saint Andrew was retained for both the
original novitiate church and the one Bernini designed to replace it. The
founding of the Quirinal church was in keeping with the 1565 decision made
by the second general congregation of the Society of Jesus, requiring that
centers for novices be made separate from the professed houses and the col-
leges to which students outside the order also had access. This decision en-
forced one of the rules laid down by Ignatius of Loyola himself in the

Constitutions, demanding that all opportunities for contact between the novices and anyone not expressly designated by a superior be kept to a minimum. This confirms the exceptional importance that the Jesuits placed on the two-year trial period that all candidates had to undergo.[1]

A century after the bishop's donation, the Quirinal complex was still being used as a center for the initiation of novices. It is curious that neither Franco Borsi's monograph dedicated to this church, published in 1967, nor the subsequent exhaustive critical anthology stress the importance of this specific function of the church.[2] The gradual shift away from the bloody iconography that characterized the recreation rooms of the Quirinal novitiate before Bernini remodeled them, examples of which may still be seen today in the German college of Santo Stefano Rotondo, probably cooled the interest of scholars in "Jesuit iconography."

The long controversy between the Jesuit fathers and the various popes, who did not want an imposing structure to be built next to their palace, finally ended in 1658 when Alexander VII approved Bernini's project.[3] The construction of the church, financed by the pope's nephew, Camillo, was finished in the years 1668–70, when the two winged figures of Fame and the stucco work in the presbytery were completed. Although some of the paintings of the lateral altars were not finished until later, it may be said that the Quirinal church is exceptional in that Bernini exercised a great deal of control over all aspects of its realization. The oval plan of the church includes seven radial chapels, the most important being the one with the high altar, located on the short axis, directly opposite the entrance (figs. 28 and 29). The altar, set within a deep apse, is separated from the body of the church by two pairs of imposing columns supporting a monumental pediment (fig. 27). The chapel is both isolated and yet conspicuously brought to the viewer's attention by an autonomous lighting source in typical Berninian fashion: light filters in from a lantern located in the vault of the apse, which is invisible to anyone upon entering the church (fig. 41).

The altarpiece representing *The Martyrdom of Saint Andrew* was painted by the Jesuit Guglielmo Cortese under Bernini's supervision (fig. 30). The stucco work in the presbytery vault is by Giovanni Rinaldi while the putti and naked figures located on the junction of the vault are the work of Antonio Raggi. The sculpture portraying Saint Andrew in glory, also known as "the soul of Saint Andrew" (figs. 35 and 39) is by Raggi as well, but is probably based on a design by Bernini. The lateral chapels to the right of the entrance are dedicated to Saint Francis Xavier and to the Passion of

Christ. The ones to the left are dedicated to Ignatius of Loyola, Francesco Borgia, Luigi Gonzaga, and Saint Stanislaus Kostka.[4] In the frescoes decorating the sacristy vault by Giovanni De la Borde, the Jesuit saints in apotheosis are shown reunited with Saint Andrew. This reinforces the strong parallel between Saint Andrew, a martyr who died *for the faith*, and Francis Xavier and Stanislaus Kostka, martyrs *of the faith*, who died in ecstasy.[5]

The iconography of Bernini's church represents the new Jesuit tendency to replace images showing the tortures undergone by their representatives in faraway missions with an iconography depicting the mystical experiences of their new saints. The figure of Saint Andrew, characterized by his "ecstatic" death on the cross as described in the epistle of the priests and deacons of Achaia, was particularly suited to this new trend.

The Jesuit general Giovanni Paolo Oliva and Prince Camillo Pamphilj undoubtedly kept up a constant exchange of ideas with Bernini during the planning and construction of this church. Bernini's conversations with Oliva, of a highly theological nature, are mentioned by Domenico Bernini. Without the generous aid of Prince Pamphilj, such a rich ensemble of precious materials never could have been created.[6]

DECORATION VERSUS ARCHITECTURE

What is most interesting in the architectural studies devoted to Sant' Andrea al Quirinale is the debate concerning the relationship between the decorative value of the church and the purely spatial value of its interior. On one side we find scholars who, like Roberto Pane, criticize the ornate decoration of the church because it limits that sharply defined spatial distinction that every well-designed interior should have and at the same time masks its structural flaws.[7] On the other side are those who praise the scenographic merits of the decoration and the overall theatricality of the church. For Maurizio and Marcello Fagiolo dell' Arco, this theatricality is the key to understanding the characteristics of this church. In their view, here everything becomes theater; there are no contradictions between decoration and architecture nor leaps from one system of representation to another.[8]

In Franco Borsi's study, the conflict between decoration and architecture is considered for the first time as an intentional and constitutive element of the design. According to Borsi, for example, the host of angels serves to challenge the tectonic value of the architectural members.

> Conceiving the lantern as suspended upon the angels' wings reveals a desire to challenge—albeit superficially, through the decoration—the very meaning

of organic unity in the classical tradition. The role of the entire host of angels
seems to be that of commenting on and contesting the form that is defined by
the continuous rings of the cornices. The angel formation is interwoven with
the garlands decorating the ribs out of which the dome rises. In this way, the
dome seems suspended in miraculous equilibrium, supported by the angels in
flight who are attached to the ribs by their garlands.

This paradox challenges the deeply ingrained conformity to the institu-
tional aspects of classical language. While Borromini's angels always seem
rather disturbing and abstract, Bernini's are concrete and corporeal, the
agents of prodigious deeds, expressive of a theatrical flair. They are clearly in
some way the instruments of a dialectic in which forms gifted with the power
of flight pose a challenge to natural forms endowed only with weight and the
power to offer contrast to one another.[9]

Borsi points out that the presbytery lantern rests upon a "sky" full of
clouds and that the wall surfaces, "which in the classical tradition signify
barriers and closure, have become ambiguous surfaces here. The wall sur-
faces are both geometrical surfaces that correspond planimetrically to pre-
cise volumes and representations of the nonsurface, of emptiness, the open
sky."[10] Even the tectonic function of the Corinthian columns, load-bearing
elements par excellence, is challenged by the "overlaying of a dominant
chromatic texture: . . . on the one hand we have the continuous and constant
cagelike effect of the pilaster strips that define the spatial volume, and on the
other hand the chromatic-plastic elements that define and enrich the spatial
volume and dominate the expressive power of the architectural structure
itself" (fig. 40).[11] The sculpture of the apotheosis of Saint Andrew appears
to have caused the cornices of the pediment to "violently retract," thereby
rejecting the traditional and harmonious insertion of naturalistic or anthro-
pomorphic elements in the architectural structure (fig. 35).[12]

Concerning the project's history, both Pane and Borsi believe that Berni-
ni's early interest in the plan and in the internal and external architectural
structure later yielded to a far stronger interest in the internal decoration.
According to Pane, this caused Bernini to stray too far from the original
design; according to Borsi, it provided a fertile conflict. This way of working
is probably in keeping with the one Bernini followed in constructing the
Fonseca chapel, the early plans for which, as the Windsor drawing shows,
testify to a specific concern for the architectural structure; however, in its
actual realization, the chapel has been largely determined by the solution to
problems concerning its internal decoration.

We therefore can hope that Franco Borsi's thought-provoking analysis

will allow us to undertake a more detailed study of the "plastic group," which, as Pane writes, "holds the key to the whole composition." As in the Fonseca and Albertoni *composti*, the "decoration" of Sant' Andrea al Quirinale may be related to the spiritual transformation being experienced by its protagonist. In order to verify this hypothesis, we must first examine the altarpiece, which, like Guido Reni's *Annunciation*, is far too simple to have attracted the attention of "iconologists."

THE ALTARPIECE

Apud Patras Achaiae natalis sancti Andreae Apostoli, qui in Thracia et Scythia Christi Envangelium predicavit. Is ab Aegeae Proconsule comprehensus, primo in carcere clausus est, deinde gravissime coesus, ad ultimum in cruce suspensus et, rogato Domino ne eum sineret de cruce deponi, circumdatus magno splendore de celo, obscendente postmodum lumine, emisit spiritum.[13]

In Patras in Achaia was born Saint Andrew, the apostle, who preached the gospel of Christ in Thrace and Scythia. Arrested by the Aegean Proconsul, he was imprisoned, grievously ill-treated, and at last crucified. When the Proconsul was asked to remove him from the cross, a magnificent light descended from the sky, surrounding the saint, who then gave up the ghost.

Caesar Baronius briefly tells the story of Saint Andrew's life in his renowned *Martyrologium romanum*. Baronius, leader of one of the most massive campaigns of the Counter-Reformation calling for the revision of the lives of the saints, discusses the problems posed by the traditional story of Andrew's life in his *Annales Ecclesiastici*. He casts doubt on the authenticity of most of the texts in existence, some of which derived from gnostic sources and had been corrupted by the Manichaeans.[14] Although he confirms the validity of the epistle of the priests and deacons of Achaia, he refrains from transcribing it, stating that "as it is worthy to be read in church, it is known to everyone." This epistle provides the basis for the story of Andrew's life as recounted by Jacopo da Varazze in *Legenda aurea*. Varazze's text includes the important addition of an invocation to God uttered by Andrew, which was long thought to be the work of Saint Augustine.[15]

Imprisoned by the Roman proconsul, Andrew was tortured and crucified until an angry crowd of newly converted Christians convinced the proconsul to let him go. The apostle, however, asked to be allowed to remain on the cross because "he saw his King waiting for him." When the guards attempted to remove him from the cross, they found their arms inexplicably paralyzed. The miracle of the guards' paralysis is the direct result of

Andrew's invocation, which Jacopo da Varazze quotes from what he erroneously believed was a text by Saint Augustine. Despite its dubious authorship, the text is very interesting indeed.

> "Oh Lord," said Andrew, "do not let them take me down alive from the cross. The moment has come to give my body back to the earth. For as long as I have carried this burden, I have watched over it and have strived to be liberated from it, to be divested of this heavy garment [*iste gravissimo indumento spoliari*]. I know how heavy it has been for me to bear, how lazy and inclined to weakness it has been. You know how hard it has tried to distract me from the purity of contemplation, to awaken me from the sleep of your sweet tranquility. How it has made me suffer! I have tried as often as I could, kind Father, to resist, to fight back, and I have succeeded only thanks to your help. To you, oh Father, just redeemer, I return this deposit. Entrust it to another so that it may cease to be an obstacle to me. May it be preserved and returned on the day of the resurrection, so that you may obtain honor from its deeds. Entrust it to the earth so that I need no longer watch over it, so that I may incline with all my ardor toward you, the source of unending joy."
>
> After these words, a blinding light appeared in the sky for nearly half an hour, so that none dared look upon the martyr. When the light vanished, he was dead. Maximilla, bride of the proconsul, took the body of the saint and buried it with due honor.

Some of the elements found in this text also appear in *The Book of Spiritual Painting*, published by the Jesuit Louis Richeome in 1611, which describes an "ideal visit" to the old novitiate of Saint Andrew's. The author uses his descriptions of the paintings displayed in the novitiate to indicate the path that every novice must follow in order to become a good soldier of Christ. A study of this book will allow us to understand the exemplary meaning that the martyrdom of Saint Andrew had for the initiatory program of the Quirinal probation house.[16] Our visit begins with the altarpiece of the old church, illustrated in the book by an engraving (fig. 32). Andrew is introduced to the novice as a man who is just about to reach the finish line in his "race to imitate Christ." The tighter the bonds around his hands and feet, the faster this athlete of the faith can run, the greater his success in the battle. The ropes binding him indeed symbolize the vows that the novice must make when his trial period has ended. They refer primarily to the vow of obedience, in which he agrees voluntarily to renounce his own will and entrust all decisions regarding himself to his superior, the representative of Christ. Paradoxically, as Louis Marin has noted, the forging of the individual as the subject of a unique, divine experience may occur only through

the annihilation of the novice's personal will, "the strongest part of his soul," or rather of that aspect of himself that previously distinguished him from others before he joined the Society. The exercise of passive will leads the seeker toward the imitation of Christ, eliciting in each novice the same image: the Passion of Christ.[17]

As Richeome points out, the painter has captured the miraculous event of the soldier's paralysis. The figure of the soldier "bends to look at his half-dead hand, astonished by this accident." In the new altarpiece of Sant' Andrea al Quirinale, Guglielmo Cortese seems, at first glance, not to have included this episode of the story. But if we are to develop a keener and more expert eye, we must take into consideration not only the different ways the story may be broken into segments, but also the main iconographic variants in existence at that time. Aside from the painting and the engraving of the old Quirinal church, Cortese could also draw from the great fresco cycle in the apse of Sant' Andrea della Valle, painted by Mattia Preti in 1650–51, and from the equally famous sculpture by François Duquesnoy, created for the transept of St. Peter's under Bernini's supervision in 1630 (fig. 34). Also very important, due to their widespread diffusion, were the numerous engravings of *The Martyrdom of Saint Andrew* by Bartolomé Esteban Murillo (c. 1670) (fig. 33), and above all, Rubens's painting of the same subject for the Real Hospital di San Andrés de los Flamencos (fig. 31).[18]

The difficulty Rubens tackled here was that of representing the sudden paralysis of the guards' arms without having to use an anecdotal figure, extraneous to the main action, pointing to his own hand. This entailed the risk of creating a confusion between the miracle of "being unable to untie" with the opposite action of "tying." Rubens avoided this confusion by showing us guards with muscular arms in the act of performing gestures of great delicacy and grace. The figure on the ladder, who is clinging to the cross, holds the rope between his thumb and index finger as if he were holding a most fragile flower. Another guard points to the knot binding the martyr's right foot, barely touching it as he does so. But the most obvious means used to render this inhibiting of the action is the nontension manifest in the rope around the martyr's waist, which binds him to the cross. A fourth figure is pulling on the rope in the vain hope of undoing the knot. The paralysis of the guards' arms becomes less emphatic in the central fresco in the apse of Sant' Andrea della Valle, where Mattia Preti has divided the action of the saint's martyrdom into three paintings. In Murillo's painting, however, the episode of paralysis is represented in a much more ambiguous way. While

the figure on the right is reaching out to tie or perhaps is straining forward to untie the knot, the figure behind the cross seems to have run into some difficulty. In its composition, this painting is closer to the one by Cortese, yet Cortese, like Mattia Preti, has used only one soldier who is barely touching the saint's ankle in the unsuccessful attempt to untie him (fig. 30).

All the paintings in this series associate the saint's vision with the luminous aura enfolding him, which separates him from the witnesses to his crucifixion. In Duquesnoy's sculpture, the ecstatic characterization of the figure is conveyed through the sense of surrender expressed by the left arm and by the mouth, two features that Bernini has used in his statue of the apotheosis of Saint Andrew's soul. Bellori emphasized these same features in his *Life of Francesco di Quesnoy*: "The Holy Apostle lifts his head to admire the sky. Behind him are the two trunks of the X-shaped cross. He clutches one trunk with his right hand while the left relaxes and opens in an expression of affection and divine love in the glory of his martyrdom."[19]

Also in Cortese's large altarpiece, as in Rubens, the agony and ecstasy of Saint Andrew is rendered in the "tensive" figure of the saint's body in which the contracting of the legs and abdomen contrasts with the surrender of the head and hands. Cortese's use of Rubens's solution plays a decisive role in determining the status of the martyr's body. The moment of the guards' paralysis corresponds to the moment when Andrew finally abandons his body while continuing to cling to his vision of God. The miracle keeps the guards from interrupting the separation of the saint's soul from his body and disturbing his ecstasy. In this critical moment, Andrew is still alive, but he has gone out of his body and has obtained permission not to return.[20] His soul is still bound to the "heavy garment" of his flesh, but at the same time he is being irresistibly attracted out of his body.

The apparition of the white figure of Andrew's soul upon the presbytery pediment represents the projection of his spirit out of the painting, a flight already implied in the action depicted in the altarpiece of "martyrdom, vision, death." In fact, in the altarpiece, Andrew is already in contact with the divine and with death, and is also miraculously isolated from all contact with life and with other human beings. His figure has been removed from the spatial-temporal context of the scene, yet is still a part of it. Here we have a soul still bound to the flesh and yet already liberated from his physical body, a man who is both living and dead, a character who is the protagonist of a story from which he has already exited.

Like the emblem of the heart set in the altar of the Albertoni chapel, the

stucco sculpture of Saint Andrew's soul reveals what is going on *inside* the martyr's body: his soul is receiving and incorporating Divine Grace, and it is shedding its "heavy garment" in order to soar up into the sky. The sculpture represents the moment immediately following the action shown in the painting, yet, at the same time, it represents the selfsame situation freed from the paradoxes concerning the martyr's persistent corporeality. In the "leap" from martyrdom to apotheosis, the figure loses the violent emotion expressed in the conflict of body and soul and acquires the features of an unequivocal harmony and joy. Before we go on to see how the emotion lost during the leap from the painting to the sculpture reappears in other elements of the *composto*, let us dwell a little longer on the relationship between these two representatives of Saint Andrew (figs. 35 and 36).

The painted figure and the sculpted one are quite similar, but the slight differences between them are very significant. In his ascension Andrew spreads his arms and opens his hands in an expression of affection and divine love, to use the tensive terminology Bellori uses to describe Duquesnoy's sculpture. The emotional configuration of ecstatic self-relinquishment veiled by the "heavy garment" in the painting emerges in the surrendered attitude of the sculpture's pose. The passage from the painting to the sculpture is emphasized by the transitory and unstable figure of the "soul." The statue in flight in fact shares the weightlessness of the cloud that serves as its support and the multiformity of stucco. This yielding body breaks through the lines of the pediment that represents the last boundary between the earthly zone and the heavenly zone in the church. In this clash, we find, although in another form, the same conflict of body and soul so clearly present in the painting. The structure of the architectural body of the church is challenged and overcome by the antitectonic power at work within the body of the saint's soul. The drapery enfolding the sculpture, stylistically reminiscent of Guido Reni, expresses this same dynamic of collision with the pediment and seems to pose one last, useless obstacle to the statue's ascension.

THE ANGELS, FRAME, AND CORINTHIAN COLUMNS The opposition between the supernatural figures and the figures "endowed only with weight and the power to offer contrast to one another"[21] becomes more violent in those areas where the latter have been made purposefully large and heavy, as in the imposing marble frame of the altarpiece, which is carried by a small angel.

Bernini worked out the relationships between the angels and the frame in a series of sketches, which show that he considered the questions posed by these two elements as a single problem (figs. 37 and 38).[22] As in the Fonseca chapel, the presentation of the painting assumes a contradictory character. This contradiction appears when we study the two large angels situated above on either side of the altarpiece. The one on the left, looking at the apostle, invites the viewer to imitate him and shows us the proper emotion corresponding to this scene of martyrdom. The one on the right embraces the frame and seems to be starting right through it at the scene in the painting, as if his eyes could penetrate the heavy marble. The first angel presents the scene while the second, who serves to call our attention to the size and weight of the frame, testifies to the material nature of the painting. This second angel also challenges the impermeability of the frame by penetrating it with his gaze.

As in the Fonseca chapel, the painted image is displayed both as an artifact and as a real scene. The upper half continues out of the painting through the dense cluster of putti extending all the way up to the lantern while the lower half is enclosed within the limits of the frame. Moreover, the upper part of the altarpiece is slightly detached from the wall, thereby allowing two gilded rays of light to pass behind it. The fusion of the light from the lantern with the light of the painting is thus emphasized while the frame receives yet one more aggressive attack on its function as a limit. Its permeability to divine light is also manifest in the irregular splashes of light scattered in tiny islands across its molding, confounding the design. The interrelationship between the gilded rays, the frame, and the aura of light enfolding the saint allow us to grasp the meaning of the variegated Cotta-nello marble used for the Corinthian columns of the presbytery and also used to cover the walls of the church. The challenge to the tectonic structure launched by these variegated surfaces is yet another expression of the inner conflict and of the infusion of Divine Grace we have already observed in Saint Andrew's body.

The fact that the densest concentration of white speckles and veins in the marble is located on the prolonged axis extending from the two gilded rays passing obliquely through the sides of the frame of the altarpiece confirms this interpretation (fig. 27). The luminescent areas are concentrated in those points where the greatest pressure of the weight of the entablature is felt. The two pairs of columns are thus conceptually and chromatically associated with the large frame of the altarpiece, and they seem to be subject to the same hypertrophic phenomenon for the same reason. They have increased

in girth at the base in order to resist the violent challenge they have received. In stark contrast to the white pilaster strips, the Corinthian columns of the presbytery have turned to pink Cottanello marble. Their proximity to the site of the martyr's miraculous transformation has forced them to react by growing stouter at the bottom. This proximity is also what has caused them to take on a rosy coloration and has allowed the light to penetrate into the marble. The formal correspondences between the frame and the cornices are closely linked to what they intend to present to the viewer: the sacrifice of the Holy Eucharist and the sacrifice of Saint Andrew in the painting, which is an imitation of the former.

The isolation of the presbytery from the body of the church, its autonomous lighting, and the imposing display of the painting seem to justify those critics who describe the spatiality of this church in terms of a theatrical scene. However, the exuberance of the display devices is constantly in danger of obliterating any effect of illusion and rendering the artificiality of the *composto*'s elements even more conspicuous. As in the Fonseca chapel, this ambiguity of presentation has been calculated to correspond to the observer's situation and point of view.

THE NOVICE'S PATH TO INITIATION Andrew's vision of the Eternal Father (fig. 41), painted on the calotte of the presbytery lantern (the altar's source of all forms of light), is concealed from the view of the visitor to the church by the entabulature of the pediment (fig. 27). We must enter the space of the presbytery in order to see it, or rather to glimpse it through a screen of light or shadow, depending on the time of day. It is not easy to distinguish, for the light is either too bright or too dim. The concealment of this fresco from the eyes of the ordinary viewer has determined a privileged point of view enjoyed by those who stand in the space reserved for the officiating priest. This point of view is quite distinct from that of the worshipper attending mass who cannot see the calotte and is excluded from Andrew's vision of God. These two points of view—the inner and the outer—are joined by a path whose threshold stands at the access to the altar and to the semivisibility of God the Father painted in the lantern. Yet if we continue to the end of this path, we will lose sight of the apotheosis of Saint Andrew, which is not visible from inside the presbytery, and we will also lose sight of the scene of Andrew's martyrdom, now located behind us. Although the novice's probation is a process of preparation quite separate from the taking of holy orders, we cannot but note the "initiatory" value of the path leading from the outer point of view from

which we witness the celebration of the mass, the martyr's sacrifice, and the flight of his soul, to the inner point of view, where the priest stands while celebrating mass and where we may glimpse the image of our eternal Father with his angel host through a veil of light and shadow.

The distinction between the outer point of view set aside for the faithful witnessing the sacrifice and the inner point of view reserved for the individual directly involved in this sacrifice is also made evident in the painting itself, where the group of Christians on the right can see only the saint while the martyr alone can see God the Father.

The transformation of the witness into the officiating priest seems strangely enough to lead the novice to renounce his contemplation of Andrew as a saintly hero, as Richeome recommended in his book. This may be understood if we consider that during the celebration of the Holy Eucharist, the priest conforms to Christ in His sacrifice and has no need for intermediary models. But perhaps this renunciation of the figure of the hero corresponds on a deeper level to a very important moment in the experience of conversion, which Ignatius of Loyola proposed to all his followers as based on his own personal experience.[23] The account of this phase of his journey may be found in an autobiographical story recorded by Father Louis Gonçalves between 1533 and 1555. From the very outset of his conversion Ignatius wanted "to follow in the saints' footsteps, doing everything they had done and even more." This desire to imitate led him to see himself "as a saint," and, more particularly, to imagine himself as being similar to Saint Francis and Saint Dominic. But then one day this image was shattered, leaving behind only the fear for "this new life" and a feeling of self-surrender that would endure until "he should awaken when the Lord desired, as from a dream." Ignatius then renounced his self-image as a saintly hero and began to concern himself with the simple things of the body, with sleep and, with food. Although he previously had flaunted the appearance of a hermit, "he gave up these excesses and began to cut his hair and nails." From this moment on, he was to proceed very rapidly along the path to conversion, with many visions on the way.[24]

This experience seems to me to be related to the pathway joining the two points of view in the church of Sant' Andrea, where the renunciation of a model of sainthood leads the novice to a direct relationship with God. The imitation of Christ, beyond the image of oneself as a saint, seems to contradict the principle of conformation that has guided our analysis so far, and would seem to place the Jesuits in an almost iconoclastic position. In fact, according to my interpretation, for the Jesuits the image of the martyr (and

in the final analysis, any image-model) was merely a tool, useful for a certain part of the journey but destined to be discarded along the way.

The "purgative" function of images in Jesuit devotional practices has been discussed by Pierre Antoine Fabre, whose analysis of the history of the first attempts to illustrate the *Spiritual Exercises* has demonstrated that they were used primarily to dislodge images previously occupying the imagination.[25] In this process, one image was replaced by another, which paradoxically led to the creation of a place in the imagination devoid of images. This journey of purification and the concept of the image as tool it implies help us to understand the contradictions that emerged from our analysis of the presentation devices of the painting. In fact, here we are dealing with a place and a contemplative tradition in which we may presume the presence of a trained observer who, like Saint Ignatius, is able to free himself from the power of the image in order to seek conformity to Christ beyond the image.

The spectacle of the *composto* is conceived in such a way that it "moves" the spectator standing on the outer edges of its mechanism. The large frame and the angel carrying it inform the novice that what he is looking at is a representation. To replace this representation, he is offered the "secret" and unspectacular image of God the Father. Through the access to this vision, the observer is placed in the same situation as the saint on whom he has turned his back and, at the same time, is set apart from the Christian converts in the painting and from the other visitors to the church. The novice's renunciation of the image of the saintly hero, and of his own self-image of sainthood, concludes his virtual journey in the *composto* and is an integral part of the way the *composto* functions. The novice's gaze moves from the luminous spectacle of the altarpiece to the frescoed vault, veiled by the light streaming in from the lantern or by the gloom of night. This veil of light and shadow endows the frescoed image with a status that is entirely different from that of the altarpiece. The image in the fresco is semi-invisible: it attempts to surpass its own limits as an image in order to present the invisible as invisible and unrepresentable. Thus the fresco is not extraneous to the way the *composto* functions as a whole: it represents the place in which we find manifest the same tension that induces the *composto* to "go outside of itself," as we have already seen in the Fonseca and Albertoni chapels.

BEL COMPOSTO 3 The montage of the *composto* of the altar of Sant' Andrea al Quirinale makes use of some of the same mechanisms that we have already identified in our description of the Fonseca and Albertoni chapels. In relation to the Fonseca chapel, we may point out a few

comparable solutions to the problem of integrating the altarpiece into a larger cosmic scheme. In relation to the Albertoni chapel, we may identify a few similarities in the way ecstasy is portrayed. The uniqueness of the Sant' Andrea *composto* derives from the way it is integrated into the vaster complex of the church. Its inner mechanisms, in fact, extend beyond its own limits, dominating the architecture and determining the entire conception of the interior. The conflict between tectonic structure and decoration becomes more meaningful if we view it as a transposition of the conflict of soul and body taking place in Saint Andrew. The saint's leap out of the painting into the vault where the sculpture shatters and deforms the shape of the pediment is the most immediate and concrete expression of the contrast between the "natural forms endowed only with weight" of the architecture and the "forms gifted with the power of flight" of the decoration (fig. 39). The resistance the "heavy garment" of the body poses to the soul's ecstatic flight in the painting has become in the architecture an architectonic obstacle created by the pediment in an attempt to block the ascension of the stucco statue of Andrew's soul. The conflict between the tectonic forces and the powers of Grace produces in both the architecture and the decoration a sort of pathos that is expressed in the retraction of the cornices of the pediment, in the enlargement of the base of the Corinthian columns, and in the coloration of the marble. These are all "tensive" expressions of the martyr's physical and emotional strain designed to have an emotional impact on the viewer.

The principle of the nonindifference of materials finds a new application here. For example, it is no mere chance that Andrew's soul is made of stucco, like the cloud on which it rests, just as it is no mere chance that the soul has been rendered three-dimensionally as a sculpture, for only in this way can it manifest a transitory state and at the same time challenge the obstacles posed by the architecture. Only in this way can it embrace the ellipse of the entire church. The painting "goes outside itself" to produce the sculpture, which in turn generates through its upward movement and its outstretched arms the entire architectural volume. The conflict of body and soul is progressively resolved in the journey upward, which virtually concludes in the lantern of the vault where the gold of the decoration mingles with the natural light. Even the architecture seems to want to "go outside itself" in order to reach that boundless space of pure light.

Juxtaposed to this marvelous spectacle of the generating of the church—from the high altar to the lantern of the vault—we find the secret image of

the fresco located in the calotte of the presbytery. The novice who is admitted here may contemplate this vision as it appeared to the martyr and participate in his sacrifice, but to do so he must renounce his image of the saint and his own pretensions of saintliness. Only then, according to the teaching of Saint Ignatius, will he be allowed to glimpse a deeper image of himself, in imperfect resemblance to the Christ of the Passion.

CONCLUSION
Flights of Love

Rays of sunshine are transformed into emblematic rays of gold, into white stucco and painted light, into the milky filaments of variegated marble surfaces, into the hidden light glowing deep within painted bodies and those made of stucco, marble, bronze, and flesh.

The light invades souls who unfold at its touch and begin to rebel against the restraints of their flesh, causing their bodies to move and filling them with an uncontainable emotion that is manifest not only in the undulations of drapery, shadows, and sculpted members but also in the architectural members and in the body of the worshipper himself. There in between the light and shadow surrounding a marble body or a painted scene the architectural space is defined and given form. Figures step out of paintings and are transformed into sculptures of bronze, marble, and stucco. The poses of the angels, saints, and blessed circulate, become incarnate, and grow distinct as they are deformed by the impact with matter.

In the worshipper's act of contemplation, the postures of physical bodies are transformed and recomposed into spiritual attitudes, into postures of the soul. The souls of the devout come to resemble the souls of the saints who have surrendered to God. The incorporation of Divine Grace induces the soul to go outside itself, to abandon its sheath of flesh, or to move within its "heavy garment," causing the exterior to twist and turn. Tension and surrender, the inner infusing of grace and the going outside oneself in ecstasy: the flux of these two movements alternates throughout the heterogeneous elements of the *composto*, causing it to contract and expand. The bodies of Gabriele Fonseca, Ludovica Albertoni, and Saint Andrew are but membranes subject to pressure from within and infusion from without. Each of these three bodies applies its own particular resistance to the boundary that separates these two currents; each one undoes itself and then reassembles itself in a constantly changing equilibrium.

The "mechanics of fluidity" governing the *composto* work within the jux-

taposition of the two basic elements underlying the sculptures' postures: action or passion, acting or being acted upon. Moving back and forth from one to the other, the posture breaks down into two parts: the action that first characterized it in its original situation is neutralized while passion is preserved and further developed. The action thus becomes so reduced that it may offer only the slightest resistance to the "action" of passion. When the posture is taken up by marble or the draperies, the passive component acts in opposition to their tectonic function and to their impermeability, producing creases and speckles of light. Emotion is the product born of this conflict between action and passion. The Corinthian columns of Sant' Andrea increase in girth in order to reinforce their function of support against the aggression of the milky body of light that has penetrated into them and weakened them. Like the figures, the columns both act and are acted upon.

Two opposing forces meet in the *composto*—a movement toward the generalization and simplification of pathos, which is expressed in the architecture, and a contrary movement toward a unique and complex emotion, expressed by the figures. The vehicles of this dynamic are the leaps from one material to another and the conversions from one system of representation to another. The unique tension of an emotion is fixed in an emblem, explained by a story, and then once again transformed into emotion. The combining of codified elements with more ambiguous ones is the very essence of the *bel composto* and determines the modalities of its reception. Guided through the *composto* by the montage of the arts, the observer undertakes a journey of contemplation encompassing both intellect and passion. The believer is urged to leave behind the consolation of images in order to let himself be filled by the inner, secret, and inimitable image of Christ. In contemplation, the *composto* tends to "go outside itself," in its own ecstasy becoming the vehicle of an experience that goes beyond all images.

The three ensembles that we have described belong to the same season of the spirit. It is a season in which the passivity of the soul in receiving Divine Grace becomes so extreme as to alarm the Holy Inquisition. These are the years of the quietist controversy in which training in the *Spiritual Exercises* is considered as an efficient remedy for Molinos's easy recipe for ecstasy. The need to determine the correct attitude of the soul between action and passion becomes the focus of attention. The Holy Inquisition weighs each adjective, ponders every adverb in the tracts written on this subject, and draws a distinction between those who claim that the soul is tranquil and passive and those who claim that it is more passive than active. The spiritual

authors calculate anew the degrees on the "ladder of perfection," measuring the degree of intensity proper to each rung and increasing their precautions without ever abandoning the model shared by all: the "race" to conformity. The Jesuits continue to defend their supremacy and their control over the initiation of acolytes into the practice of mental prayer. But if the Church insists that the gifts of mystical union can be acquired neither rapidly nor mechanically through the practice of the exercises proposed by the quietists, they do so in order to preserve the authenticity of their own members' mystical experiences. Indeed, during the last quarter of the century, the number of ecstatic experiences multiplied, the martyrs of *incendium amoris* were beatified, and the founders of modern devotion were glorified: Teresa of Avila, John of the Cross, Ignatius of Loyola, Francis Xavier, Philip Neri, Carlo Borromeo, Francis of Sales. . . .

Action and passion, attitude of the body and posture of the soul, composition of the figure in representation and composition of the spirit through the act of contemplation. The soul and the body are never definitively separated. The body signifies the soul and at the same time resists it. The soul wishes to abandon the body, but remains imaginary and retains the body's form. Emotion circulates freely, trespassing the boundary between the body and the soul.

Active conformity and passive surrender. Passive will and the active annihilation of the will. The structure of each of these three ensembles, each in its own way, is stretched taut between the two poles of a posture that breaks down into passion and action and then is made whole again. Creases and variegations are its purest features, the simplest and most abstract expressions of its tensive construction. The figures are unique compositions made of creases and splashes of light; the architectural space folds and bends and is colored by light and shadow. The interplay of emblem and flesh, the conceptual and the sensorial, the general and the particular, provokes a flood of waves one upon the other, emerging and disappearing in an unending rhythm.

NOTES

Introduction

1. Filippo Baldinucci, *The Life of Bernini* (University Park: Pennsylvania State University Press, 1966).

2. Maurizio and Marcello Fagiolo dell' Arco, *Bernini: una introduzione al "Gran teatro barocco"* (Rome: Bulzoni, 1967).

3. Leonardo da Vinci, "Conclusione del Poeta, del pittore e del musico," chap. 28 of *Trattato della pittura*, in *Scritti*, ed. Jacopo Recupero (Rome: Editrice italiana di cultura, 1966), p. 41.

4. Marcello Fagiolo dell' Arco, "La 'maravigliosa composizione': Bernini e l'unità delle arti," in *Gian Lorenzo Bernini e le arti visive*, ed. Fagiolo dell' Arco (Florence: Enciclopedia Italiana, 1987), p. 9. In this article, Fagiolo dell' Arco uses the term *composto* to refer not to Baldinucci's formulation but to Domenico Bernini's elaboration of this term, where it is modified by the adjective *maraviglioso* (marvelous). Fagiolo stresses the "marvel" created by the *composto*, emphasizing the theatrical character of Bernini's work, a subject he previously treated in his 1967 book *Bernini*. I. Lavin outlined the meaning of *composto* in his introduction to *Bernini and the Unity of the Visual Arts* (New York and London: The Pierpont Morgan Library and Oxford University Press, 1980).

5. G. P. Oliva, *Sermoni domestici detti privatamente nelle Case Romane della Compagnia da Gio, Paolo Oliva* (Venice, 1673), p. 218.

6. S. M. Eisenstein, *La natura non-indifferente*, ed. Pietro Montani (Venice: Marsilio, 1981).

7. Montani discusses the relation between the notion of the "non-indifference" of nature and Vygotsky's theory of internal discourse in his introduction to *La Natura non-indifferente*, pp. xxvi–xxix.

8. The *appareil formel de l'énonciation* is a linguistic device that inscribes the speaker's position and relationship to the message and situation of a spoken or written discourse. See Emile Benveniste, *Problèmes de linguistiques générales* (Paris: Gallimard, 1983), 2:79–88.

9. The term "theoretical object," employed by H. Damisch and L. Marin, was the subject of two seminars held at the Centro Internazionale di Semiotica e Linguistica in Urbino in 1979 and 1989.

Chapter One

1. R. Wittkower, *Gian Lorenzo Bernini: The Sculptor of the Roman Baroque*, 3d ed., rev. H. Hibbard and M. Wittkower (Oxford: The Phaidon Press, 1981), p. 256.

2. U. Donati attributes the stucco decorations to Giovanni Rinaldi (Donati, "Gli autori degli stucchi in S. Andrea al Quirinale," *Rivista del R. Istituto di Archeologia e Storia dell' Arte*, 1940, 144–50).

3. D. S. Pepper, *Guido Reni* (Oxford and New York: The Phaidon Press, 1984), p. 38.

4. J. Dobias, "Gian Lorenzo Bernini's Fonseca Chapel in San Lorenzo in Lucina, Rome," *The Burlington Magazine* 120 (1978): 65–71. Dobias proposes a revision of the theories developed by D. Graf and E. Shleier in "Some Unknown Works by Guglielmo Cortese," *The Burlington Magazine*, 115, (1) 1973, 794–801.

5. Fonseca's will, rediscovered by I. Lavin, is preserved in the Capitoline Archives, Not. 30 Capitolini, Sez. 19, Notary J. B. Rondinus, 10 December 1668, Envelope 56, *Testamenta & Donationes ab anno 1667 usque 1672.*

6. Dobias does not take these two elements into consideration.

7. See B. Brocher, "L'iconographie du Carmel," in *Carmelus*, vol. 2 (Rome, 1955), p. 92.

8. See, for example, the *Life* of Saint Teresa of Avila (chapter 11, 6°).

9. See Fonseca's will, mentioned above.

10. Dobias, "Gian Lorenzo Bernini's Fonseca Chapel, p. 70."

11. G. L. Bernini, *Drawing for the Altar of the Fonseca Chapel*, Royal Library, Windsor Castle, 5599, reproduced in Wittkower, *Gian Lorenzo Bernini*, p. 256, plate 113.

12. One can see immediately that the color and position of this rectangle repeats the rectangular shape of the altar below, which encloses a host with cross from which irradiate arrows of light. The similar chromatic treatment and spatial arrangement of these two elements provide the key to the meaning of the upper rectangle. At the moment of the elevation of the host, the "upper altar," like the one below it, receives the transfigured body of Christ and encloses it within a black rectangle. Like the Virgin's halo, the two altars contain a luminous zone surrounded by a darker area. They, too, obey the rule of the *composto* in which the mystery of the Incarnation is represented as a source of light surrounded by darkness.

13. P. Freart de Chantelou, *Journal de voyage du Cavalier Bernini en France* (Paris: Pandora, 1981), p. 61.

14. G. P. Bellori, *Le vite de' pittori scultori e architetti moderni* (Florence, 1672; Turin: Einaudi, 1976), pp. 501–2.

15. The relationship between the perspective grid and the cloud, "body without substance," has been examined by H. Damisch in *Théorie du nuage* (Paris: Seuil, 1972).

16. J.-L. Chretien, "Le language des anges selon la scolastique," *Critique* 387/88 (1979), p. 672.

17. See, in particular, J. Molanus, *Tractatus de angelis* (Lovanii, 1583), pp. 192–93; Molanus, *Scolasticorum Theologorum in Thomae Aquinatis Summam*, vol. 4 (Coloniae Agrippinae, 1618); F. Suarez, "De angelis," in vol. 2 of *Opera omnia* (Paris: Vivés, 1856); and D. Petau, *Opus de theologicis dogmatibus*, vol. 4 (Paris: Vivés, 1864).

18. I have borrowed Albertus Magnus's scholastic definition of the Incarnation— *mirabilis operatio*—from G. Didi Hubermann, "L'hymen et la couleur, figures médiévales de la vierge," *La parte de l'oeil* 4 (1988): 14.

19. I. Lavin, *Bernini and the Unity of the Visual Arts* (New York and London: The Pierpont Morgan Library and Oxford University Press, 1980).

20. Thomas Aquinas, *Summa Theologica*, Ia, q. LII.

21. Concerning the frame, see C. Brandi, "Togliere o conservare la cornice come problema di restauro," *Bollettino dell' Istituto Centrale di Restauro*, 36 (1958): 143–48 and G. Careri, "L'ecart du cadre," *Cahiers du Musée d'art Moderne* 17/18 (1986): 159–67. The motif of two angels bearing a painting may also be found in Roman funerary art, where two winged victories carry a portrait up to heaven. The idea of a "glorious apotheosis" is also expressed in the case we are examining, although it is difficult to conceive the apotheosis of a narrative scene. See G. Berefelt, *A Study of the Winged Angel, the Origin of the Motif* (Stockholm: Alnquist & Wiskell, 1968).

22. C. S. Peirce, "Elements of Logic," in *Collected Papers*, 8 vols., ed. Charles Hartshorne and Paul Loriss (Cambridge, Mass.: Harvard University Press, 1931–58), 2:306.

23. Wittkower, *Gian Lorenzo Bernini*, p. 30.

24. H. Hibbard, *Bernini*, 3d rev. ed. (Harmondsworth: Penguin Books, 1981). p. 217.

25. See M. Petrocchi, *Il quietismo italiano nel seicento* (Rome: Edizioni di Storia e Letteratura, 1948).

26. F. M. Catherinet, "Conformité à la volonté de Dieu: époque moderne," in *Dictionnaire de Spiritualité*, 16 vols. (Paris: Beauchesne, 1932–xx), 2:1457–61.

27. P. Le Gaudier, *De perfectione vitae spirituali* (Paris, 1643): 626–30.

28. See Lavin, *The Crossing of Saint Peter* (New York: New York University Press, 1968).

29. G. P. Oliva, *Prediche dette nel Palazzo apostolico da Gio. Paolo Oliva e dedicate ad Alessandro VIII*, X, (Rome, 1659).

30. "Une tendance motrice sur un nerf sensible" is H. Bergson's definition of emotion as developed by G. Deleuze in *L'image mouvement* (Paris: Minuit, 1983). I found Deleuze's ideas concerning the representation of emotions and his phenomenological descriptions of "image emotion" extremely stimulating for my own analysis.

31. J. Marechal, "Applications des sens," in *Dictionnaire de Spiritualité*, 1:810–28.

32. See ibid., and M. Olphe-Gaillard, "Contemplation au XVIème siècle," in *Dictionnaire de Spiritualité*, 2:2023–24. This subject is treated in the spiritual writings of Balthasar (1533–80) and Everard Mercurian (1514–80) in particular. This same topic is also dealt with on a more theoretical level in A. Gagliardi's *Commentarii seu explanationes in Exercitia Spiritualia*, ed. Van Aken (Bruges, 1882). See also F. Suarez, *De religione societatis Jesu*, (Paris: Vivés, 1859), 9.5–7.

33. Ignatius of Loyola, *Esercizi Spirituali*, trans. Giovanni Giudici (Milan: Mondadori, 1988).

34. Bernini's relationship to the Jesuits has been examined from several points of view by R. Wittkower and I. B. Jaffe in *Baroque Art: The Jesuit Contribution* (New York: Fordham University Press, 1972). Wittkower and Jaffe devote much space to a discussion of the Jesuits as patrons of the arts, but they do not examine the relationship between Bernini's works and the forms of mental prayer typical of the *Spiritual Exercises*. R. Kuhn has proposed a Jesuit reading of a few of Bernini's works and has explored the extremely close relationship that linked Bernini to Giovanni Paolo Oliva. See Kuhn, "Die Unio mystica der Hl. Therese von Avila von Lorenzo Bernini in der Cornarokapelle in Rom," *Alte und moderne Kunst* 12 (1967): 2–8. See also Kuhn's "Gian Lorenzo Bernini und Ignazio von Loyola" in *Argo: Festschrift fur Kurt Badt*, ed. M. Gosebruch and L. Dittmann (Cologne, 1970), pp. 297–323, and "Gian Paolo Oliva und Gian Lorenzo Bernini," *Romische Quartalschrift fur christliche Altertumskunde und Kirchengeschichte* 64

(1969): 229–33. Kuhn attempts to shed light on the characteristics of an iconography that bears specific references to texts written by the Society and to the basic concepts of Jesuit theology.

35. See P. A. Fabre, *Le lieu de L'image* (Paris: Vrens EHFF, 1991).

36. Ibid.

37. Lavin, *Bernini and the Unity of the Visual Arts*, p. 13.

38. F. Baldinucci, *The Life of Bernini*, trans. C. Enggass (University Park: Pennsylvania State University Press, 1966), p. 74.

39. D. Bernini, *Vita del Cavalier Gian Lorenzo Bernini* (Rome, 1713).

40. J. Nadal, *Platicas espirituales*, ed. M. Nicolau (Granada: Facultad Teologica de la Compania de Jesus, 1945).

41. Baldinucci, *Vocabulario Toscano dell'arte del Disegno* (Florence, 1681), in *Opere di Filippo Baldinucci* (Milan, 1809), 12:72.

42. The autonomy of posture is clearly visible in the paintings of Caravaggio, where the effects of the lighting isolate the body from the spatial and narrative context of the painting, thereby calling attention to the rich meaning of the posture.

43. See E. Panofsky, "Die Scala Regia und die Kunstanschauungen Berninis," *Jarbuch der preuszischen Kunstammlungen* 40 (1919): 241–78, and E. Barton, "The Problem of Bernini's Theories of Art," *Marsyas* 4 (1945–47) 81–111.

44. Ibid.

Chapter Two

1. Gaspare Celio's painting was later transferred to the Altieri Palace. Today all trace of it has been lost. See K. S. Perlove, "Blessed Ludovica Albertoni and Baroque Devotion" (Ph.D. diss., University of Michigan, 1984), p. 43.

2. R. Wittkower, *Gian Lorenzo Bernini: The Sculptor of the Roman Baroque*, 3d ed., rev. H. Hibbard and M. Wittkower (Oxford: The Phaidon Press, 1981), pp. 257–59. See also V. Martinelli, "Novità Berniniane. Le sculture per gli Altieri," *Commentari* 10 (1959): 221, and Martinelli, *Il seicento europeo* (Rome, 1957), pp. 257–58, cat. 338, plate 84.

3. H. Brauer and R. Wittkower, *Die Zeichnungen des Gianlorenzo Bernini* (Berlin, 1931), n. 128a and n. 93.

4. G. B. Gaulli, *La Beata Lodovica Albertoni*, Musée Atger, Montpellier.

5. Concerning the *bozzetto* preserved at the Hermitage, see Martinelli, *Il seicento europeo*, pp. 257–58, and N. Kosareva, "A Terracotta study by Gianlorenzo Bernini," *Apollo* (December 1974): 480–85. The London *bozzetto* is discussed by M. Mezzatesta, *The Art of Gianlorenzo Bernini: Selected Sculptures* (Fort Worth, Tex.: Kimball Art Museum, 1982), plate 10.

6. *Processo Apostolico per la beatificazione di Ludovica Albertoni: positio super dubis . . .* (Rome, 1671); Giovanni Paolo da Roma, *Vita della Beata Lodovica Albertoni Piermattei Paluzzi del terz'ordine di San Francesco* (Rome: for Giuseppe Corvo, 1672); B. Santini, *I voli d'Amore* (Rome: for Cardinal Altieri, 1673).

7. F. H. Sommer, "The Iconography of Action: Bernini's Ludovica Albertoni," *The Art Quarterly* 33 (1970): 30–38.

8. H. Hugo, *Pia Desideria* (Antwerp, 1624).

9. Ibid., p. 227.

10. Sommer, "The Iconography of Action," p. 35.

11. Perlove, "Blessed Ludovica."

12. Trithemius, *Carmen de sanctissima Anna*, ex castro heidelbergensi, kalendas februarii, 1512.

13. Perlove, "Blessed Ludovica."

14. M. Baxandall, *Patterns of Intention: On the Historical Explanation of Pictures* (New Haven, Conn.: Yale University Press, 1985).

15. Santini, *I voli d'Amore*, p. 7.

16. H. Hibbard, "Lodovica Albertoni: l'arte e la vita," in *Gianlorenzo Bernini e le arti visive*, ed. Marcello Fagiolo dell'Arco (Florence: Enciclopedia Italiana, 1987).

17. Teresa of Avila, *Relazioni spirituali*, in *Opere* (Rome: Postulazione Generale dei Carmelitani Scalzi, 1949).

18. Teresa of Avila, "Pensieri sull' amor di Dio," in ibid., p. 1437.

19. T. de la Cruz, "L'extase chez sainte Thérèse d'Avila," in *Dictionnaire de Spiritualité*, 16 vols. (Paris: Beauchesne, 1932–?), 2151–60.

20. Ibid.

21. Hibbard, *Bernini*, 3d ed. (Harmondsworth: Penguin Books, 1981), 220ff.

22. This may be deduced from the Leipzig sketch. See Brauer and Wittkower, *Die Zeichnungen des Gianlorenzo Bernini*, n. 93a.

23. G. Deleuze discusses the correlation between decontextualization and the development of the "virtual conjunctions" of the emotions in *L'image mouvement* (Paris: Minuit, 1983), p. 146ff.

24. Wittkower, *Gian Lorenzo Bernini*, plate 76.

25. Concerning the intimate relationship between death and ecstasy, see the passage below from Santini, *I voli d'Amore*.

26. Deleuze develops the idea of the "intensive series" as a characteristic feature of emotional expression in *L'image mouvement*, p. 125ff. This notion is implicit in S. Eisenstein's *Nonindifferent Nature*. See *La natura non-indifferente*, trans. and ed. Pietro Montani (Venice: Marsilio, 1981).

27. Santini, *I voli d'Amore*, pp. 27–29.

28. Sommer, "The Iconography of Action."

29. I. Lavin, *Bernini and the Unity of the Visual Arts* (New York and London: The Pierpont Morgan Library and Oxford University Press, 1980), p. 132ff.

30. Hibbard, *Bernini*, and Perlove, "Blessed Ludovica."

31. John of the Cross, *El Cantico Espiritual segun el Ms. de las Madres Carmelitas de Jaén*, ed. M. Martinez Burgos (Madrid, 1936), p. 16.

32. Ibid., p. 1134.

33. Concerning meaning and paradox as the basis for comprehension, see E. Garroni, *Senso e paradosso* (Rome and Bari: Laterza, 1986).

34. Hibbard has already discussed the relationship between the position of the sculpture and the linear folds of the drapery in *Bernini*, p. 226ff.

35. I have taken this expression of Eisenstein's from Montani's introduction to Eisenstein, *La natura non-indifferente*, p. xi.

36. L. Reypens, "Ame, son fond, ses puissances et sa structure d'aprés les mystiques," in *Dictionnaire de Spiritualité*, 1:434ff.

37. Richard de Saint Victor, "Benjamin Minor," in *Patrologia Latina*, 196, c. 59, cited in ibid.

38. This is another formulation taken from Montani's introduction to Eisenstein, *La natura non-indifferente*, p. xi.

39. Ibid., p. xi.

40. Ibid., p. xiiff.

41. Ibid.

42. Ibid., p. xix.

43. Ibid., p. xxviff.

44. Ibid., p. xxviii.

45. Eisenstein, *La natura non-indifferente*, p. 52ff.

Chapter Three

1. Ignatius of Loyola, *Constituciones de la Compañia de Jesus y sus declaraciones*, ed. Giuseppe Silvano (Milan: Ancora, 1969).

2. F. Borsi, *La chiesa di S. Andrea al Quirinale* (Rome: Officina edizioni, 1967).

3. See T. Kaory Kitao, "Bernini's Church Facades: Method of Design and the Contrapposti," *Journal of the Society of Architectural Historians* 24 (1965): 263–84.

4. The first chapel to the right, dedicated to Saint Francis Xavier, includes three canvases by Giovanni Battista Gaulli: the altarpiece showing the saint's death, placed here in 1676, and the two lateral canvases showing the saint preaching and performing the rite of baptism. On the vault of the chapel, Saint Francis Xavier is represented in glory surrounded by angels in a fresco painted by Filippo Bracci in 1716, which replaced an earlier fresco by Gaulli. The second chapel includes a Deposition of the Cross, a Veronica, and a Christ on the column by Giacinto Brandi (who received payment for it in March 1682). In the second chapel to the left of the altar, dedicated to Saint Ignatius of Loyola, is a painting showing Ignatius, Francesco Borgia, and Luigi Gonzaga worshipping the Virgin and Child. The two lateral paintings include an adoration of the Magi and an adoration of the shepherds by Ludovico David (1691). Farther to the right, in a chapel dedicated to Saint Stanislaus Kostka, we find an altarpiece by Carlo Maratta showing the saint in the midst of a vision of the Madonna. The lateral paintings illustrating episodes from the saint's life are by Mazzanti. The frescoes of the sacristy vault were painted by Giovanni De la Borde, a pupil of Pierre Mignard, in 1670, following the indications given in a sketch approved by Bernini. Mattia De Rossi, Bernini's favorite pupil, who accompanied the sculptor to Paris in 1655, supervised these works after his master's death.

5. The shift away from the iconography depicting the martyrdom of missionaries in favor of an iconography illustrating mystical experiences has been treated by E. Male, in *L'art religieux après le Concile de Trente* (Paris: A. Colin, 1932), p. 116ff.

6. For more on the patrons who commissioned the artworks found in the church of Sant' Andrea, see F. Haskell, *Patrons and Painters: Art and Society in Baroque Italy* (New Haven, Conn.: Yale University Press, 1980), p. 88.

7. R. Pane, *Bernini Architetto* (Venice: N. Pozza, 1953), p. 67ff. For a less extreme yet implicitly negative judgment, see P. Portoghesi, *Borromini nella cultura europea* (Rome: Officina edizioni, 1964).

8. M. and M. Fagiolo dell' Arco, *Bernini: Una introduzione al "Gran Barocco"* (Rome: Bulzoni, 1967), p. 61ff.

9. Borsi, *La chiesa di S. Andrea al Quirinale*, p. 33.

10. Ibid.

11. Ibid., p. 35.

12. Ibid., p. 37.

13. C. Baronius, *Martyrologium romanum* (Rome: for Sixtus V, 1588).

14. Baronius, *Annales ecclesiastici* (Rome: for Gregory XIII, 1588).

15. Jacopo da Varazze, *Legenda aurea sanctorum divini verbi* (before 1264; for Antonio Ibañez, 1688). The *De vera e falsa poenitentia* attributed to Saint Augustine by Pietro Lombardo and Thomas Aquinas is probably apocryphal. See Saint Augustine, *Oeuvres Complètes* (Paris: Vivés, 1873), 23:11ff.

16. L. Richeome, *Le livre de la peinture spirituelle, ou l'art d'admirer, aimer e louer Dieu* (Lyon, 1611).

17. Louis Marin addressed this question in a seminar on the emergence of the subject in Montaigne's *Essays*, held in 1988-89 at the École des Hautes Études en Sciences Sociales in Paris.

18. See H. Vlieghe, *Corpus Rubenianum Ludwig Burchard* (Brussels, 1970), n. 8, p. 4, fig. 22.

19. G. P. Bellori, *Le vite de' pittori, scultori e architetti moderni* (Florence, 1672; Turin: Einaudi, 1976), p. 29ff.

20. The paralysis of the guards who have attempted to interrupt Andrew's smooth passage from life to death is symmetrically opposite to the petrification of Orpheus after interrupting Eurydice's safe return from death to life (Ovid, *Metamorphoses*, 10.1). It is also reminiscent of the paralysis that afflicted the "prince of priests" who tried to reach out toward Mary's death bed, as described in the passage dedicated to the Assumption in Varazze's Legenda aurea.

21. Borsi, *La chiesa di S. Andrea al Quirinale*, p. 33.

22. These sketches were studied by Sharon Cather on the occasion of an exhibition organized by Irving Lavin at the Art Museum, Princeton University. See Lavin et al., *Drawings by Gianlorenzo Bernini from the Museum der Bildenden Künste Leipzig, German Democratic Republic* (Princeton, N.J.: The Art Museum, Princeton University, 1981). According to the order established by Cather, the first sketch is the one that appears on the upper part of plate 86a in the general catalogue of Bernini's drawings edited by Brauer and Wittkower (*Die Zeichnungen des Gianlorenzo Bernini* [Berlin, 1931]) (fig. 37). In this charcoal drawing, the outline of the three angels, the edges of the frame, and the gilded rays behind the upper corner of the frame have been gone over in ink. One angel is holding a crown and a palm branch; another angel, flying in front of the frame, seems to be exerting pressure on the upper edge; while the third, whose back rests against the outer edge, turns to grasp hold of the frame. In the second sketch found on the bottom half of the page, the angel on the right has been turned around and has assumed a position quite similar to that of the gilded stucco angel holding the frame in his arms. The position of this angel undergoes few modifications in the three later sketches. In the final sketch, Bernini introduces a change that may be interpreted in one of two ways. In letting go of the frame, the angel either has assumed a position of compassionate welcoming and

attention similar to the angel to the right of the presbytery, or he has been switched from right to left and instead of holding up the frame he is now pushing against it. (Brauer and Wittkower, *Die Zeichnungen des Gianlorenzo Bernini*, n. 85; Lavin et al., *Drawings by Gianlorenzo Bernini*, n. 48) (fig. 38).

23. Ignatius of Loyola, *In fontis narrativi de Sancto Ignatio de Loyola et de Societatis Jesu initiis* (Rome, 1943), vol. 1.

24. J. C. Dhotel stresses the importance of renouncing the image of oneself as a saint in his introduction to the recent French edition of *Récit écrit par le père Louis Gonçalves aussitôt qu'il eut recueilli de la bouche du Père Ignace* (Paris: Desclée de Brouwer, 1988).

25. P. A. Fabre, *Le lieu de l'image.*

INDEX